The Guide to Lost Wonder

The Guide to Lost Wonder
Jeff Hoke

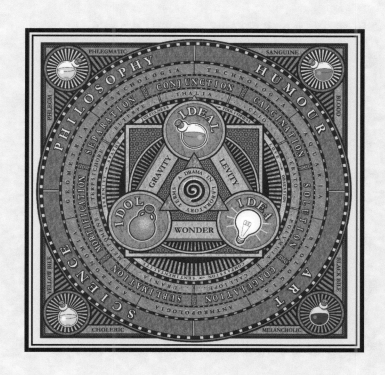

Published in 2023 by
The Museum of Lost Wonder
www.lostwonder.org

Cover and illustrations by Jeff Hoke

ISBN: 978-1-0881-1964-8

Typeset in Minion Pro.

Printed in USA

Dedication

To all the readers of The Museum of Lost Wonder, who have written and shared their wonder with me, and forever keep me inspired. Special thanks to my friend and muse Stephanie Thomson, an editor in London, whose gentle guidance has made me look good despite my many flaws. And to my co-conspiritor, Clint Marsh at Wonderella Printed, who's always had my back.

"All religions, arts and sciences are branches of the same tree"
—Albert Einstein

"There's nothing in this world that you see that wasn't first imagined"
—Neville Goddard

❦ Contents ❧

Preface

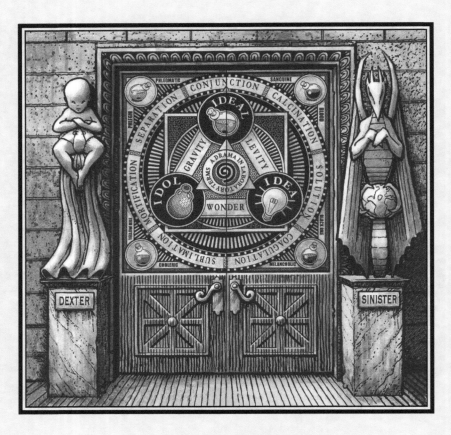

"Fiction is the lie through which we tell the truth"
—Albert Camus

The Museum of Lost Wonder

It is said we need both fact and fancy to survive—one to endure the present, the other to create a future. It was with this in mind that the Museum of Lost Wonder was born: an ephemeral institution that aims to combine science with myth. The Museum gets its name from its dedication to the wonderful weirdness of life—and the sense of awe, curiosity, and desire to create that arise from it. For us, mixing myth and truth is how we find meaning in our lives.

The Museum of Lost Wonder is a museum made up of museums, containing not so much a group of objects as of ideas—a collection of memories. It's constructed from those concepts from mythology and the history of science that continue to color our view of the world today. Each exhibit hall is its own 'museum', with its own rules of arrangement, reflecting a different way of looking at the world. Taken as a whole, they reflect the process of creativity and self-discovery. Like other imaginary places, the Museum is also a memory palace, whose visualized objects become signposts along the journey towards self-illumination. It's a winding path that differs for each individual. It's not a prescriptive route, but is descriptive of the process of self-discovery that is available to all of us.

The Museum's path takes its inspiration from the process of alchemy, with each exhibit hall named after one of its seven steps. Alchemy's mythical structure has both practical physical applications, as well as psychological connotations, which straddle both myth and science. It mirrors all great 'Hero's Journeys' where one becomes the hero of their own adventures.

Although it springs from the imagination, our Museum has very real precedents in history. It derives from an ancient practice of creating imaginary palaces to embody a progressive view of the world and establish one's place in it. This visionary tradition was followed by those forwarding utopian views, visionaries who modeled these palaces as architectural structures in their minds—places to share their vision with others who entered them. Like these ancient Dream Palaces, the Museum of Lost Wonder becomes real as a result of all those who tour and embrace its possibilities. The shared experiences are the bricks that build its presence in the mind and make it a reality.

The Museum of Lost Wonder advocates a do-it-yourself philosophy. The activity book you hold in your hands is both an extension and a foundation of it. Hopefully, it will also form the foundation for realizing your own dreams through practical experiments and activities that reveal the depths of your own creative process.

Introduction

What drives humans to indulge in fanciful fallacies? What infects our minds to make us love fabrications and take them as truths? What compels us to create wonderfully weird and useless things? And why do we find them meaningful? We'll address these questions, and more, in the following pages as we explore the heights and depths of the human imagination.

Fantasy and creativity aren't limited to artists. For better or worse, they're inherent evolutionary gifts we all possess—whether you're an artist, scientist, historian, or even an accountant. It's what helps anyone survive and succeed at any endeavor they're passionate about. All it takes is imagination—the ability to visualize different possibilities before making them real. Our imaginations can be a blessing or a curse, but they've made us who we are, and put us where we find ourselves today. Part problem solving, part leap of faith, the compulsion to create is our greatest natural resource.

Tower of Babel

What compels us to love fictions and fallacies?

This activity book focuses on creativity and the imagination. Where they come from, how they evolve, and where they can take us. We'll explore not only the creative process, but what takes place in the brain when you use your imagination to visualize a notion, and the importance of memory when coming up with novel ideas.

> *"Fiction reveals truth that reality obscures."*
> —*Ralph Waldo Emerson*

We'll uncover examples from history, to see how people have tackled the question of creativity in astounding ways. We'll see how they've invented new worlds as inspirations for making this one better. In the end, we'll show examples of these imaginary creations that have led to sweeping social change.

Memory is the wellspring of creativity. It's what gives our subconscious the resources it needs to ferment and grow surprising new connections, and concepts that feed our intuition and imagination. Memory works best when supplied with dramatic imagery and metaphors. Visual metaphors are the magical building blocks of memory, as they provide multiple layers of associated meanings— multiple access points to create and retrieve ideas in the vast neural network that makes of the mind. The more associations we have with a particular idea, the easier it is to access it and combine it with others to generate new and novel creations. The richer the picture, and the more peculiar it is, the better it works to cement new concepts together. That's one reason why you'll find so many pictures in this book. They help our brains to encapsulate ideas, and make them more meaningful by generating multiple links to what's already in our heads. They build upon the known to take us to the unknown. Evocative imagery, working as a visualized three-dimensional space, is even better, as it allows us a place we can imagine ourselves in. That's why you'll find so many architectural visions in the following pages. Just like Memory Palaces, they surround us with an alternate world we can walk around in, where we are the actors in our own dramas.

Architecture is used throughout this activity book not only as mnemonic device, but as a metaphor for the mind and memory—the place where our creativity lives and grows. Buildings create a three-dimensional Mental Model for us to physically envision ourselves inside a particular concept. This makes for easy absorption, retention and retrieval of information, thus creating a rich foundation for the imagination. Picturing ourselves in a structure filled with imagery is an ancient mystical practice that's

traditionally been used when creating Memory Palaces. This metaphorical method has been employed around the world and throughout history to embody a philosophy, solidify its ethereal metaphysical concepts, and bring those ideas to life in the mind.

The antique style of this book is intended to demonstrate a reverence for history. The use of so many little pictures to illustrate it is inspired by illuminated manuscripts from the Middle Ages, which put images on each page to act as mnemonic devices that helped to "illuminate" the text. The use of etchings is primarily motivated by prints from the 1600s, when publishing bloomed and became the first democratic use of mass media to forward a philosophy. It was followed by the 17th century, when science was in its nascent form and still mixed with magic—a magic we've lost the art of wondering about in our own time. At this point in history, magical hopes and dreams were combined with the practical application of scientific methods to create something meaningful. It led to our own modern search for meaning, and should not be forgotten. It's where many of today's struggles for democracy and personal freedom began. History is the collective memory that lays the foundation of our fancies for the future. We end our tour of it by offering examples of architectural fantasies that have fueled philosophies that made the world what it is today.

The aim of this activity book is to inspire curiosity, doubt and wonder. Its mission is to encourage you to harness your own unique creativity through do-it-yourself exercises you can pursue in the comfort of your own home. Creativity is not an idea, but an experience—something you need to practice with your head, heart, and hands to really understand. The physical activities in this book are meant to help you join in this journey and encourage further personal exploration on your own.

The paper models are unique, and key to exploring the creative process in this book. They demonstrate how creativity embraces the magical transformation of an idea into reality, encouraging you to use your hands to traverse dimensions when visualizing a simple idea. Like pictures, models act as mnemonic devices, but enhance the reinforcement of ideas with their multiple dimensions.

These paper models will help you make even better mental models when you're crafting a concept, providing even more associations to your own personal experience, and acting as splendid springboards to your memory and imagination. As with picturing architecture, just visualizing the models helps cement an idea in your memory. The physical act of making them with your hands adds an extra dimension to this experience.

The magic of manifestation

For some, picture books and paper models may seem the sole property of children—too playful to be taken seriously by adults. We trust you're not one of those people! Museums aren't built for children, either, but children seem to be their biggest draw. Shame… There seems to be a gap in our education that leaves most adults lost between the scholars and school kids. We have to wonder why this this happened. Pictures and 3D models propel art and science, discovery, innovation, and aesthetics. Does wonder have to wither away when we become adults?

Come along with us as we explore the inner vaults and towering heights of the human imagination. We'll uncover a lost method of self-discovery through the process of creativity. We'll learn how it arises in the mind through visualization, and becomes a reality through practical experimentation—fed by the inspiration that springs from our individual memories. We earnestly hope the stories, exercises, activities and paper models act as a guide to help you on your own personal journey of fun and creativity. It just takes a first step.

Codex of Creativity

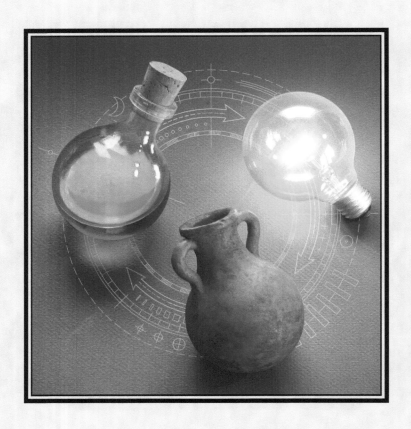

What creates creativity?

CODEX *of* CREATIVITY

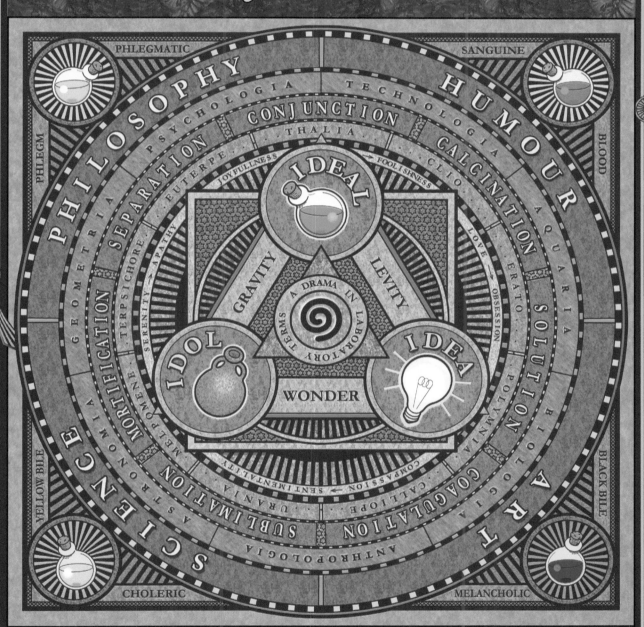

I begin with an idea and then it becomes something else — Pablo Picasso

CODEX *of* CREATIVITY

"A drama in laboratory terms"

We're all creative at heart. We can't help it. We're born this way. We've evolved this talent out of necessity—the ability to come up with metaphors, analogies, and abstract symbols, then float these ghostly representations of reality in our minds, was an improvement to survival over the simple stimulus/response circuitry that evolved millions of years before it. It's been a blessing and a curse. Our ability to abstract our experiences has allowed us to create novel things never before seen in the world. (Some useful, some silly, some downright disastrous.) But it has also made us terribly neurotic, as we often mistake the ephemeral apparitions we conjure up for reality. Nevertheless, our talent for abstraction is the source of much humor and fun, and the basis for our individual creativity. Embarking on a creative journey, one would expect an expert guide, but I'm only a fellow traveler on this adventure. Like most people, I have my moments, but I'm probably not the most original or visionary human being you're apt to meet. What does set me apart is a passion for making things, and the ability to muddle through the creative process day in, day out, without giving up. I've also come to realize that drawing and writing answer an obsessive need in me that other aspects of life don't come close to satisfying.

As a creative person who has worked with other creative people in museums over three decades, I've also gained a unique perspective on how we communicate visions and share experiences with a wider audience. Museums draw on a wealth of talent—from scientists and teachers, to architects, painters, sculptors, filmmakers and musicians. In spite of this, sometimes the most creative people are the carpenters, engineers and multi-media experts who are left to do the actual work that's involved in manifesting the visions of "idea-comer-upper-withers".

Not surprisingly, museum folk also love history, and are inspired by the ideas and accomplishments of those who came before us. After all, their artifacts populate the environment we work in every day. So I'll be bringing in a few expert opinions on creativity as we go along, too. Most of the ideas in this work may not be original, but like others before me, I try to make sense of them for myself in the context of the times I live in, and hopefully make them relevant to others.

IDEALS, IDEAS, and IDOLS
The vessels of our virtual vernacular

THE PORTAL TO ADVENTURE
Supporting The Museum of Lost Wonder's door are our two guides and fellow travelers —the playful inner baby who wants to make things, and the dreaming dragon of our imagination.

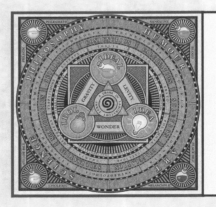

ABOUT THE MANDALA The official emblem of The Museum of Lost Wonder is a series of concentric rings. On the outer circle are its primary tools: art, science, and philosophy, laced with humor. Inside this is the array of disciplines these can apply to—a museum of museums. The third ring outlines the stages of alchemy, which give themes and structure to our journey. Supporting these are the nine muses—sisters in creativity and tour guides on our adventure. The inner ring shows the range of emotions brought about by our experiences—along with the four humors at the outer corners. In the centre is the triangle of creativity that we'll be exploring here, and the three basic forces in our Museum's universe: Gravity, Levity and Wonder. In the centre is our motto—"A drama in laboratory terms"—which was coined long ago to describe the process of alchemy. Finally, the spiral symbolizes and delineates our path of discovery.

On our journey through the creative process, we'll revisit some of the symbolism used in an earlier book, The Museum of Lost Wonder. In the Museum, these symbols acted as a route map for gaining knowledge and self-awareness. They suggested an approach to answering some of life's big questions, including our purpose in the world and the mystery of our creation. But these symbols are also relevant to creation on a much smaller scale—they can guide us through the act of self-expression in making real, tactile, physical things.

The Museum of Lost Wonder is an homage to creativity and the history of the human imagination.

Setting the stage

A wonderful reviewer referred to The Museum of Lost Wonder as "The history of the human imagination". So we'll start with the history of the symbols used to illustrate creativity on the emblem of the Museum and throughout these pages—IDEALS, IDEAS, and IDOLS. These three basic aspects of creation were the brainchild of Plato, a very imaginative thinker who is known as the father of modern philosophy. Although many of his ideas weren't new—he borrowed freely from the Egyptians, Babylonians, and Chaldeans that came before him—they are still surprisingly relevant to us today.

Plato's notions of the interplay between the ephemeral unconscious world and the concrete, perceptible world before us set the stage for modern psychology's discovery of the world of the subconscious mind. His 'allegory of the cave' introduced IDEALS, IDEAS, and IDOLS—a circular concept where IDEAS come from manufactured IDOLS, whose forms, in turn, are mere projections of IDEALS from another realm.

Plato's ideas have continued to inspire thinkers down through the ages. Along the way, alchemy absorbed Plato's mix of psychology, science, and magic to create a method for finding individual

The Alchemist Guided by God—Barchusen, Elementia Chemiae, 1718

Here you see an alchemist in his studio, getting help from his subconscious guide in order to create something new. The etching shows the basic aspects of the alchemical process—Lego, Ora, Labora— Read, Pray and Work. Books help the alchemist study the ideas of others. The lab equipment helps him work through the ideas of nature. The ethereal deity in the cloud is his inner 'Self' that guides him.

truths. Alchemy was a method that used refining raw materials as an analogy for inner refinement. It was a do-it-yourself practice that valued individual discovery above the dogma of the times.

Since this is The Museum of Lost Wonder, we'd be amiss if we didn't dredge up this strange and wonderful way of looking at the world and play with it again. Alchemists saw themselves as co-creators of this world—they were helpers in hurrying the natural course of evolution. Their final goal was to perfect the understanding of creation and connect with its source. We'll use alchemy as a metaphor for the creative process, because at heart it was an art that that mixed both psychology and practical work to craft something that was individual and original.

Creativity is something inherent in nature and ourselves. In the following pages, we'll explore the adventure of what it takes to make new stuff, but also what lies behind the universality of creativity.

THE TRIAD OF CREATION

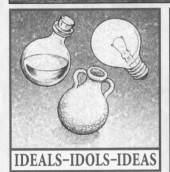

IDEALS-IDOLS-IDEAS

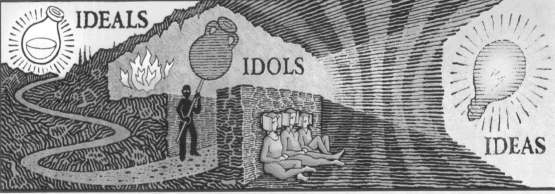

PLATO'S CAVE

The three symbols come from Plato's story of the cave, an analogy of how we perceive the world and re-create it in our minds. To Plato, the concrete world was made up of IDOL forms, and simply an imitation of another, IDEAL world. This IDEAL world was the real one, where IDEAS originate. The world we experience with our senses is a mere projection, paying homage to the IDOL forms. Today, we think of these concepts in psychological terms—they represent perception, how the mind works, and the way perceptions drive our thoughts and feelings in everything we do. The physical world we experience with our senses is only known through our perceptions. These are malleable, depending upon our subconscious drives and the invisible cultural context we grow up in.

IDEALS drive the subconscious fluid of feelings in the flask of our emotions

The fluid-filled flask is an example of what Carl Jung called the 'contained container', a symbol for the inner subconscious self that is given form by our outer, conscious selves and social norms. The liquid inside represents our feelings and passions, held in check by the glass of biological, cultural, and social concepts that influence our perceptions. The flask also symbolizes our emotional self, our bottled passions, and the depths of those subconscious, pre-verbal feelings that drive all of what we see, say, and do. The flask holds the reflections of our inner selves, our memories, and what our hearts dream about and aspire to.

IDEAS shed light on our conscious thoughts and perceptions

The light bulb represents the mechanism of our mind—how it perceives the world and tries to make sense of experience. It's our left-brain rationalizations. It's the part of ourselves that ignites the passions of inspiration by creating images and language that give form to our thoughts. Since its creation, the light bulb has permeated our culture as a symbol for a new IDEA. We use it as a reference for mental activity, perception and the cogitations of our conscious brains, as opposed to our subconscious drives and feelings.

IDOLS inspire and mold meaning in the physical world

As an empty container, a vessel's importance lies in the hidden meaning we put inside of it. This underlines the concept that the physical objects we pay so much attention to are ultimately unreal—except as evidence of our ideas and ideals. We use a clay vessel as a metaphor for an IDOL, as it represents one of the first inventions made by humans to carry their desires. In our trinity of symbols, it represents the body, our hands that create forms, and the physical world in general. It also embodies the four elements, as it is made from earth mixed with water, that dries in the air and is fixed by fire.

The names of these three concepts stem from the Greek word 'eidos' or phantom, and they exhibit the same ghostly tendencies, shifting in meaning according to the context they appear in. Their intent is to be a convenient shorthand—a mnemonic device for how meaning is created by our perceptions, which are formed by our unconscious drives.

INVENTING IDOLS

Renaissance thinkers expanded Plato's philosophy, and used it to interpret how we create things in our minds according to our biology, language and culture. Early scientists and alchemists understood the ephemeral nature of perceptions and how they could lead to erroneous ideas. That's why they stressed studying natural, physical phenomena to ground the truth for oneself. Scientist and alchemist Francis Bacon elaborated on Plato's idea of IDOLS being projections of our own misapprehensions. He suggested four types of idols that lead our minds to mistake fiction for the truth. He published these in 1620, in his work *Novum Organum—The New Instrumentality for the Acquisition of Knowledge.*

IDOLS OF THE TRIBE

These refer to misunderstandings generated by our biologically evolved brains. Bacon called these "deceptive beliefs inherent in the mind of man". Even though we have the ability for abstract thought, our perceptions are still affected by basic biological drives in our subconscious circuitry. Fundamental animal drives for food, sex, safety, and defense (fight, flight, food, and fornication) still color our abstract beliefs by creating false perceptions.

IDOLS OF THE CAVE

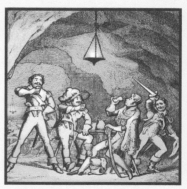

This analogy explains how our point of view is influenced by our individual backgrounds. The mind is viewed as a cavern. Our thoughts roam about in this cave and are modified by temperament, education, habit, environment, and intent. Lost in the dark, we lose perspective, and interpret what we experience according to our own interests. The little brigands in the cave to the right certainly have a different view of this little party than the innocent lord who thinks he's simply there for the beer…

IDOLS OF THE MARKETPLACE

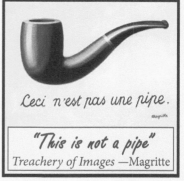

Here we wonder about words losing meaning. Language is a cultural construct that evolved from trying to communicate in the marketplace of society. At best, words are vague abstractions of the experiences they're meant to convey and the phenomena we use them to refer to. Much humor is based on the misunderstanding of the meaning of words. Specifically, this is how words can be misused to persuade other people of one's opinions, and how they can be used to manipulate meaning and persuade others' beliefs.

Ceci n'est pas une pipe.

"This is not a pipe"
Treachery of Images —Magritte

IDOLS OF THE THEATER

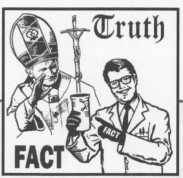

This is the idea that those with power know better than the rest of us. The opinions of historic and public figures are idolized and mistaken for the truth, simply because of their elevated social positions. These idols are created in the arenas of theology, philosophy, science, and academia. These groups form huge lobbies that profit from proselytizing their own beliefs to persuade the masses of their point of view.

Truth

FACT

Francis Bacon, and other early alchemist/scientists, were fervent iconoclasts. Many were persecuted, tortured and killed for going against the opinions of those in power. They stressed that the only way to truth was through personal experience with natural phenomena and experimentation with physical matter.

Although alchemy's stress on individual experimentation led to modern scientific methods, it was more of an art than a science. It was a spiritual discipline seeking to comprehend creation through one's own creativity. Manipulating matter was a mirror for seeing how our inner selves invent the world around us. Alchemy's intent was to understand the innate creativity of our own hearts and minds.

The Alchemy of Creativity

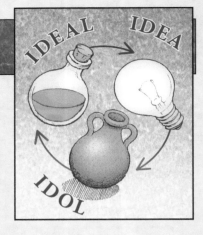

The study of alchemy goes back to ancient Egypt and beyond. It is a lost art that was a precursor to modern science. We like its lost way of wondering about the world because it encouraged using individual interpretations of truths to create meaning instead of separating ourselves from personal truths as science does today. Alchemy was quirky, obscure and full of myth and metaphor, and its symbolism sought to reach our subconscious selves. It thumbed its nose at organized religion, and its seekers sought salvation through individual effort. Instead of propagating a prescriptive philosophy, each adherent of alchemy had to work through the process of creation for themselves. Seekers worked to transform physical matter as an analogy for inner refinement. Transforming base materials into gold was seen as a process of natural evolution. Making gold was simply helping nature reach its own state of perfection, while simultaneously perfecting yourself. The final production of gold was a metaphor—a symbol that you'd reached the goal of inner refinement.

We like alchemy's iconoclasm and emphasis on a personal way of knowing things, and its stress on making a connection with nature's matter as a way of connecting with yourself. In this way, it's a perfect analogy for creativity in general. It's not the noble or creative idea that matters, it's working through the matter that matters. The alchemists' tripartite motto was the Latin phrase Lego, Ora, Labora—read, pray, and work—or, in modern terms: research, muse, and experiment.

The stages of alchemy follow an ancient pattern of a sevenfold process. The Babylonian mystery cult of Mithras included seven levels, and this same convention was later to be adopted by the Roman legion and mystics in the Middle Ages. Over time, alchemy's stages evolved into a cyclical process—coming full circle brought you to the start of a higher level, where you could repeat the process for further refinement.

Applied to the creative process, the alchemical stages aren't prescriptive, complete or concretely ordered. Rather, the sequential steps help provide a blueprint and a memorable form for the act of creation. You may move through them quickly, find that a single stage takes many weeks to complete, or even skip stages altogether. Taken in sequence, the stages

can also be seen as an archetypal narrative that is similar to Joseph Campbell's twelve-stage 'Hero's Journey'—derived from the ancient storyline used by many cultures to describe the engagement, initiation, confrontation and epiphanies a person goes through to share a 'boon' with society. Our 'boon' in this case is creating something unique that the world has never seen before, that has the possibility of inspiring others.

The Universality of Creativity

AH-HA	HA-HA	AHH
SCIENCE	HUMOR	ART
Paradigm	*Conjunction*	*Metaphor*

Above adapted from Arthur Koestler's Act of Creation

IDOLS	IDEAS	IDEALS
GRAVITY	LEVITY	WONDER

Viewed as an archetypal journey, the creative process is not limited to artists, but shared by scientists, comedians, and the rest of us seeking a little refinement.

The purpose of our adventure, or 'drama in laboratory terms', is to encourage some experimentation and propagate a bit of play. It will be full of joys and surprises, as well as frustrations and pitfalls. Creating something new always has its ups, downs, and detours. As with alchemy, while you're changing matter to create something, it should change you in return. The real goal is to start a conversation with your subconscious. Let it be your guide. The objective is not to make something perfect, but to perfect the connection to your inner self.

It's time to outline the steps in the journey we're about to take. Follow along as the little vessels tell the story. You'll discover a recurring theme of swinging between emotional immersion and rational reflection, and back again, each time with new insight.

Seven Stages in the Creative Process

flasks of fancy

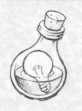

CALCINATIO

STAGE 1 **DESIRE DRIVES IDEAS**

—INTENT & INSPIRATION—

Igniting the fire of creativity with the fuel of our passions

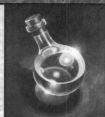

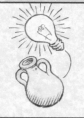

SOLUTIO

STAGE 2 **IDEAS SPRING FROM IDOLS**

—IMMERSION & INCUBATION—

Absorbing others' idols to inspire new ideas

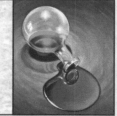

SUBLIMATIO

STAGE 3 **FEELINGS ENGENDER FORM**

—ASCENSION & IMAGINATION—

Allowing impressions to bubble up into our imaginations

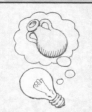

COAGULATIO

STAGE 4 **MATTER HAS A MIND OF ITS OWN**

—CONFRONTATION & CONNECTION—

Playing with matter while matter plays with you

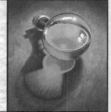

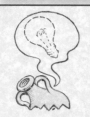

MORTIFICATIO

STAGE 5 **DEATH LEADS TO NEW LIFE**

—SACRIFICE & REBIRTH—

Encouraging new life to spring from the ashes

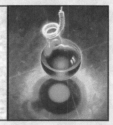

SEPARATIO

STAGE 6 **FAILURE IS PART OF THE FUN**

—REFLECTION & REFINEMENT—

Patience, perseverance, practice, perception & more play

CONJUNCTIO

STAGE 7 **ONE IDEA LEADS TO ANOTHER**

—CONNECTION & COMMUNICATION—

Setting the work free to gain a life of its own

#1 DESIRE DRIVES IDEAS

An IDEA immersed in the fluid of its IDEALS

CALCINATIO—feel the fire of desire

> "Discontent is the first necessity of progress" —Thomas Edison

Our first encounter is with the fire of desire. Some folks may think that the IDEA comes first in the process of creation, but they'd be mistaken. Behind every IDEA is a reason to embark on a creative endeavour in the first place. Every IDEA springs from the desire to fulfill a need, whether it be practical, personal, poetic or pragmatic. It comes from the feeling that something isn't quite right, and could be better. Passion is the pressure our inner and outer worlds put on us to come up with something new. IDEAS are driven by a need to make a change—in yourself, or in the world at large.

> "Necessity is the mother of invention" —Plato

The Peculiarities of Passion

Passions can take many forms, and some will have more merit than others. Their value will be measured by the quality of the desires that compel you. First, foremost and most beneficial of passions, from a creative standpoint, is the love of play. Our subconscious just loves to have fun. The sustained suspension of disbelief that play offers will quiet your critical mind and allow your inner self to shine through.

A chief component of play is curiosity—to wonder what will happen next. It's important to have a passion for the possibilities and a love of surprises. Try to watch yourself at play and be curious about the motivations, feelings and aspirations that express themselves while you're having fun. These will reveal the longings of your subconscious self— where our IDEAS and dreams come from in the first place.

> "I have no special talent. I am only passionately curious" —Albert Einstein

Creative types seldom understand their own work—that's one of the reasons they make things to begin with. The urge to create comes from a hope that giving form to an IDEA will bring to light an understanding of one's inner needs. Working through an IDEA in a physical medium will externalize it and give it a perceptible structure for your inner self to respond to.

The thirst for insight can also be quenched by connecting with others or something larger than yourself. This craving to share an IDEA is a positive passion that can help give it meaning. To create something new that will inspire others and possibly provide further insights by allowing them to share passions of their own is hugely rewarding. Valuable too is the perspective offered by being a part of something larger than yourself. This can be achieved by connecting to history, or through culture, humanity, or nature in general.

> "I find out what the world needs. Then I go ahead and try to invent it" —Thomas Edison

Whether your passion is for connection, curiosity, self-expression or self knowledge, it is the strength of your enthusiasm that will see you through the laborious and difficult moments in the ensuing adventure.

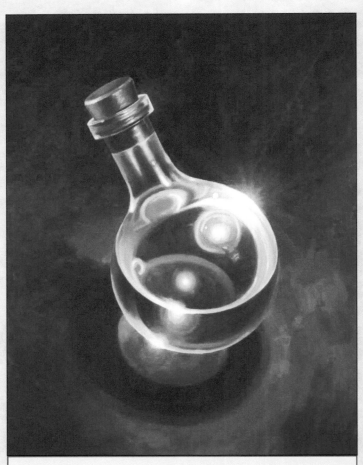

Passion is the fluid that fuels the fire of our ideals, and brings our desires to light.

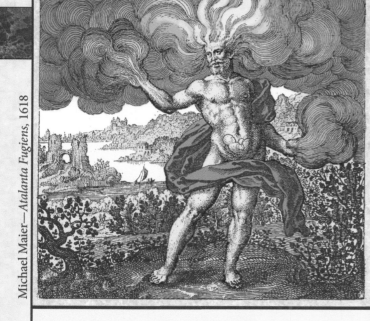

Michael Maier—Atalanta Fugiens, 1618

CALCINATIO

The fire of the imagination comes from our need to feed our innermost desires. Look closely and you'll discover an inner child in the belly that drives the fire of the mind, and comes to its fruition through the action of the fire in our hands.

The old saying that ideas are a dime a dozen is held in high regard here at The Museum of Lost Wonder. IDEAS are cheap, and take little effort. It's the drive of working through them in matter that gives them meaning. Many IDEAS will come and go in the journey ahead. There is no need to question their validity now. Don't judge, doubt or negate your passions—it's the practice of working through them that will determine their value.

"Inspiration exists, but it has to find us working"—Pablo Picasso

Beginners often become frustrated because they expect an idea to pop out of their heads fully formed. They think it is just a matter of having mastery over the materials that's holding them back. It's not. It's understanding that creating something is a process with many pitfalls—and having the passion, patience, and persistence to work through each step—that's the real challenge. It takes time. It takes work. The process is an inner journey that many dilettantes avoid embarking on for fear of effort and fear of failure.

Among alchemists, dilettantes were called 'puffers', because they would madly blow on their furnaces with bellows to try and hurry along the process. Their only goal was to manufacture gold for recognition and riches. But in alchemy, as in art, the real goal is not to make something physically perfect for another's approval, but to have a perfect conversation between the materials and your inner self.

All the way through our adventure, you'll need to remember and re-embrace this passion to fulfil a need that drove you to begin with. This will ground you in times ahead. Don't fall in love with the IDEA or the final outcomes. Instead, fall in love with the need to play with the materials. In the beginning, you may have a medium in mind—or not. Sometimes you'll skip around, rearranging or repeating, going back and forth between reasoning and your imagination, reflection and intuition. It's the back and forth—between you, your self and the manipulation of matter—that will tell you what really matters.

Whichever needs you want to fulfil, the ultimate goal is not to make something beautiful for others to admire, but to create a conversation and a closer connection between your heart and your conscious mind.

As we see in the etching here, IDEAS are children, waiting to be born. They need love and persistent nurturing to succeed in the world. It is passion that conceives a child, but it is by listening to, acknowledging and supporting their own needs, and sometimes sacrificing your own expectations, that you will give them independent form. You'll need to share your desires with the demands of your creation if it is to grow up into something useful and inspired.

Practicum

1. *Feel the need*
2. *Embrace your inner self*
3. *Follow your passions*

Next stage —SOLUTIO— *Immersion*

Next, we'll dive in and submerge ourselves in the inspiration that fires our passions. We'll explore existing IDOLS that give birth to our IDEAS. This immersion is key to the process of creativity. It's an elevated emotional state, full of drama and intensity, that makes you feel fully alive.

"Science may give you the means of living, but art will give you a reason for living it"
—*Author*

IDOLS have IDEAS of they're own

SOLUTIO—immerse yourself in your inspirations

Follow the passion that inspires you and immerse yourself in your interests. Surrounding yourself with sources of inspiration is a major activity in creativity, not only at this stage, but with all the others, too. During this process, we'll go back and forth between rational and emotional states, but this is where we begin to dive deep into the world of the things that move us.

Every IDEA that pops into your head has to come from somewhere. Sometimes it's easy to figure out where an IDEA comes from, sometimes not. But one shouldn't wait for inspiration. It's best to consciously study the things that appeal to you—to bury your mind in the minutiae of what's been created before. You will need to make a mental space for this to happen. Put the concerns of your daily life aside and give yourself permission to do something you don't understand the reason for yet. Reason comes later.

This is the time to get absorbed in the work and IDEALS of those who inspire you by studying the IDOLS they've made. It is a stage of research and learning. Look to your personal IDOLS, the IDEALS that inspired them, and their work that you idolize. Pay close attention to how others have approached and realized an IDEA.

> "Bad artists copy. Good artists steal" —Pablo Picasso

Picasso's distinctive style didn't jump out of him fully formed, nor did he sit in front of a blank canvas and wait for the muses to tell him what to do. Instead, he turned to a passion for paint and the art of others that spoke to him. You can see this in his early work, which experiments with Naturalism, Impressionism, Cubism, Collage and other techniques. He emulated the styles of artists he admired to learn from them. Eventually, he absorbed their influences and created something uniquely his own, according to the context of his own life and times.

This state of submersion is like meditation. It's also something we can find ourselves practicing on a daily basis. Have you noticed how time flies when you're involved in conversation? Or how about going into a darkened theater, only to be swept up by the alternative world presented by a film or performance. After the show, when you go outside, doesn't the ordinary world seem different somehow? This is the immersive state—our daily concerns are forgotten while we're absorbed in the things we love.

This is the time to fill the 'toy box' of your imagination with goodies, experiment with different styles and find out what turns you on. It's time to play. The subconscious loves surprises, play and pleasure, fancies, foolishness and fun. You may or may not have in mind the materials you want to create with yet, but you don't

> "The artist is a receptacle for emotions that come from all over the place: from the sky, from the earth, from a scrap of paper, from a passing shape, from a spider's web" —Pablo Picasso

necessarily have to study the same media. Artists can become inspired by music, writers by art, inventors by a piece of prose. The mind loves to explore and cross-reference, and will go to town mixing things up, swapping them round, and making new connections.

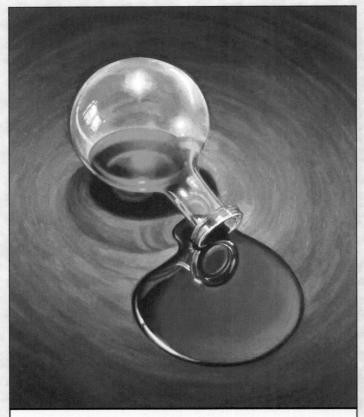

The flask spills its contents, looks down and sees its desires reflected, then becomes immersed in its own interests.

Michael Maier—*Atalanta Fugiens*, 1618

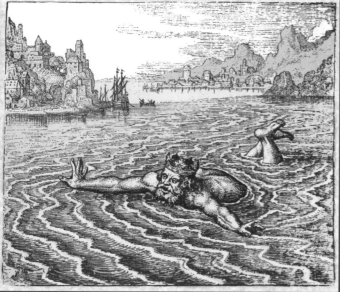

SOLUTIO
The king (everyday consciousness) swims in the ocean of his unconscious passions.

Start by remembering and gathering together all your favorite things. Fill your mind with memories and let your subconscious do the rest. Just let the ideas float around for a while. Don't feel pressured to commit or decide what may be useful yet. Simply engage yourself in passionate play with the things you love—paintings, sculpture, music, toys, cockamamie contraptions, silly stories, and magical movies. Excite your mind with the possibilities that your source materials suggest.

> "There is no new thing under the sun" —Ecclesiastes 1:9

Every idea needs a context in which to flourish. Filling your mind with forms of inspiration provide this fluid environment. Allow your favourite things to flow around, and mix and match. Let them simmer together into your subconscious, where they can incubate and make new connections. Let them ferment and dissolve into each other to create totally new combinations.

> "Those who don't want to imitate anything, produce nothing"
> —Salvador Dali

Don't worry about being unoriginal by wanting to emulate others' work. All great artists and inventors have done this. They started by studying and copying the works of those before them, to learn from them. Creativity is evolutionary—one thing builds upon another. Copying is the best form of flattery—so never borrow an idea, steal it! Eventually, you will turn it into something else and make it your own.

> "To invent, you need a good imagination and a pile of junk"
> —Thomas Edison

Thomas Edison became famous for coming up with the first practical light bulb, which has become the universal symbol for an IDEA. But the invention wasn't Edison's—his renown came from coming up with a version of the light bulb that was practical and affordable for most people. He started his endeavors by building on the work of others.

The IDEAS of others will sink into your subconscious simply by the weight of your enthusiasm for them. The subconscious, by nature, is unique to each individual. The connections it makes, and the forms it envisions, will always ensure an original interpretation. You may feel what it comes up with is not as good as the source of your inspiration, but don't worry about that. What it comes up with will be your own. If you're quiet, and you look, and you listen to your inner voice, it might just surprise you.

Give yourself the luxury of filling your fantasies with what you love. Embrace, don't criticize, your enthusiasms. Let them sink into your subconscious. Give your inner self time to absorb, incubate and ferment these ideas and images. Give yourself permission to imagine making something wonderful.

Practicum
1. *Find the things that inspire you*
2. *Fill your mind with what matters to you*
3. *Don't evaluate—let it incubate*

Next stage —SUBLIMATIO— *Imagination*

Now that your mind is filled with ideas and inspirations, let them incubate in your subconscious. Let them ferment and make new connections by themselves. Next, you'll want to let them percolate and bubble up. Be to ready to be aware and catch them when they come to the surface.

SUBLIMATIO—capture ideas as they float into the air

The IDEAL imagines being an IDOL

> "Painting is a blind man's profession. He paints not what he sees, but what he feels, what he tells himself about what he has seen"
> —Pablo Picasso

Now we shift from a mood of immersion to flights of fancy, gaining real inspiration by letting things bubble up from below. Ideas may be just vague feelings at this point, yet they dearly desire to express themselves.

Once you've filled yourself with the things that tickle your pickle, give them time to fester. All these thoughts and feelings have their own life, and will stir and percolate in the subconscious. One morning, they may surface in a flash of inspiration. Something new. Something you haven't consciously thought before. This can only happen if you've 'filled your toy box' and laid the groundwork by throwing yourself into an obsessive passion for what you love. Once your mind's memories are filled with materials, the subconscious will go to work. It can't help itself. It loves to create drama by designing new relationships and mysterious metaphors. Trust, have faith, and depend on it. Your 'alter ego' is your best friend, and *wants* to play.

The inner processing of experiences is something we do every day, and a normal function of our brains. It's what the subconscious does. We notice this nightly with our dreams. Evolutionary biologists believe that dreams evolved as a way for our mind to remember and learn from our experiences. It does this by repeating and re-playing those experiences at night, in order to strengthen and reinforce our neural pathways and connections. The subconscious speaks in a language all its own. It mixes metaphors to form memorable messages—the weirder the better. That's how memory works. Ordinary, everyday events are ultimately forgettable. Unusual apparitions are not. The subconscious puts ordinary things in strange guises to give them meaning by metaphor, and creates allegorical stories for us to make them memorable. That way, we'll remember our experiences, and be quicker to recognise new opportunities or sources of danger.

> "You have to have an idea of what you are going to do, but it should be a vague idea"
> — Pablo Picasso

Like dreams, the ideas that bubble up at this stage may not make sense right now, but they may be useful later. Let them come. Turn off your daily mind, suspend judgement and allow any insights to speak to you. Allow yourself the freedom to embrace something unusual. Your subconscious self will appreciate it and, if you've done your homework by feeding it, it may provide you with some amazing food for thought in return. It has a passion and intent all its own, but its still 'you'. In fact, it's the *real* you.

> "If only we could pull out our brain and use only our eyes"
> —Pablo Picasso

Giving physical form to our inner ideas and feelings is a pure joy and a goal in itself. Our subconscious selves yearn to be a part of our conscious daily lives, if only we'd listen. Our conscious mind, full of the obsessive minutiae of daily life, needs to take a break once and a while and remember

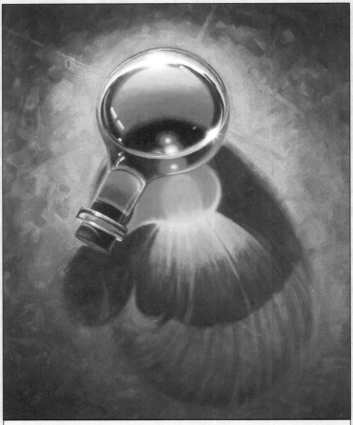

Through the light of inspiration, our imagination breaks free from the glass container, (our lens of daily consciousness), and strives to project itself into the real world.

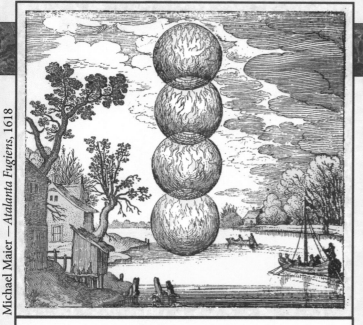

Michael Maier —*Atalanta Fugiens*, 1618

SUBLIMATIO

Fiery orbs of inspiration bubble up from the inner world to reach the light of day.

there are things more mysterious and wonderful than simple day-to-day survival. That's why we court our intuitive self—to play and give our true selves expression.

Be ready for things to surface. Many times, this will take place in the morning when your dreams are fresh and your critical mind has not quite woken up to its usual survival mode of dismissing things that aren't immediately threatening or useful. Creative types often say their best ideas come to them while they're taking a morning shower, (among other activities).

Ideas and images can surface any time during the day, but mainly in moments of relaxation. Triggers are often unexpected and can come from anywhere. A conversation, a word, an image, a smell, a feeling, or a touch can release inspirations that your inner self has created from the experiences you've previously stored away in your memory. The trick is to turn off your critical thinking and make an empty space where those emotionally charged images can appear. Nature abhors a void, and will fill that space with whatever you intend. Meditating, napping, or just clearing your head on a walk around the block will allow stuff to trickle into your conscious mind and bubble up from below.

> "To do much clear thinking a person must arrange for regular periods of solitude when they can concentrate and indulge the imagination without distraction" —Thomas Edison

To court his muses, Thomas Edison took naps in a chair in front of his work bench. He'd purposely place himself in front of the objects he intended to work with and drift off into a hypnogogic trance—the state we all experience just before sleep. In order to catch any ideas, he'd hold little steel balls in his hands, which would drop and wake him up if he happened to fall asleep. With this method, he found he could consciously capture those little snippets of solutions from his own subconscious.

Inspiration may come on its own, but sometimes it needs help. You don't have to wait for your subconscious to give you gifts in a flash one morning. You can tease it along and play by providing a fluid medium where ideas can manifest themselves. Sketches, notes, and scribbles can help the flow of ideas. Give them credence by keeping a notebook (or at least keep a pencil and paper handy). The practice of having fun and putting down whatever suits your fancy in a fresh, freeform way can induce the flow from the subconscious into consciousness. These notes, sketches, and scribbles create another source of inspiration to absorb and let sink into your intuition too. They're a precursor and practice run for the creative work to come. Your subconscious mind loves when you give its ideas form—the more spontaneous and sillier the better.

It's well to remember the feelings of ease, fluidity, and fun of making these humble scribbles when it comes to the work that lies ahead. This playfulness and immediacy is the core of creation.

Practicum

1. *Let your inspirations bubble up from below*

2. *Make room in your mind*

3. *Capture them with scribbles and sketches*

Next stage —COAGULATIO— *Mattering*

Get ready to abandon the world of unlimited possibilities, and pass into the profane world of reality—where the dilettantes dither and the doers dig in. Now we must channel all the fancies we've found and turn them into something solid and meaningful. While doing this, we'll have to share our fantasies and intent with the medium we choose, because *matter* has a mind of its own.

#4 MATTER HAS A MIND OF ITS OWN

COAGULATIO—*mixing with the materials to see what matters*

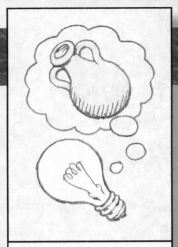

The ethereal IDEA dreams of becoming real

> "Vision without execution is hallucination" —Thomas Edison

The time of endless probabilities is over. This is —literally —where we come down to earth to play and engage with solid matter. They say that creativity works best within constraints. And some of the most meaningful constraints are supplied by the matter of the medium we choose. This is where we get to the work of play. This is where doers get cooking and dilettantes quail.

For dilettantes, spouting ideas is everything. But that flash of inspiration is still just words, and words are cheap. So how does an idea gain meaning? What makes something ethereal worthy of value? For an idea to be given any credit, it must be given form. (World Peace is a great idea, and spouting its virtues may give the speaker momentary value in the eyes of others, but the idea itself has no real value until somebody figures out how to make it happen.)

> "Genius is 1 percent inspiration and 99 percent perspiration"
> —Thomas Edison

When creating anything, one's original IDEA will be changed by the process of reacting to the mind of a medium that has the real power to give form to the imaginary concept. In the process of creation, we'll be manipulating materials, but we need to be responsive too—because while we play, the materials will also change us. To make the real magic of transformation happen, we should become putty in the hands of the medium while it's putty in ours. One must lose control, and that's a scary thought. Yet this fear is what separates the doers from the dilettantes. To be a doer is to be fearless in the face of uncertainty—to go forward along with the materials, not knowing the what the outcome may be.

Mixing yourself with the materials is the most primal form of immersion. This is diving in deep and blending with the elements. So deep that your boundaries between matter and what matters to you can become lost. At the same time, daily cares are washed away, and future anxieties are replaced with curiosity. Getting lost in the wonder of possibilities is the real joy and core of creation. This is where the magic happens.

> "Life must be lived as play" — Plato

The Ritual of Making Magic
One must make time and space for magic to happen. Many artists and inventors, like alchemists, have specific rituals they follow. You may have some of your own. The usual ritual is creating a special place and state of mind for the magic to emerge.

Clear a dedicated space of distractions and surround yourself with all the resources you need: tools, toys, libations, etc. Have everything at your fingertips so you're free to be enraptured by the ritual of creation. You don't need a seperate studio—it could be the dining room, garage, basement, attic, the porch, or even the kitchen table.

> Play is the work of children and toys are their tools —Aphorism

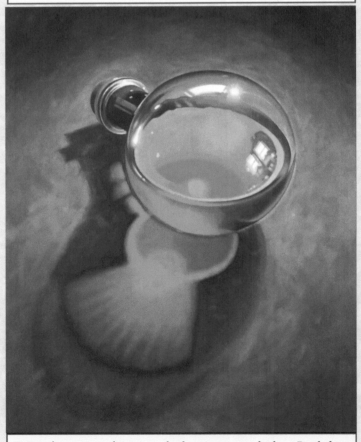

You know something is real when it casts a shadow. Bottled up ideas express themselves by casting their form on the earth below.

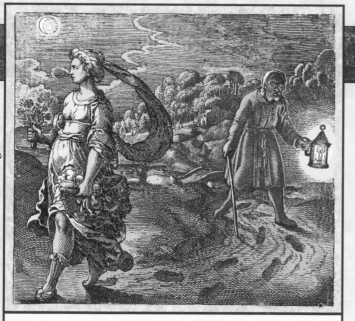

Michael Maier—*Atalanta Fugiens*, 1618

COAGULATIO

Following in the footsteps of Mother Nature, the seeker uses the lamp of insight to bring her secret intent to light, and to discover what matters to matter.

> "I never did a day's work in my life. It was all fun"
> — Thomas Edison

This is about play, and your materials are your playmate. There are no rules. It doesn't matter who wins or loses. Don't worry about the end of the game. Find joy in being in the moment. In the NOW. The past and future have no meaning. Reflection and refinement will come later. Now is the time to get lost in the work of having fun. That's all the materials and your inner you want.

> "I begin with an idea and then it becomes something else"
> —Pablo Picasso

Playing with the materials is not about control. It's not about mastery—craft is about mastery, art is about mystery. Creativity is about a conversation. Matter too has an intent, by the very nature of its own physical properties. It's meant to do some things well, and not others. For example, clay is malleable and can take almost any form, but it is also limited by other external and internal forces such as heat, air and the type of earth it was taken from. On the way to matching your vision, it might suggest a vision of its own. The properties of paint, prose, music or mechanical media all have their own enertia, and they all have something to say.

Materials want to express themselves. They want to tell you things. Learn to become a good listener. If you don't, nothing new will happen, and you'll have missed the real magic of the experience. And be ready for unexpected outcomes as the material responds to your feelings and desires as you express your idea in a tactile way.

The Source of Inspiration Moves

If you've been paying attention while playing, your focus of inspiration will have moved from referencing your original IDEA, IDEAL, or other IDOLS you were inspired by, to the work in front of you. The material you're working with will start to change—it will start making its own sense and have a life of its own. This is the real magic of transformation, to make something come alive that didn't exist in the world before. Something new, something special. It doesn't need to perfect, just a perfect expression of the relationship between you and the materials.

The Real Transformation

To be a good playmate is to compromise. Your original IDEA and IDEAListic vision should shift as a result of what the materials have told you. They will give you new IDEAS and a new way of looking at things. This is the purpose of manipulating matter in the first place, so it can change you into something new and different too. After getting lost in the wonder of the moment, you'll have found yourself transformed. But only if you're not afraid of losing yourself and let the materials speak for themselves.

Practicum

1. *Perform the ritual of setting up a work space*
2. *Bury yourself in the work of play*
3. *Listen to the materials*

Next stage —MORTIFICATIO— *Sacrifice*

You've gone to the heart of matters, and still nothing has worked out as planned. You may have to sacrifice something at this point, to make room for something new. Don't be sad. This is a natural part of the process. Rejoice in the fact that your work will improve by getting rid of the dross and by creating something better to replace it.

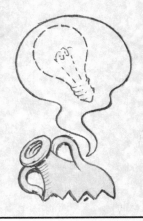

The previous form of the IDEA gives up the ghost

MORTIFICATIO—sacrifice old ideas so new ones emerge

> "Every act of creation is first an act of destruction"
> —Pablo Picasso

You're almost finished. By now, your original idea or reference should be forgotten, and all new inspiration and direction should come from the possibilities of the piece in progress. But some things may not have turned out how you wanted. Your first IDEA may no longer fit into what you made. The purpose or need you intended it to fill may no longer apply. The work might be trying to meet another need. It might have another purpose you haven't recognized yet. The old IDEAS you envisioned and IDEALS you felt might not be reflected in the new IDOL you made. This could mean further refinement, or putting the piece to rest indefinitely and starting anew. It depends on whether you can let your old habits and ways of looking at things die first.

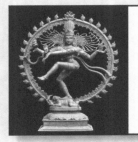

Shiva Nataraj – A Hindu idol, symbolic of the natural cycle of destruction and creation. The baby in the belly of the first fiery idea, (see Calcinatio etching) has become a dwarf demon that needs to be sacrificed to make room for something else to be re-born.

You may have to mourn your old idealistic visions. You may have to bury them and let them ferment so something new can rise from the ashes. If you've become disappointed with the work, go ahead and deny it. Be angry, make deals and justify what happened. Get it out of your system until you reach acceptance. The work has taken on a life all its own. Something new is about to be born, and you should focus on taking care of this new life instead of hanging on to something that once served its purpose but is no longer useful. This is a natural in the process of creation. Old inspirations might get lost and die in importance as the materials suggest new ones. Instead of being anxious about moving forward, be curious about what might happen and what new novelties might arise.

> "Many of life's failures are people who did not realize how close they were to success when they gave up" —Thomas Edison

If it's just further refinement that's needed, you'll want to be sure you don't work the piece to death by trying to make it fit an old vision and killing the freshness of the work.

Alternatively, there may be old favorite parts of your composition that no longer fit. You love them and have worked around them, but they might have to be sacrificed so the other elements can pull together. You may have to 'kill your darlings' for the new things to breathe. But be careful you 'don't throw the baby out with the bath water'. Don't abandon the new possibilities because they don't fit in with the old ideas.

Sacrifice and work give value and meaning to your efforts. Sometimes you might have to let the work lie. Put it aside for the moment and get on with something else, until your old ways of looking at things have died and you can look on with fresh eyes. You may have to sleep on it again. This process could take days, weeks, or even months. Be

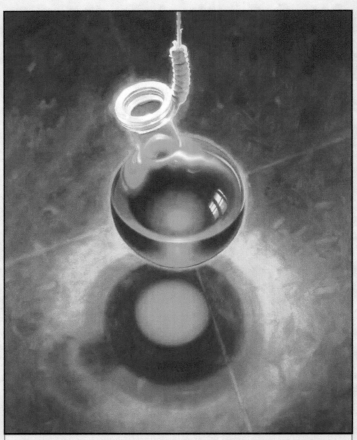

Suspended judgement. Sometimes old ways of looking at things have to die in order for new opportunities to arise.

16

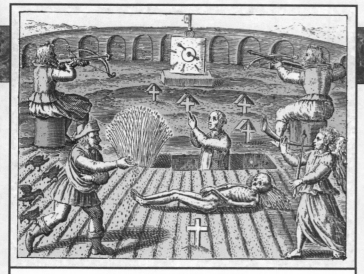

MORTIFICATIO

"Death and decomposition are necessary conditions for life and perfection"—Basil Valentine's *Musaeum Hermeticum*, 1678

patient and let things ferment. Trust your subconscious to transform your perceptions. Trust that your conscious mind will perceive a new order when the time comes. You may have to re-invent your outlook until you gain the confidence to let go of your old old way of looking at things, so that new ideas become clear. Ideas are ephemeral and can shift without notice. They yearn to gain value and meaning within matter, so they can matter. Sometimes, their phantom spirit might fail to manifest in the present matrix of materials, and will have to wait to be re-born another time.

"The most important of my discoveries have been suggested to me by my failures" —Sir Humphrey Davy

Don't give up hope. You may just have to re-immerse yourself in the new possibilities the work has begun to offer. Remember, the goal here is not to make something perfect, but to express that perfect moment when you and your subconscious come together—allowing your inner self to express itself.

It's normal to start out with more ideas than you can fit into one piece. In fact, it's good to have too many ideas—it means you'll have enough to throw away and still be left with good ones. If the discarded concepts have value, they'll continue to ferment and arise another day.

The Zen Enso
Traditionally in Japan, this is a symbol of perfection. The goal in creating an enso is not to draw a perfect circle, but to record a perfect moment. It's meant to be an expression of the enlightened heart and mind of its maker.

"Just because something doesn't do what you planned it to do doesn't mean it's useless" —Thomas Edison

Be open to unusual things that present themselves. Your work might not have been in vain. History is rife with examples of people who worked hard to create something that failed miserably at its original intent, but proved successful at something else. In 1728, the geologist John Woodward sought evidence for the biblical flood. His conclusions were criticized, but his impeccable research led to the discovery of the ice ages. In 1938, the chemist Albert Hofmann was looking for a cure for common ailments like migraines. Instead he discovered the mind-expanding substance LSD.

What drove these people was their insatiable curiosity. They may have failed at their original task, but their hard work and impeccable efforts succeeded in inspiring the creation of something different. So don't mourn the loss of old ideas, or that your work didn't turn out the way you wanted it to. It has a life of its own now and can still have value.

"The important thing is not to stop questioning. Curiosity has its own reason for existing" —Albert Einstein

Practicum

1. *Accept that not every idea will fit into one piece*
2. *Leave some stuff for next time*
3. *Quit fussing and get on to the next thing*

Next stage —SEPARATIO— *Refinement*

You could consider your work finished after your initial efforts. But at some point you'll have to come out of the immersive state of play, and face your work another day. You might find that your original vision is only a shadow of the intent the piece is telling you. The new intent might not be clear and want further refinement. Your critical mind will eventually take over, so you might as well let it play too.

SEPARATIO—evaluating and refining what matters

Does the object you've made with your hands sometimes not quite match the IDEAL of the IDEA you had in your head? As you work with materials to give form and meaning to your imagination, they will often change your original idea—and the passions and purpose of the ideal behind it. If the materials have modified your emotional ideals enough, they may create a new mental idea. This can happen over and over again as you manipulate matter, trying to make a physical expression, or IDOL, out of your inspiration.

> "I have a horror of people who speak about the beautiful. What is the beautiful? One must speak of problems in painting!"—Pablo Picasso

On the journey through the creative process, there are customarily many changes to the materials and your self—some of which could be construed as failures. They're not. The piece may just need a little refinement or you may have to accept a new idea that's different from your original vision. If you were truly engaged and immersed in manipulating the material of the medium, if you have let it become the prime motivator and a real source of inspiration, everything will have shifted from the original, ethereal idea to the physical work in front of you. And if you've really listened and shared creativity with what the materials told you, there will have been a transformation—magic. You will have experienced something you didn't expect. This new direction might not fit with the original idea and you'll have to step back from the work to re-assess and evaluate where to go next.

> "Nearly every person who develops an idea works at it up to the point where it looks impossible, and then gets discouraged. That's not the place to become discouraged" —Thomas Edison

This disengagement, shifting from obsession to reflection, is a natural part of the creative process. Accept the ebb and flow, that you will go from deep submersion to pulling your head above water to get a fresh perspective. Instead of giving free range to your subconscious, you'll have to trust in your conscious mind to do what it does best—discern, differentiate, order, organize, fill in gaps, make choices, and generally try to make sense of things in the light of communicating what you want. There is no real practical reason to create anything expressive in the first place. Reasons are always found afterwards. So take a deep breath and let your mundane mind have fun now. Let it do its work, and trust that it's still your own voice that wants to be in

harmony with the voice of the materials and your inner self. You'll need to evaluate what matters most to finish the work. Let the rational mind flow. It loves to create order from chaos, and it has a sense all its own. It can't help itself—it wants to play too.

The IDOL of inspiration is not quite what it wants to be

> "I am always doing that which I cannot do, in order that I may learn how to do it"
> —Pablo Picasso

Reflection and Evaluation

This is another form of the work of play. This time, the playmates are reason and the imagination, Bring them together so they can become honest friends. This is not the time to doubt or disapprove, but the time to be curious and

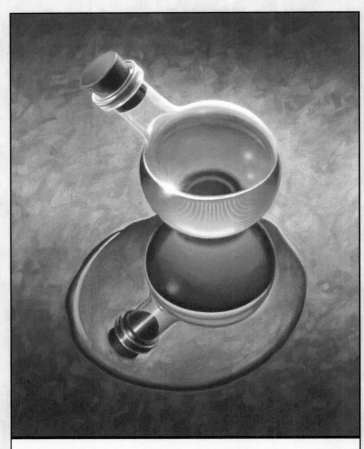

The flask rises above the state of immersion to see its reflection, and distinguish and discover what matters.

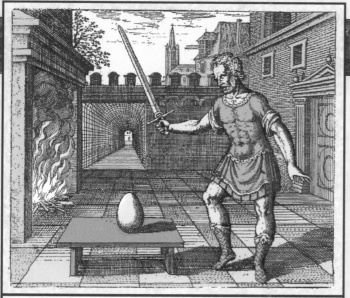

Michael Maier—*Atalanta Fugiens*, 1618

SEPARATIO

The seeker hesitates before cutting the seemingly perfect philosophical egg—his inner self. It's a precious problem, but sometimes the only way to understand the secrets of the subconscious is to willfully cut it apart to see what's inside.

delight in the discovery of what new possibilities there are now. Some things to ponder are:

- How is what you made different from your original IDEA, or the IDOL you were trying to emulate?
- How are they similar?
- What new things have appeared in the piece in progress?
- Was your original IDEA really better?
- What do the differences inspire you to do now?

> "I know quite certainly that I myself have no special talent; curiosity, obsession and dogged endurance, combined with self-criticism, have brought me to my ideas" —Albert Einstein

Re-engagement

If you're not sure where to go next, don't get discouraged — just play some more. You need a fresh point of view, and you won't get it by mulling over what you think are 'mistakes' just because things didn't come out as you expected. If you're blocked and afraid to face the feeling of failure, just stand in front of the work and let your curiosity take over. Be brave and trust your heart and head to re-engage with what you've created and find a novel approach.

> "Negative results are just what I want. They're just as valuable to me as positive results. I can never find the thing that does the job best until I find the ones that don't" —Thomas Edison

Try looking at what you did in a different way. Turn it upside down, backwards or inside out. What other purposes could it serve? What things could you re-arrange, modify, magnify,

minimize, substitute, or re-combine? If you're still stuck, the best thing to do is to go back to the beginning of the process, remember your passion for the project and re-immerse yourself in another way. Let the work sit for a moment until you find another way to recapture the desire that originally inspired you. Try anything to wipe clean your present slate of expectations so you can gain a new outlook. Play with some of the other ideas that arose in the process of getting where you are now. Keep playing until you get a fresh perspective. Or sleep on it, and let new things percolate up from your subconscious.

> "The only mistake you can make is trying to control chaos"
> —Zachary Adam Cohen

Creating something is chaotic. The intent of doing all this is not to try and control the materials through mastery (that's craft, not art or self-expression), but to surrender to new and unexpected results and ideas that happen along the way. The goal is to see if you can recognize something new in the work. If you do, it means you've gained a new way of seeing the world—that you've been transformed inside during the act of transforming something else. Remember, the perfection of the final piece is not as important as its ability to act as an artifact—recording the process of how you got there, and how it changed you. The work should reflect the fun you had in making it. If it doesn't, it won't have the ability to re-inspire you or tickle others, who in return can re-kindle your own enthusiasm.

> "I have not failed. I've just found 10,000 ways that won't work"
> —Thomas Edison

Practicum

1. *Step back and take a deep breath (re-inspiration)*
2. *Be receptive to new possibilities*
3. *Re-immerse yourself in this new direction*

Next stage —CONJUNCTIO— *Connection*

It might not be what you expected, but now you've finished the work and it's ready to see the light of day. No need to be either proud or ashamed—just be curious about what reaction it will provoke. Put it on display!

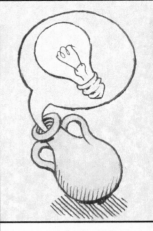

CONJUNCTIO—communicate and connect

> "The value of an idea lies in using it" —Thomas Edison

So how do you know when you're really done? When the work becomes tedious and boring and is no longer fun to explore, and when new ideas compel you to do something else. It's time to kick the new baby out into the world for it to find its real value. Art and utility are concepts defined by society, and your work is measured—and may only find its true purpose—by being experienced, accepted, and used by others. Think of how best to share your creation to gain further inspiration.

Even if your original need didn't include displaying what you made, and even if you never show it to others, thinking of the work as an act of communication by exploring ways to make it easier for others to understand will help you clarify the piece for yourself. Teachers know this intimately. You're never as clear with an idea as you are when you are trying to teach it to others. In this sense, every creation engenders a continuing conversation. At first it's between you, your Self and the materials, then your creation becomes an envoy for communicating that conversation to an audience.

It starts with an idea, but to have any value, that idea has to be grounded in a form that satisfies the ideal passion that sees it through, even after many failures. It can be long and arduous process, but it's the process that's the key. The work's value will only be respected if the strength of your passions comes through. When this has been accomplished, it is truly a miracle. Something unique has been created in the world. A physical IDOL for the eyes to see and the soul to experience can now inspire others to make use of it, which in turn will inspire other IDEAS and motivate the creation of other new things.

> "Art is never finished, only abandoned" —Leonardo da Vinci

In a sense, a work of art or new invention is never really done, at least until it no longer serves a purpose. Creators are never satisfied with their work—something can always be better, or at least different. Yet obsessively refining and reworking something can also kill it—burying the passion that inspired it by concealing its honesty and freshness. That's why finishing is important. To let it go in order to share it with people so you can get on to next thing you're inspired to do. It's time to move on, to save the new ideas and passions for later, instead of muddying the work by forcing them all together in the same piece.

You can use an audience reaction as a jumping off point for your next idea, to answer a question you hadn't thought of even asking yet. Replace any anxiety about criticism with curiosity about what inspires their subconscious minds to say something.

The finished IDOL shares its own IDEAS

Sharing and Showing

If you understood why you made the thing, you never would have started it in the first place. Where's the adventure in that? Sometimes we share a work with others so they can tell us what it means to them—possibly providing clarity for us on why we did what we did. This is NOT the time to be

All the elements come together, connect, and complement each other. Fiery ideas find their reflection in the fluid of our inner feelings, and are given form by the solid idol containing them. The transparent honesty of the flask and its fluid act as a magnifiers, projecting an aura into the atmosphere around it for others to experience.

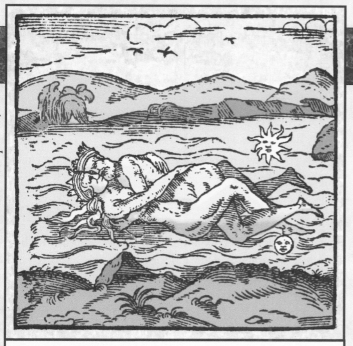

Arnold de Villanova—*Rosarium Philosophorum*, 1572

CONJUNCTIO–The Union of Sol and Luna
Symbolized by a king and queen—our conscious and unconscious selves come together. Outer culture and the inner individual connect and re-immerse themselves in joy and mutual inspiration.

The Ultimate Goal

The process of creation is evolutionary and circular. In the process of creation, steps are continually repeated until something solid is created that may, or may not, have anything to do with the original idea. But the final work is still just an IDOL—something that reflects your own transformation and the process of perfecting your own fluidity. Much of its value is derived from its ability to spark that process of 'flow through' over and over again—allowing you to go back and forth, from immersion to reflection and back again, and create a closer conversation between your conscious and unconscious selves. Or, if you like, the right and left brain. This practice of going back and forth will bring fluidity, and make it easier for your inner self to join with your outer ego. It's the union between the two that will help make you feel whole and authentic. Making physical stuff is just a method—a process for expressing and giving feedback to your own process of re-creation.

immersed in your passions, but to step back and have an objective perspective. Let their subconscious play, not yours. Other people's reflections might inspire you to new ideas, or help you be clearer the next time around.

For some, what differentiates art from craft is having your work appreciated as art by other people, because it has communicated the personal passion of its maker. Art does this by "showing the history of its own making". In craft, you try to avoid or cover up what would be considered unfinished blemishes. In art, you need to expose these in order to express the process of discovery and dialogue you had with the materials. If you really want the work to communicate something and touch other people, you need the freshness, honesty, immediacy and authenticity of your feelings to show through the work. This is what will inspire others, and invite them to have a conversation and adventure with materials for themselves.

Need and passion have always been the inspiration for new ideas, and they continue to evolve and interact with each other over time. Thomas Edison created practical solutions that inspired many to continue what he started. The carbonized filament in his first light bulb was a practical solution for his time, but the tungsten filament we use today was created by a Hungarian in 1904. And even this idea is morphing into something else. Fluorescents replaced energy hungry tungsten filaments, and these are now being replaced by LEDs. Every idea joins in a larger dance of creation that spirals through our existence.

Alchemy was the art of transformation. The goal of alchemy was not to make gold. This was only a reflection—a proof of one's inner accomplishments. It was about the transformation that happens inside you. Although internal refinement was the real goal in alchemy, the 'lab' work was important in order to perpetuate this inner transformation. This personal metamorphosis is evolutionary and happens in small steps. Repeating the process again and again was important for continued refinement.

Practicum

1. Let the work go, so it can find its own value

2. Listen to others to clarify your communication

3. Play at being more fluid and transparent

Next stage—CIRCULATIO—*Recapitlation*

Now you've finished and shared your work, and it's ready to re-inspire further ideas. Wasn't that fun? There may have been arduous tasks and torturous moments, but don't you want to do it again? All those new ideas that came from making the piece are just waiting for you to re-immerse yourself, play some more, and repeat the creative process to make something else. It's time to start the cycle again.

CIRCULATIO

Recapitulation

- 👁 **LEGO** Study and absorb yourself in the things that fire your passion. PLAY.
- ❤ **ORA** Go wherever your subconscious heart takes you. HAVE FUN.
- ✋ **LABORA** The more you go back and forth between playing with your hands, your heart, and your head, the closer you bring them all together. RE-CREATE!

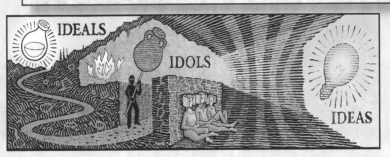

The Name of the Game

Science, art and alchemy are all ways of working through our misapprehensions, and have a lot in common. The scientific method is 'Look, Guess, Test, and Tell'. A scientist will make an

Science—*Look, Guess, Test & Tell*
Art—*Look, Feel, Play & Share*
Alchemy—*Lego—Ora—Labora*

We've come full circle. We've finished making something, and learned that the act of creation offers us something else too—a method for gaining self knowledge through the mirror of self expression.

Plato's cave tells us that all IDEAS, and the IDOLS we create from them, are illusory—they come from an ethereal, IDEAL world we can sometimes feel, but only imagine. By re-creating this process of projecting one world on to another, we have a chance to understand what makes our hearts and minds tick.

Francis Bacon's four idols are a wonderful reminder of how thoughts and feelings can fool our 'evolved' brains, how slippery the language that our mind uses can be, and how these can affect our perceptions.

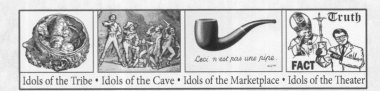

Idols of the Tribe • Idols of the Cave • Idols of the Marketplace • Idols of the Theater

Working in the lab, or studio, is a method for grounding our ethereal IDEAS and the IDEALS they come from, by making physical IDOLS that mirror and can objectify our thoughts and feelings.

observation of a phenomenon, come up with a hypothesis as to what it is, test his ideas by creating experiments, then publish the method so that others can repeat the experiment to come to the same conclusions. These results then become scientific 'facts'. But where scientists look for facts, artists pursue 'truths', and truths are always personal in nature. The artistic method is similar, but it goes after subjectivity rather than objectivity. You might say that the artist's method is Look, Feel, Play and Share.

Alchemy was a mix of the two methods that sought to objectify personal experience by experimentation, instead of relying on the 'truths' of others. It valued inner truths over objective facts, mixing psychology with technology to find a connection with nature. That's one reason why this strange, quirky method for seeking inner refinement still has meaning today. It was a process that sought verification through experimentation, and it serves as a marvelous metaphor for creativity in general. It shares the belief that an IDEA has no value unless it can manifest itself in some meaningful and useful physical way. That's why the lab work

> "Don't think. Thinking is the enemy of creativity. It's self-conscious, and anything self-conscious is lousy. You can't try to do things. You simply must do things" — Ray Bradbury

was so important. Alchemists needed to express their ideals in a physical form for their ideas to have meaning. If one's experiments were successful, manifesting one's inner nature in nature's matter became positive feedback that a real connection had been made between the outer world and one's inner world—the Macrocosm and the Microcosm. The goal was a reciprocal evolution between nature and one's soul.

The secret to art and alchemy lies in incessant play and continuous curiosity—repeatedly submersing yourself in your passions, coming out to absorb, question, engender new inspirations, then repeating the process. The subconscious, like memory, loves repetition.

What you make doesn't have to be great art or win a patent. If it's meaningful or useful to yourself and others, so much the better. It doesn't even need to be in the realm of art or science—gardening, cooking, or even a conversation can become an exchange between yourself and the matter at hand. 'Self' expression is what matters. While your hands, head and heart are immersed in the materials, it can quiet the mind and let your subconscious self bubble up from below. Expressing its intent in the matter at hand gives the subconscious the acknowledgment it needs. There is a saying in psychology, that alchemists abided by a long time ago: "The more you pay attention to your subconscious, the more attention it will pay to

The alchemist reads his books to gain inspiration from others. He then consults his inner muse, who tells him how to listen to the materials in his studio to find the gold of illumination.

you." The more you practice and play with the loop between your heartfelt IDEALS, IDEAS and IDOLS, the more fluid the connection to your subconscious will become.

"The creation of something new is not accomplished by the intellect, but by the play instinct acting from inner necessity. The creative mind plays with the objects it loves" —Carl Jung

Psychologist Carl Jung studied the rich metaphorical symbolism in alchemy and saw it as a psychological process. He likened it to what he called the 'path of individuation'. Its goal was to gain a sense of authenticity and wholeness, that was achieved by bridging the gap between the archetypal world of the unconscious and the everyday world inhabited by the conscious mind.

The conscious mind loves symbols to decipher, the subconscious loves to create drama through meaningful parables. So make friends with your conscious mind, but do not forget your subconscious self. It's the best friend you'll ever have, and is always there to help.

Most of the time, your inner self will only communicate in metaphors—manifested in the form of abstract dreams, images, and vague feelings. But if you talk to it, it just might talk back. Just ask.

Verbal answers may be confusing at first. They will often be in your own voice. But the difference between the answers and your usual inner monologue is that the subconscious voice only speaks in concise, one-word to three-word answers. So if you hear a voice meandering on with all sorts of caveats, that's not it. It's the still, quiet, direct actions you should listen to. That's your 'Self' talking.

The closeness and clarity of this conversation with something larger than your everyday self is the goal—to find a more personal and meaningful way of knowing things about yourself and how you fit into the world. This is a method of understanding something by re-creating it. And remember, re-creation is just recreation with a hyphen. So let us play.

THE SPIRAL OF CREATIVITY

Schematic Section	Plan View	Isometric

The creative process follows a circular path, but that doesn't mean you're chasing your tail. Think of it as a spiral, each revolution being offset as you go back and forth and up, closer to the goal.

THE CRUCIBLE OF CREATIVITY

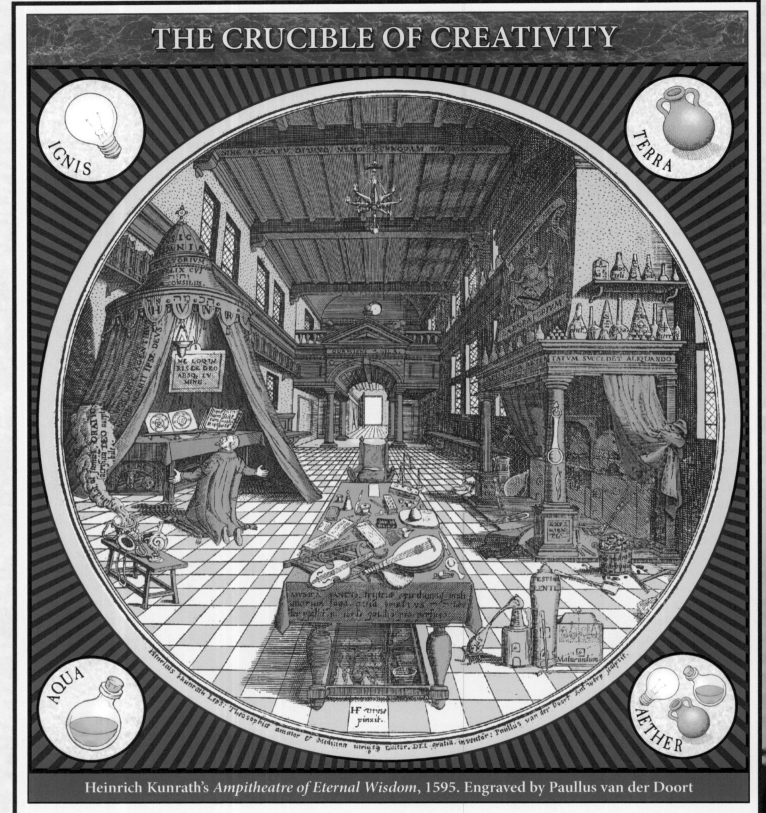

Heinrich Kunrath's *Ampitheatre of Eternal Wisdom*, 1595. Engraved by Paullus van der Doort

The three essential aspects of creativity can be seen in this alchemical 'lab-oratory' from the 16th century. At the right is a workshop where one labors. To the left, the oratory where one prays. In the middle are the arts that will put the two together.

1) IDEAS arise from an IDOL of worship that comes through meditation. *(Seen in the 'Oratory', left)*

2) IDEALS, or feelings, come through while expressing those ideas. *(Table with art instruments, center)*

3) The work of making something real gives meaning to idle thoughts and feelings. *(The lab, right)*

We're inspired by IDOLS of creation that produce IDEAListic feelings, but only through the work of creating your own IDOL can you express and understand that inspiration. This is the way to gain meaning. The lost sense of wonder is found through the work.

24

CODEX *of* CREATIVITY
Zoetrope model instructions

BUSY HANDS ARE HAPPY HANDS

Revealing the intimate evolution of Plato's IDEAS, IDEALS, and IDOLS

Museum of Lost Wonder Zoetrope model

Why build a model?

Building your own zoetrope will test your curiosity and passion for manifesting an IDEA with an unknown outcome. It's also a way to illustrate the magic and misguiding nature of our perceptions. Hopefully, you will find putting the model together is a grounding experience—a hands-on way to test drive the creative process and strengthen your visualization abilities.

 This exercise is meant to be an example of how the heart inspires the head to move the hands.

The process you'll go through will demonstrate the motivating force of IDEAListic desire, the importance of visualizing IDEAs, and the significance of grounding IDEALs and IDEAs by manifesting them in a physical IDOL (in this case, the zoetrope) to give them meaning. To embark on this experiment, you'll need a passion to finish the project and see the results —an IDEAListic desire to bring something to life. You'll need to exercise your skill in visualizing the IDEA, imagining these flat pieces of paper coming together into a three-dimensional object. Even before you begin to build, you'll have to see with your mind's eye how the static images will be transformed when they are animated in this 'wheel of life'. You'll need to work with the paper—cutting, folding and separating it—before bringing the pieces back together in a new order to create your IDOL. The final act will be viewing the wheel yourself and sharing it with others to inspire a new cycle of IDEALs, IDEAs and IDOLs.

Tools & Techniques: SCORE - - - - - CUT ——— GLUE ▨▨▨▨ PLACE · · · · ·

Choose a glue suitable for paper – we find a simple glue stick works just fine. Then find an implement to score with such as a dull knife, a letter opener or a dead ball-point pen. Anything comfortable to hold that can score a line on the card without cutting it will do. Use a straight edge to keep your scoring straight and centered on the dashed lines. Scoring all the fold lines before you cut out the shapes is very important for the success of your model. After folding the card, crease the folds with your thumbnail to make sure they're nice and sharp.

Assembly instructions

FIRST, SECOND & THIRD

FIRST: Score all fold lines, cut out shapes, and crease the folds. Then cut out central cut-outs.

SECOND: Assemble sides (sheets 1 and 2)
Fold, crease and pre-curve zoetrope sides. Pay extra attention to the top fold crease when curving – bend *between* the slots, and leave the fold above the slots alone. Do not glue yet.

THIRD:
Cut out the viewing slots in the curved sides from the inside, so they're aligned. After cutting the slots, apply glue to the insides of side 2 and press together, curving it as it dries so it stays in the proper shape.

FOURTH

FOURTH: This step must be done quickly before the glue sets. *(A glue stick is most suitable here.)*
Apply glue to the insides of side one. Fold over and press together, leaving the ends open. Apply glue to the tabs on side 2 and quickly insert these into the ends of side 1. Carefully position the sides so their bottom tabs are aligned and flush. Press together, evening out the circle as it dries. Remember to curve between the slots, not above them.

Step by step assembly instructions

FIFTH

SIXTH

SEVENTH

EIGHTH

FIFTH: Arbor sleeve (sheet 3)
Pre-curve the sleeve by rolling it tightly around the wooden arbor stick. Unroll the sleeve, apply glue to it, then roll it together again until the folded-out tabs form a triangle. Press the sleeve together.

SIXTH:
Glue arbor sleeve to the center of the outside bottom disk (sheet 4), keeping it perpendicular as it dries.

SEVENTH: Pyramid support (sheet 4)
Build the pyramid support. Make sure bottom tabs are flat and even by pressing them against a tabletop while assembling.

EIGHTH: Pyramid support to bottom, over the arbor sleeve.
Glue pyramid support to outside bottom disk, centering the round tabs and making sure the arbor sleeve sticks through the apex. Straighten the arbor and glue the small apex tabs to it. Square the assembly, then allow to dry.

NINTH:
Fold the bottom tabs of the cylinder drum inwards. Apply glue to the inside of the tabs and the edge of the outside bottom disk, then lower the disk into the cylinder. Press together, adjusting the drum to insure it remains circular. Glue the inside bottom disk to the base of the cylinder, aligning the half-spark at the edge with the half-spark on the inside wall of the cylinder (just before the light bulb). Press and flatten.

TENTH:
Glue together the arbor rest inside the base. Pre-fold the base, then unfold and glue the tabs and surfaces they will attach to. Glue sides and top together first, then glue the bottom to the sides. Poke your finger inside the top hole to help secure inner tabs. Do not glue inner triangle sides.

VIEWING — *NOTE: You'll need a bamboo skewer to spin the zoetrope on. See below*
The stand makes a nice display for your zoetrope, but the real fun is in spinning it to view the magic of the motion. To get the best effect, hold it under a bright light and tilt it so the light shines on the bottom. Spin the zoetrope counterclockwise, about eight inches away from your eyes.

NINTH

TENTH

Base:
inside view

VIEWING

Turn counter
clockwise

To complete the model you will need a #8 Bamboo skewer.
These can easily be purchased at any grocery or hardware store, and at many pharmacies. It should be about 1/8" in diameter.

About the Zoetrope

Zoetrope comes from the Greek words for 'alive' and 'turn', and translates as 'wheel of life'. The earliest known zoetrope was created in China in around 180AD. The cylinder was set in motion by heat rising from a lantern beneath it. The machine was 'reinvented' in 1833 by English mathematician George Horner, but didn't become popular until the 1860s, when its magic spread around the world. It also was key to the development of motion pictures. The first 'movie' was produced by an adaptation of the magic lantern zoetrope that used lamps and lenses to project a series of images on to a screen.

The zoetrope's optical illusion is created by viewing a series of images in quick succession as they are isolated through slits. These rapidly changing images present themselves to the brain as a single moving image. A similar effect is created by the rotating shutter used in traditional movie cameras and projectors. ✪

This simple phenomenon from long ago has continued to fill folks with wonder well into the 21st century. Sculptural and life-size zoetropes have been built that use strobes instead of slits to isolate images so they can be free viewed.

The rotorelief

The central figure on the bottom of the cylinder employs a different phenomenon from the zoetrope. It's known as a 'rotorelief'—a term coined by its inventor, the famous French multimedia artist Marcel Duchamp, in 1935. Originally, his rotoreliefs were 'played' on phonograph turntables at about 33rpm. When spun slowly, the rotating image has the illusion of depth. To best see the illusion, look straight down at the image and turn it slowly—about 1-2 revolutions per second. Focus on the central yellow star, then look alternately at the top cork and the inner aqua circle.

The zoetrope animation

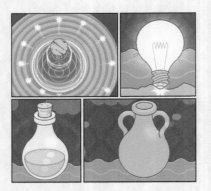

The spark of desire flies up from the IDEALized flask on the rotorelief to create that 'lightbulb moment' IDEA in the zoetrope animation. The IDEA bulb then morphs—first into an IDEALized flask and then into a physical vessel, or IDOL—illustrating the mutable nature of the relationship between the three icons. Inspirations bubble up during this transition, rising through the jug vessel to become clouds of thought overhead. These cloudy concepts nudge the flask of IDEALs, causing it to pop its cork. This allows a way for inspirations to escape and energize the ongoing process —sparking more IDEAs.

Creating the zoetrope

In designing this zoetrope as a do-it-yourself model, I went through the same basic creative process described in the Codex. First there was a passion to create an IDEAL zoetrope (Calcinatio), followed by IDEAs that were inspired by other examples (Solutio), Lots of other IDEAs developed (Sublimatio) in response to working with the practical materials (Coagulatio). There were trials that involved abandoning some of my original IDEAs (Mortificatio) and tribulations when decisions had to be made (Separatio), in order to create something practical and wonderful to share with others (Conjunctio).

ZOETROPE MODEL

Before cutting slots, fold sides together, then cut through both slots at the same time from the inside. Cut edge just inside the black line, so it will disappear when assembled.

Cut edge just inside the black line, so it will disappear when assembled.

Note: This page and other's throughout the book are purposefully left blank as they become the back of a model section.

Note: If you don't want to rip up the book and would like to build the model on more appropriate coverstock, type 'Museum of Lost Wonder Zoetrope Model' in your browser's search bar.

▼ Glue to this edge

Cut slots from the inside, *after* gluing and curving sides together.

Glue to this edge ▽

▲ Glue to this edge

Glue to this edge ▲

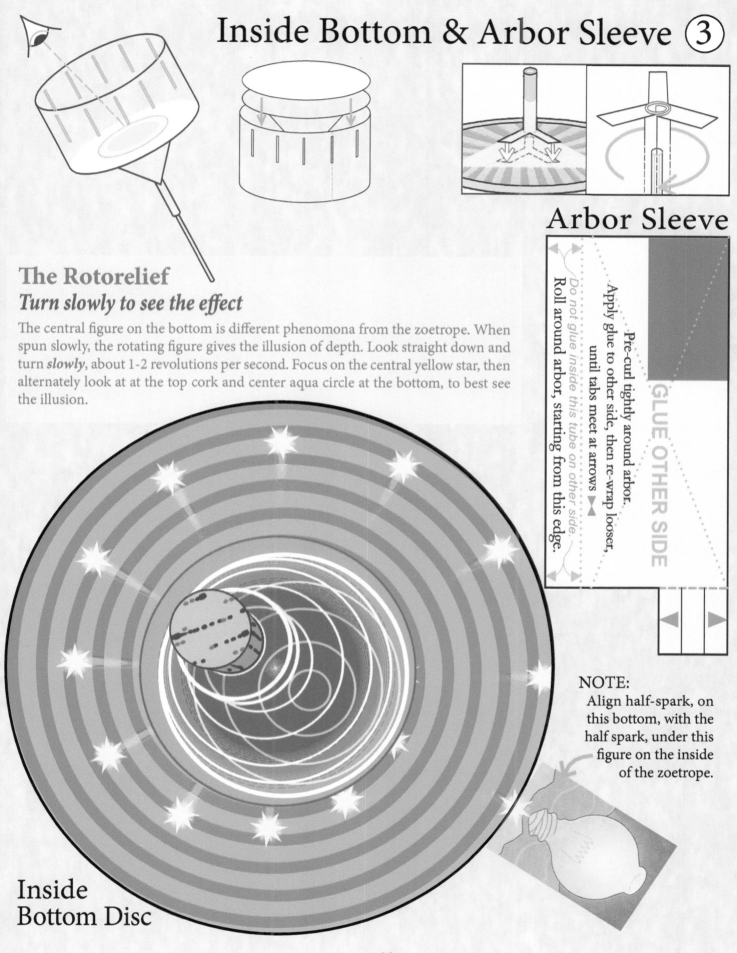

The Rotorelief
Turn slowly to see the effect

The central figure on the bottom is different phenomona from the zoetrope. When spun slowly, the rotating figure gives the illusion of depth. Look straight down and turn *slowly*, about 1-2 revolutions per second. Focus on the central yellow star, then alternately look at at the top cork and center aqua circle at the bottom, to best see the illusion.

Arbor Sleeve

Pre-curl tightly around arbor.
Apply glue to other side, then re-wrap looser, until tabs meet at arrows ▼

Do not glue inside this tube on other side.
Roll around arbor, starting from this edge.

GLUE OTHER SIDE

NOTE:
Align half-spark, on this bottom, with the half spark, under this figure on the inside of the zoetrope.

Inside Bottom Disc

④ Support

Outside
Bottom
Disc

GLUE SIDE TABS HERE

GLUE SIDE TABS HERE

GLUE SIDE TABS HERE

GLUE TAB

Pyramid
Support

Base ⑤

1. Assemble arbor rest *inside* of the base.

2. First glue sides and top together. Apply glue to tabs *and* the surfaces they'll attach to.

3. Glue and fold bottom up into the sides. Secure tabs inside, by pressing with your finger through the top hole.

GLUE TAB

GLUE TAB

GLUE TAB

GLUE TAB

GLUE TAB

GLUE TAB

EARTH

WATER

FIRE

AIR

MUSEUM OF LOST WONDER

ZOETROPE OF CREATION

IDOLS inspire IDEALS

IDEALS inspire IDEAS

IDEAS inspire IDOLS

IDOLS

IDEALS

IDEAS

Cut edge just short of the black line, so the edge will disappear when assembled.

Glue to this edge

Glue to this edge

Cut edge just short of the black line, so the edge will disappear when assembled.

Cut edge just short of the black line, so the edge will disappear when assembled.

Glue to this edge

Glue to this edge

Cut edge just short of the black line, so the edge will disappear when assembled.

Mental Modeling

How does one see an idea?

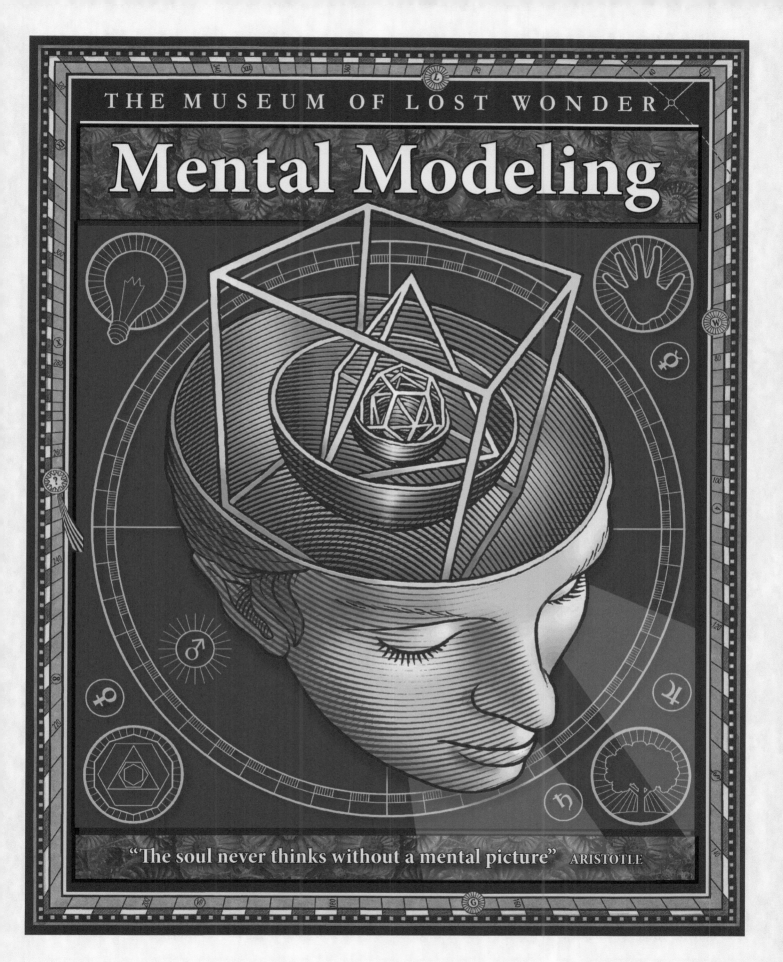

Mental Modeling

"The soul never thinks without a mental picture" ARISTOTLE

What is Mental Modeling?

At the Museum of Lost Wonder, we love making models. But as well as making models with our hands, we also make them in our heads. Many of these 'mental models' are made unconsciously, and affect the way we see things and experience the world. We'll explore these notions through examples, and have fun making some models of our own. It's satisfying to make models, but they also teach us a great deal about the way we understand the world and think about it. Why? Because they act as a mirror that reflects the way our mind works.

Everything we see is in our minds. Our eyes sense things, but it's our brains that translate these into the images we 'see'. One of the most remarkable things our brains do is make us believe that the world we see is 'out there' instead of 'in here'. Yet there is no definitive 'out there'—it's only a construction in our heads that gets triggered by external stimuli. When we 'see' something, a cogent, inverted image is projected on to the retina through its lens, but those impulses are then broken down into shapes, colors, light, dark, motion, etc. Then these raw sensory data are split up and electrochemically bounced around our brains in circuitous routes that eventually form mental images that we perceive as real. There is no screen in the back of our head that the retina projects its image on to—the visual images we 'see' are just electrochemical impulses swirling around our brains. (See Figure 1.)

What's more, the world we see is ambiguous, incomplete, and constantly changing, according to our present level of

attention, and how what we perceive relates to our previous experiences. The raw visual sensations we get are never recorded in every factual detail—they are sensed, routed, and translated by our minds in order to find meaning. So what we think of as external reality is actually a mix of fleeting sensations and impressions we've already made. In reality, we don't really see reality (the world out there)—only a vision that is molded by our mind.

As we experience 'reality', some of the swirling mental images become etched into our neural network. They are combined with the ideas and verbal descriptions that we use to make sense of the world 'out there'. They become mental models.

Mental models are also what make up our memories. Rather than a static image, memories are nothing more than groups of neurons that fire together in the same pattern every time a stimulus evokes that memory. A memory is a pattern—an incredibly complex series of diverse processes that take place simultaneously in various parts of the brain, which are replayed when prompted by similar sensations.

Memory is stored as a procedure, not a picture. Sights, sound, smells, shapes, colors, textures, spatial context and size are stored in different areas in the brain, along with the emotions they were associated with, within a complex neural network. Our minds are incredibly adept at displaying this web of sensations to us in a cogent, sequential and meaningful fashion. But in reality, it's just an illusion. *(See arrow illustration next page.)*

Figure 1. A mental model showing the neural net that is how we really see the world. Gently cross your eyes to see it in 3D. And remember—what you see is not on the page, but in your head!

The term Mental Modeling was coined in 1943 by British psychologist Kenneth Craik. Craik "proposed we use 'small scale models' of reality in our minds to conceptualize the world around us and anticipate events". These were made up of both our perceptions and our imaginations. They can be concrete or abstract, and include words, pictures and other sensations. Mental models are like architects' models or physicists' diagrams—simplified sketches of reality, but rich in associations.

Exposing Our Mental Models

A mental model is something we unconsciously hold in our memories. Everything we see is matched against an internal memory model image we hold in our heads. Sometimes what our eyes see is not what our brain sees, because it conflicts with the unconscious order that our brains try to impose on it.

Kernels of thought. Picture this field of arrows as the synapses in your brain in constant flux—but obviously the paper isn't moving! This is another example of vision encountering a mental model in our heads that is at odds with reality.

Rabbit/Duck Illusion

First appeared in a German humor magazine in 1892. Philosophers picked it up "to point out that perception is not just a product of the stimulus, but also of mental activity".

Classic Illusions

Fascination with the illusory nature of vision has been around for a long time. Which image you see first is dependent on which mental model you use to view it with. This is called priming. Simply saying rabbit or duck, or young or old, will influence which figure you see. Psychologists have adored these old German postcards, and there have been endless variations over the years.

Young girl or old woman? *1888*

The Creation of Creating

Mental models are constructed on top of our genetic neural hardwiring, which evolved a long, long time ago in our primeval past.

Originally we used to experience nature more directly, in all its glorious cacophony of sights, sounds, and smells. We had simple stimulus response circuits that helped us survive: to flee from threats, find food, fight foes, and follow the fickle nature of our affections. These neural circuits were a simple, efficient means to anticipate good or bad things and to keep us alive.

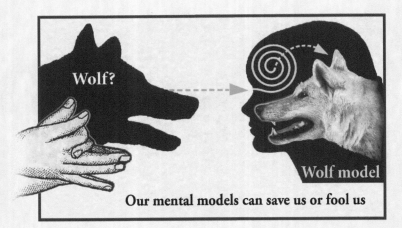

Our mental models can save us or fool us

Our nascent mental models were wonderfully evocative and useful for survival. A fleeting shadow (which could indicate danger) conjured up a memory of a previous predator, with all the emotional charge of the original encounter, that would quickly and subconsciously cause us to duck, dodge, flee or follow. (We still retain many of these unconscious physical reactions.) Our brains were constantly comparing our present experience to a similar one from the past—a crucial survival tool. The talent to respond instinctively to what's around us without becoming mired in minutiae is critical to the sort of quick decision-making that keeps us alive.

As our brains grew, they created more complicated shortcuts to store all the sensory data they encountered—symbols for an experience rather than the entire experience itself. This is how mental models evolved.

Our First Mental Models

As our brains develop during childhood, raw information from the external world recedes from consciousness and is replaced by related mental models that our minds make. Without these models to help sort through new experiences, we would become overwhelmed by the huge amount of meaningless, disorganized and detailed sensory information that bombards us at any given moment. (Think of a newborn baby in the middle of a dizzying discotheque.)

New things can be bewildering, even threatening, unless they're given a meaningful context from past experience. Mental models act as filters to help us organize and make sense of the world around us. When challenged by an unfamiliar experience, the brain brings up a simplified mental model from its memory that best matches what we are sensing at the moment to give us a template for dealing with it. This happens incredibly fast and unconsciously. We are totally unaware of it, and it is a process that's been hardwired in our brains since day one. As we grow, our perception of the reality 'out there' is replaced increasingly by the mental models in our heads. We start to see only the category, the symbol, the shorthand—not the real thing in front of us. A rose is a rose, is a… cartoon.

An approximation of a mental model of a rose

The first mental model we develop as infants seems to be a human face, imprinted into our brains for survival recognition of our first source of food and protection—mom. This mental filter is so pervasive that we seem to able to see faces in most anything and everything.

On the left is a simple arrangement of three dots. Moving to the right, how many other clues do you need before you see a face? And once primed by the image at the far right, don't they all become faces?

Prehistoric Mental Models

These 32,000-year-old pictograms still evoke life and death struggles from the past. Cave painters just didn't record events—they encapsulated their thoughts and feelings about themselves in the world, and made them into mental models to magically influence the future.

Mindset Makes Meaning

Mental models can 'prime' our perception—making us see things that aren't really there, but which we want to be. This phenomenon is known as 'pareidolia'. Pareidolia is the misperception of a random or obscure stimulus that we decipher as a meaningful pattern. From miracles to Martians, we're always looking for meaningful connections in the universe at large. The most common association is with faces—our first hardwired mental model.

The Famous Face on Mars

Wild speculations and conspiracy theories have abounded since this image went viral in 1976. Photos from other angles show it to be the simple mesa, but our mental models love to create connections wherever they can.

▽ Images courtesy of NASA △

The Happy Face on Mars

Amused by the furor over the previous face on Mars, researchers found this one. Yes, It's a real crater formation on Mars, and yes, NASA does have a sense of humor.

Jesus on a Tortilla

The religious see icons anywhere a mental model wants them to—from rocks and clouds, to trees and tortillas. A comfort for those who like to feed their faces and souls at the same time.

Emoticons on your walls

This surprised image clinches the argument that we see faces everywhere and in everything, thanks to our ever-present and tenacious mental models.

Mental modeling evolved through our experiences, nurturing, and cultural development. As the eons of human existence went by, our brains kept devising faster, more efficient, more abstract, and more ambitiously abstract shortcuts to made us the marvelous mammals that we are today. One of the most profound of these shortcuts was language.

Words verses Pictures

Words are wonderful things. Small, concise and abstract, they can quickly encapsulate a whole host of different experiences. And by mixing, matching and re-combining them, we can describe even more marvelous things that we've never actually experienced at all. But is this always a good thing? If pictures can lie, words can do it even better, and we can get lost in abstract confabulations that boggle the mind. Words can also turn experience into a rather 'bloodless code', robbing it of the richness that a visual image can conjure. Hence the saying, 'a picture's worth a thousand words'. Pity we don't use them more to think with!

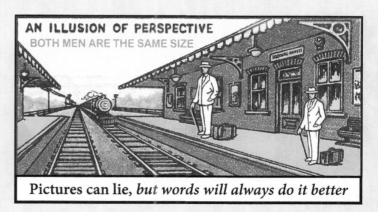

AN ILLUSION OF PERSPECTIVE
BOTH MEN ARE THE SAME SIZE

Pictures can lie, *but words will always do it better*

Somewhere along the line, we began to lose the ability to think visually and to rely more on words than pictures. As children, we naturally begin by thinking in pictures. But at an early age learning basic drawing skills is pushed aside and becomes confused with art. At least that's what they teach in schools today, where reading, writing and 'rithmetic are stressed, and drawing is relegated to the realm of recreation. People begin to believe they have to be Picasso or Rembrandt in order to pick up a pencil. Drawing is no longer fun, but a source of embarrassment. What a shame!

Most people will furiously text or talk with abandon, carefree of any rules of grammar, spelling, or pronunciation. Nobody worries about being Faulkner or Shakespeare when texting. But give someone a napkin and ask them to draw a simple picture and you'll be greeted by all sorts of fear and excuses about not being able to make a straight line. Nonsense! People don't think they need to be writers to write, but somehow they feel they need to be artists to sketch the simplest of thoughts. Where did that concept come from? A drawing doesn't have to be art, or even good—just recognizable, like language.

Drawing sketches are a way of making better mental models, too. Creativity and memory function better through imagery. And many modern memory aids depend on putting pictures in your head… just to remember words!

Picturing a Passion

Sketches and snippets of text are the siblings of mental modeling

Mental models can contain an array of sensations and symbols, what interests us most is how they're visualized and how to become better at creating those pictures in our heads. The illusions we've used so far have begun to stretch those visualization muscles. Now we're going to exercise them even more.

Most writers know the value of putting a picture into their reader's heads, and purposely write in ways that will put them there. They know that the ideas, values and evocative emotions of their character will be much more meaningful and memorable if they can put the reader 'in the picture'. The Imagist Movement in literature sought 'clarity of expression through the use of precise visual images', as in in this poem by WC Williams. Get the picture?

> ### The Red Wheel Barrow
>
> so much depends
> upon
>
> a red wheel
> barrow
>
> glazed with rain
> water
>
> beside the white
> chickens.
>
> *William Carlos Williams*
> *1883–1963*

Our goal at the Museum of Lost Wonder is to undo the ravages of erroneous enculturation and recover the appreciation of the innate skills we've lost. That's why we use so many pictures and fearlessly go forward, regardless of sometimes being thought of as 'just for kids'. As if pictures or museums were only for children or artists, as if 'adults' can only maintain their maturity by being bound to the meaningless mires of language!

We think it's scandalous that adults are afraid to draw. Images are integral to thought.

> "Words or language…do not seem to play any role in my mechanism of thought. [My] elements in thoughts are certain signs and more or less clear images" —Albert Einstein

 Simple sketching and model-making externalize the fuzzy ideas we have, and help clarify and concretize them. Using our hands gives us physical feedback about our mental models, and crafts them into clearer tools of thought.

Artists aren't the only ones, scientists do it too. Sketches help turn everyone's hazy ideas and realities.

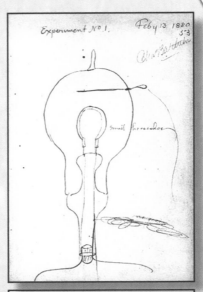

Edison's sketch of the idea for his first light bulb from 1878

Thomas Edison's brilliant ideas didn't just pop out of his head into concrete 3D inventions. Like everybody else, his ideas started out as fuzzy, incomplete, piecemeal notions, that he gradually brought to fruition through a step-by-step process of sketches, models and mock-ups. A practical application didn't come about until there had been a lot of give and take between his mental models and his handiwork. But it all started with little sketches.

Courtesy of Cold Spring Harbor Laboratory Archives, NY

Watson and Crick's model of DNA's double helix from 1953

Visualizing the building blocks of life was no mean feat—especially when they're virtually invisible. James Watson and Francis Crick spent years trying to figure out how all the little molecules of our genes fit together. The structure was so complicated that all the little sketches and diagrams they visualized wouldn't make sense until they constructed a physical model of their mental models. So they took some wire and metal and came up with the spiraling double helix configuration we all picture in our heads today. Is it art? Maybe not, but some would cite this sculpture's elemental elegance as something beautiful. And who cares, anyway? Their sculpture is a classic in critical thinking.

Mental Modeling Fun

Time to hone your visualization muscles a bit more so you can picture and manifest your own yearnings. These simple mental puzzles add another dimension to the process of seeing. *Note: Answers appear at the bottom.*

FAVORITE ICONS

Because we are hardwired for recognizing faces, these two images are easy to identify as humans. But which ones? These are like the little favorites icons, or 'favicon' image links, you find on your computer's desktop. Enlarged, they're difficult to discern—but if you've seen their pictures before, you might have a mental model template in your mind that would make them easier to identify.

Marilyn Monroe or Isaac Newton? Stand back from the page to see them.

MENTAL ROTATION EXERCISES

Fig. 1 A. B. C.

If you rotated Figure 1 in your head, which of the other shapes would it match? *Hint: only one is correct.*

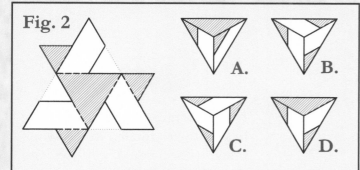

Fig. 2

A. B.

C. D.

If you folded up Figure 2 to form a tetrahedron, what would it look like? *Hint: two views are correct, the other two are not.*

If you looked at Figure 3 from the top, what could it look like? *Hint: two views are correct, one is not.*

Fig. 3

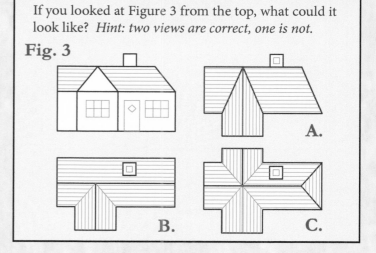

A.

B. C.

This mental rotation puzzle, called a Shepard Object, was created by cognitive scientist Daniel Dennett, inspired by the research of Roger Shepard and his students.

If you look through the spy hole, would you see the 'X'? To test your guess we've provided a paper model on the next page.

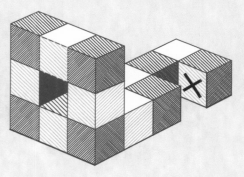

ANSWERS

FIGURE 3–A and C are correct

FIGURE 1–Only B is correct *FIGURE 2–A and C are correct*

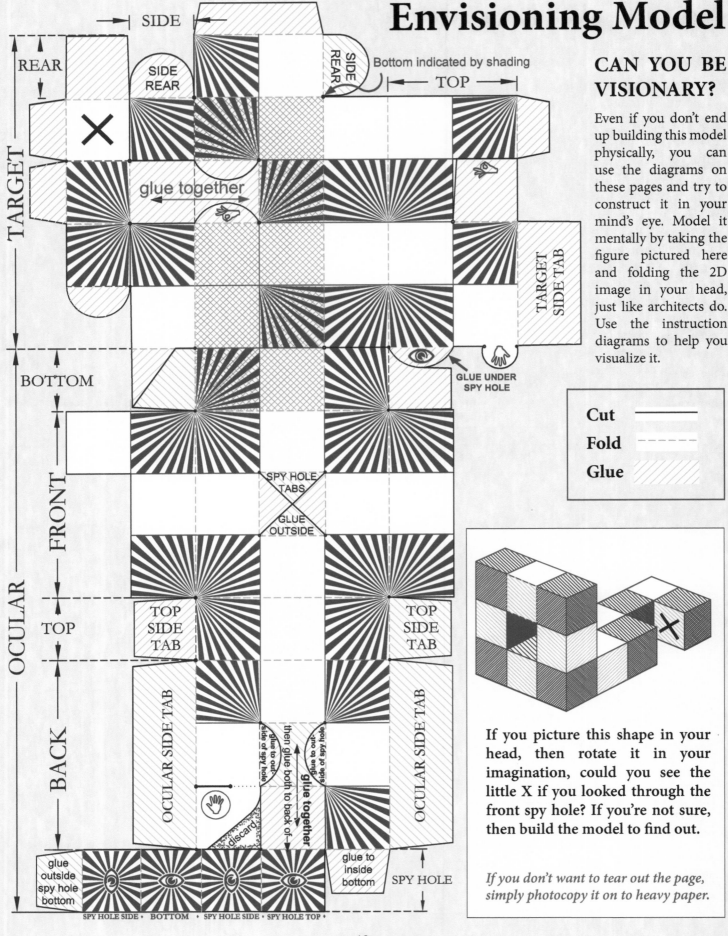

Envisioning Model

CAN YOU BE VISIONARY?

Even if you don't end up building this model physically, you can use the diagrams on these pages and try to construct it in your mind's eye. Model it mentally by taking the figure pictured here and folding the 2D image in your head, just like architects do. Use the instruction diagrams to help you visualize it.

Cut ——————

Fold ‒ ‒ ‒ ‒ ‒

Glue ////////

If you picture this shape in your head, then rotate it in your imagination, could you see the little X if you looked through the front spy hole? If you're not sure, then build the model to find out.

If you don't want to tear out the page, simply photocopy it on to heavy paper.

Instructions

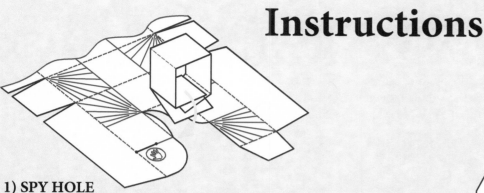

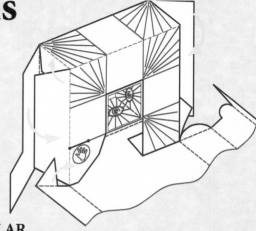

1) SPY HOLE
Fold up the spy hole cube and glue it together. Then glue it to the two base folds. When dry, push it through to the reverse side and glue it to the rounded side tabs. Press against a table top while drying so it's flush to the face of the ocular.

2) OCULAR
A. Flip figure over and fold up the front. Glue triangular tabs to spy hole cube. While gluing, press ocular face to a flat surface to ensure cube is flush to the face.
B. Fold down upper side tabs. Glue side tabs to sides. Keep square.
C. Glue sides of ocular. Put fingers inside to apply pressure to both sides while glue sets. Keep square.
D. Fold up the bottom. Glue to the tabs.

3) TARGET BASE
Front side walls
A. Fold up from the bottom, then glue tab under the slot.
B. Apply glue to both sides of all pertinent tabs. Glue tab under the spy hole while inserting the hand tab into slot, then press sides together. Square up figure while the glue is still wet.

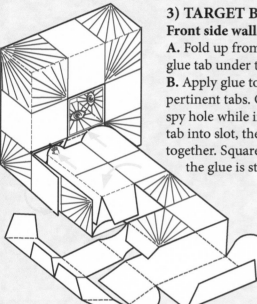

4) TARGET 'X' GAP
A. Glue the two bottom tabs together.
B. Glue curved and square 'hand' tabs together. Let dry.
C. Glue tabs around gap. Arrange tabs as shown and push partially into figure so you can align and insert the rounded tab into the side slot.
D. While glue is still wet, push in tabs all the way, then secure then while squaring up the cavity.

5) TARGET REAR
A. Glue together the remaining sides of the cube behind the 'X'.
B. Glue rear side together.
C. Glue final rear tabs inside the figure.

NOTE:
There are a number of 'blind tabs' in this model—where you won't be able to apply pressure from the other side to help you squeeze the surfaces together. When you encounter these tabs, make sure to load up the connecting corner edges with glue, then gently press them in and position. Let them dry before continuing.

6) PEEK THROGH THE SPY HOLE
Did you guess right when you visualized the shape in your head? Can you see the X through the spy hole... or not?

Modeling the World We Make

This painting from 1818 is a fantasy view of the buildings designed by architect John Soane—a sort of mental model of models of his mental models! These models were never assembled together in reality, but the painter was so impressed with Soane's ability to model the places he built that he made up this view of what it must be to crawl into the cavern of the architect's subconscious.

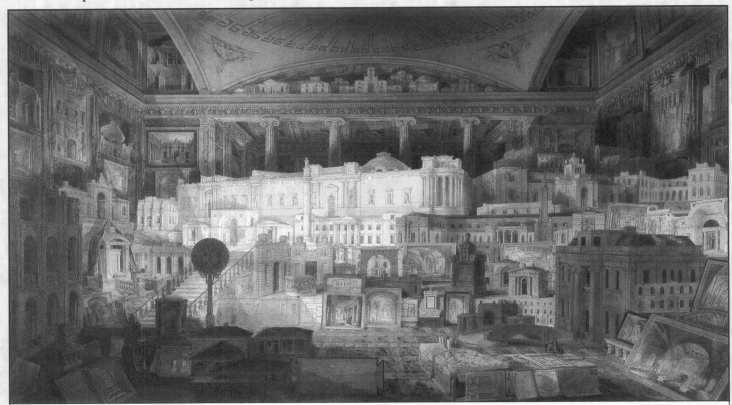

"Perspective of various designs for public and private buildings executed by John Soane between 1780 and 1815 shown as if they were models in a gallery", 1818. Joseph Michael Gandy. Pen and watercolor. © Sir John Soane's Museum, London

Visualizing abstract ideas as mental models and turning them into a 3D reality is a daily task in the realm of architecture. An architect's brain is curious place, where space is malleable, and the man-made world is viewed as a series of flat planes to be floated and connected to form a three-dimensional dream.

Mental models are abstract simplifications of the world we perceive. That's why the mind loves simple geometric shapes. Reality is complicated and messy and makes it difficult to discern a comforting pattern. Geometry, like mental models, reduces this mess to something elegant and orderly—something we can easily grasp. That's why we see beauty in simple shapes and even elevate them to being a mystical ideal. Architects can draw buildings, gardens, neighborhoods, and even whole cities from the disorderly natural environment, reducing it to basic geometrical forms. The world we impose on nature becomes easier to conceive, navigate and live in when rendered in neat lines, with points and angles we can count and carry in our heads.

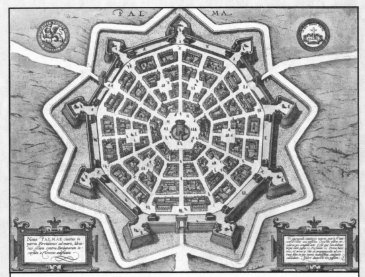

Palmanova, Italy, 1598
Architects have sought to order nature according to simplified geometric mental models since time immemorial.

Manifesting a Mental Model

Map data ©2015 Google
Google — Imagery ©2015 Google

Stonehenge

Pyramids

Cube at Mecca

Our minds love geometry for its magical simplicity. Palmanova still exists in all its geometrical glory—this nine-pointed 'enneagon' has been used by mystics for ages.

Buildings don't just spring fully formed out of architect's heads. There's a whole back and forth between ideas and mental models before it even gets to the builders. But it all starts with simple little sketches. *Note: architects can't draw straight lines either—that's why they use rulers.*

Elevation Section Front elevation

Floor plan Top plan

Above we show how architects expand two-dimensional sketches form a three dimensional design. On the right, we break down this process a little more clearly. This is the same process we use for making paper models—we start with a 3D sketch, unfold the sides, then draw the views so they will fit together when folded back together again.

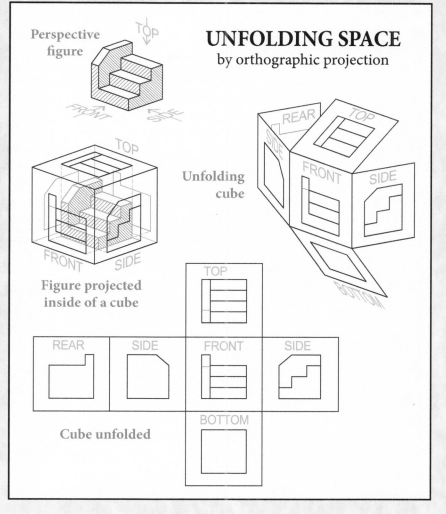

Perspective figure

TOP
FRONT SIDE

UNFOLDING SPACE
by orthographic projection

Unfolding cube

REAR TOP SIDE FRONT SIDE BOTTOM

TOP FRONT SIDE

Figure projected inside of a cube

TOP

REAR SIDE FRONT SIDE

BOTTOM

Cube unfolded

Modeling the Natural World

Creating mental models based on the natural world is an ancient tradition—a talent our ancestors developed to navigate and survive when rocks were landmarks, rivers were roadways and hilltops offered visual confirmation of a destination. In a world full of concrete and cars, many of the subtleties of our landscapes have been lost as the natural world shrinks in size and status.

By its nature, wilderness is rough and rugged—a disordered organic confusion full of pitfalls and perils. Before the natural world was reduced to its present recreational status by farming and fences, it was a place of fear as well as fascination. Before Eden was a 'garden', it was first a place of pagan brutality—full of unknown threats and mythic dangers (including snakes). To gain dominion over this verdant chaos, Adam's first job was simply to name things. In doing so, he took unknown entities and made them knowable. The previous menace was now reduced to a few syllables—easily tamed and held in the head.

Topographical terms still mirror our moods and infect our language through metaphor. Expressions like no man is an island, stream of consciousness, mired in a stalemate, old

Nature is mirrored in the mind
The upper branches of our neural pathways define the heights of our imagination, while their roots expose the depths of our subconscious.

as the hills, dumb as dirt, steady as a rock, a fruitful endeavor, and family tree, still imbue our views and give richness to our ramblings.

Our bodies and brains reflect geography, as they too have evolved from the organic forces that created them. Our arteries meander through our bodies and feed our limbs like the network of waterways that feed the seeds of fields and forests. Even the undulating surface of our brain resembles the hills and valleys of the countryside. In nature we see reflected the anatomy of our own minds.

On the following pages is a litany of little landscapes. Many names for them have fallen out of fashion, but were once key to our connection to nature. This volume of visualizations is a memorial to the mental models we've lost, a reminder of who we were and where we came from—terms that helped us avoid becoming lost while understanding where we were. Some are familiar, some foreign, some so ancient their use only survives in old-world place names. We hope that by re-connecting these words and images in your head, you'll reclaim some of these ancient mental models and use them to give meaning to your moods and reflect your own inner landscapes.

Little Landscapes as Lenses

BARROW
An ancient burial mound

BECK
A quickly flowing stream

BOLE
A trunk of a tree

BRAKE
An overgrown thicket of brush and bramble

BURN
A small stream—a brook

CAIRN
A small pile of stones, marking a route or summit

COOMB
A small valley, often wooded, with no river

COPSE
A thicket of shrubs and small trees—a small wood

DALE
An open broad valley, usually in an area with low hills

"We see it [nature] as being outside ourselves, even though it is only a mental representation of what we experience inside ourselves"

–Rene Magritte *1938*, talking about his painting *"The Human Condition"*

DENE
A steep-sided wooded valley through which a burn runs

DEFILE
A steep-sided, narrow mountain pass

DELL
A small valley, usually among trees

DINGLE
A deep wooded valley

DOLMEN
A megalithic stone plinth or tomb

EYOT
A little island in a river or lake

FELL
An upland stretch of high, uncultivated moorland

FEN
A low marshy, or frequently flooded, area of land

FOSSE
An excavated trench, usually with water. A moat or canal

GLADE

An open clearing in a forest

GLEN

A deep, narrow secluded mountain valley, with a river

GORE

A small triangular piece of land lying in a fork of a road

GROT

A small, picturesque cave. A grotto

GRYKES

Naturally occurring limestone fissures resembling pavement

"It is in vain to dream of a wildness distant from ourselves. There is none such. It is the bog in our brain and bowels, the primitive vigor of Nature in us, that inspires that dream.

This world is but a canvas to our imagination"

—Henry David Thoreau

GHYLL

A deep, wooded ravine, usually with a stream

HAG

An isolated pedestal of peat topped with grass

HEATH

Open uncultivated land, with low shrubs and heather

KNOLL

A small rounded hill

KNOTT

A small rocky hill

MERE

A small lake, pond, or marsh

RILL

An eroded channel cut in the ground by running water

SWALLET

A sinkhole in the ground that streams disappear into

The gyri and sulci of the brain's surface landscape mirror the mounds and moats of the countryside.

Gyrus Sulcus

SWARD
A stretch of turf. A lawn or meadow

TARN
A small mountain lake

TOR
A naturally occurring rocky pinnacle on top of a hill

TUMULUS
An artificial mound over a prehistoric tomb—a barrow

TUSSOCK
A clump of growing grass

VALE
A long valley among hills, usually with a river

WASH
A dry channel created by flooding on a desert plane

WOLD
An area of high, open, uncultivated hilly land

Modeling Your Mind

If you haven't done so already, review the images and their titles. Say the labels aloud while thinking of places you've been to that remind you of the pictures. Try to imagine what it would be like to be there. What would it smell like—fresh, green, grassy and flowery, or fetid, dusty and fusty? What sounds might you hear—birds, water rushing, the rustling of leaves, or the crunch of twigs? What would the ground beneath your feet feel like as you walked—hard, pebbly, and crunchy, or soft, mushy, and moist? Would it be warm, cold, windy or rainy? Might you feel the sun on your forehead or a breeze on your cheeks? Breathe slow and deep while you evoke these sensations and say the names of each locale.

Some of these places might ring a bell as you connect them to places in your past. We promise that once you've uploaded these little mental models, they will act as lenses in the future—templates of perception that will mold what you see and experience when you're out in the countryside again. Seeing other pictures like this might cause these little mental models to jump into your head too. If they do, you'll know your mental modeling endeavors have been a success.

Train your brain and mold your mind as you use these little pictures to create mental models that will perfect your perception of the natural world.

Modeling the Macrocosm

Containing the Cosmos

Humans have tried to grasp the immensity of the infinite as long as we've been in existence. Throughout history, we've attempted to distill the complexities of creation into simpler forms. Many thinkers have approached this by trying to understand the secret structure of the universe by imagining its basic building blocks. Today we know these as molecules, atoms, and other particles. Then as now, philosophers and mathematicians were looking for a unifying mental model that could tie together the infinitesimally small as well as the gigantic structures of the cosmos.

To understand this search, we have to go back to a time when spiritual truths were synonymous with scientific facts. When mathematics and mysticism were inseparable. When people asked, "What would be the geometry of God?"

First, we'll go back beyond 3,500 years to Scotland, when these odd little stone figures were carved.

The Five Platonic Solids

Tetrahedron - Hexahedron - Octahedron - Dodecahedron - Icosahedron

No one knows why or by whom, but these bulbous balls perfectly portray what the ancient Greeks later discovered to be very special shapes indeed. In 360 BCE, Plato defined these shapes as being unique. They became known as the five Platonic Solids, and are the only known geometric shapes in the universe to contain these qualities:

1. **Each one has faces that are exactly the same shape.**

2. **The same number of faces meet at each corner, at exactly the same angle.**

3. **All their vertex points fit perfectly into a sphere.**

With all the geometric possibilities, there are only five Platonic Solids. Just five. Their unique qualities were thought to be divine, and it was believed these geometric patterns defined the basic structure of the universe—from flowers and animals, to humans and the heavens beyond.

Plato

Ever since the ancient Greeks, academics, artists, and architects have been fascinated by these shapes and their harmonious proportions. Their unique properties have been used to model just about everything.

In the early 1500s, the occultist Heinrich Cornelius Agrippa used sacred geometry to map out the meaning of man and creation. But it wasn't until 1596 that an astronomer thought to use them to model the known universe.

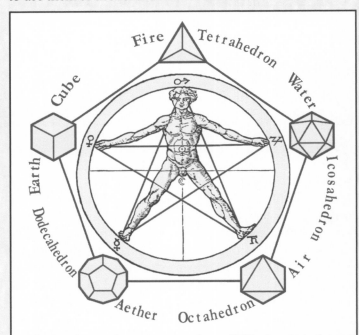

Agrippa's occult pentagram from 1533 showing the microcosm surrounded by the five Platonic Solids, and their corresponding elements shared by the macrocosm

Inspired by Plato and Pythagoras, Johannes Kepler was convinced that God made creation according to a mathematical plan. He is now famous for establishing the basic laws of planetary motion named after him. Kepler was one of the first to confirm Copernicus' radical new theory that the earth revolves around the sun, rather than the other way around.

Kepler with Calipers

The late 1500s were dangerous times for budding scientists, when math was mixed with magic and the church held the rights to heavenly thoughts. Kepler escaped the clutches of the Catholic church by seeking protection from Rudolph II in Prague. He became Rudolph's imperial mathematician, and was joined by other magicians and alchemists who were trying to uncover the primordial essence of everything.

During his astronomical studies, Kepler also became captivated by the five Platonic Solids, and used them to explain the orbits of the planets in his treatise, Mysterium Cosmographicum. By nesting the solids within each other, Kepler found they closely mirrored the size and relationships of the planets' orbits, and thought he'd found God's plan behind the construction of the cosmos. He assigned particular planets to each shape, as well as five elements, including the quintessential aether. He capitalized on our unique human gift for mental modeling and reduced the mysteries of creation to a few easy-to-conceive characters.

He was so excited that he even made models with colored paper of his mental image, and planned to have one built of silver as a punch bowl for a potential funder. (We love the way science's history is rife with examples of ingenious geeks making fun toys for the amusement of the idle rich in order to extract coins from them.) Kepler never found the funds to build his silver model, but his sketch for the project remains.

Kepler's Mysterium Cosmographicum Model from 1596

Following in the footsteps of this famous paper modeler, we invite you to build your own Mysterium Cosmographicum and share in Kepler's adventure in sacred geometry.

Johannes Kepler's Mysterium Cosmographicum model was soon discovered to be flawed (Kepler himself admitted this), and even in its own time didn't exactly match the planetary orbits,

Build this Do-It-Yourself model *Mysterium Cosmographicum*

or account for all the known planets. But his passion for these magical polyhedra, and making the inconceivable graspable, has inspired many thinkers since then and motivates many others today. Salvador Dali, Le Corbusier, Buckminster Fuller and numerous others have all embraced Kepler's passion for polyhedra in their creations. The subject of sacred geometry is still covered in colleges today.

The subject of sacred geometry is too vast and intricate to encapsulate here. What interests us is the way the mind loves to reduce vast complexities to simple, easy-to-remember structures—in other words, mental models. If there is a secret structure behind the cosmos and our connection to it, it will be found not by measuring it, but by how we make models of it in our minds.

The human imagination and desire to deduce the unknown, and reduce it to the known, knows no bounds.

Science has shown us that we make mental models whether we want to or not. For better or worse, they subconsciously direct our thoughts, behaviors, and the way we perceive things. Good ones can help us to see things in new ways and create some wonderful stuff. But left unchecked, erroneous mental models can skew our view of the world and prejudice our judgements. (Kepler didn't notice his flawed model of the solar system until after he published his theories in a book. But embarrassment is a great learning tool.) Unconscious mental models can influence us in negative ways, so we might as well have some fun consciously making good ones. By forming ideas, then visualizing them, picturing them in little sketches and building external physical models, we can enhance our perception, imagination and creativity.

Envisioneering

When we consciously generate mental models, they can also help us realize our dreams. Science says that when we imagine a situation, the brain and body respond in the same way as if it were really happening. Erotic fantasies can cause physical arousal, and bringing up stressful memories can cause a surge of adrenaline to course through our veins along with a horde of other physical changes in a 'fight or flight' response.

Now that we've been through several mental modeling exercises, let's try one last one. This time, we'll put our skills to use by following an age-old practice that takes your ideas and makes them happen. It's a visualizing method that's widely used in sports, business, and goal-setting, but it was created eons ago in the East and in western mystery schools. Some sceptics see aspects of this practice as magical thinking. And yes, its history is teeming with mystics and magicians who thought that your mind could activate some mysterious etheric medium that would make your wishes come true. We're not sure what to make of that, but we do know that consciously forming a clear idea in one's imagination will embed it in the subconscious, where it will influence what you think and do unconsciously from then on. And the subconscious is a pretty mystical, magical, awesome thing already—who needs mysterious mediums?

We'll call this procedure 'Envisioneering'. It's mental modeling with a purpose. This mindful effort works by sinking positive expectations into your subliminal self to counteract doubt and set up a series of constructive, conscious behaviors—positive steps towards achieving the objectives you hope to attain.

"*Fuji at Torigoe*"— Hokusai, c. 1831
Capturing creation in imaginary models has motivated many people in history. Here is a fanciful print by Hokusai showing his mental modeling skills. There were no known armillaries in Japan at that time, but this didn't stop the artist from imagining one in his famous "One Hundred Views of Mt. Fuji" series. Eventually Japan developed all sorts of armillaries and orreries, but they needed to be visualized first.

ENVISONEERING EXPERIMENT

1. First, clear your head. This is easier said than done. You need to empty your mind of all the usual commentary in order to focus on a singular thought and image. Try focusing on your breathing for a while, acknowledging random thoughts as they come to you and then letting them go.

2. Focus on one idea—something you want to do, something you want to make, something you want to happen. Be clear about it. Turn it into a single, simple request to your Self.

3. Picture yourself with the goal achieved—in all its technicolor glory. Picture yourself in a scene with your objective. Sense it, smell it, hear it. Clearly see and be with this object of your affections. Your mind and body won't be able to distinguish this from reality, and will react subconsciously to that imaginary scenario.

4. Forget about it. Trust your subconscious to do the rest. You don't want to muddy the lovely image you just created when your mind returns to its usual worries and doubts, so clear your head again. Remember, any doubts will sink into your subconscious too, and negate what you've done by telling your mind that you don't want or can't have the goal you just pictured.

Later, you may find little ideas and urges pop into your head as they bubble up from the subconscious. Be ready, and draw/write them down when they come. More ideas will spring from these as they gain momentum.

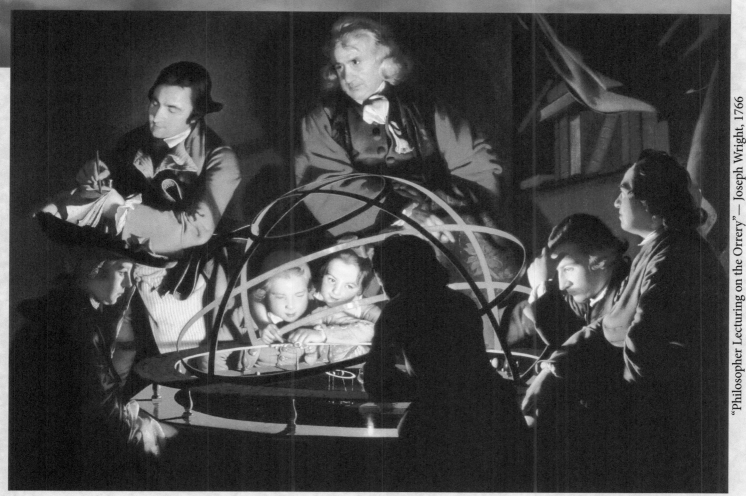

"Philosopher Lecturing on the Orrery" — Joseph Wright, 1766

Models of the cosmos can be fun for the whole family! Look at their faces as they try to cram a mental model of creation in their heads. The first Orrery was made by clockmakers in 1704 and given to a potential funder, the Earl of Orrery, as an amusement to incur his patronage. As a result, all subsequent models of the solar system have been named after him.

We hope you've enjoyed this time spent exploring and trying to understand mental models. They are key to our perception, and valuable tools for our imagination and creativity. We hope you'll continue to experiment with consciously creating them as fuel for your imagination, and a springboard to help you realize your dreams.

Suggested reading

Ackerman, Diane, **An Alchemy of Mind**. New York, NY: Scribner, 2004

Carter, Rita, **Mapping the Mind**. Berkeley, CA: University of California Press, 1998

Crick, Francis H.C., **The Astonishing Hypothesis**. New York, NY: Charles Scribner's Sons, MacMillan 1994

Dennett, Daniel C., **Consciousness Explained**. Boston: Little Brown and Company, 1991

McKim, Robert H., **Experiences in Visual Thinking**. Belmont, CA: PWS Publishers, 1980

Robertson, Ian, **Opening the Mind's Eye**. New York, NY: St Martin's Press, 2002

Schama, Simon, **Landscape and Memory**. New York, NY: Alfred A. Knopf, 1995

Sheldrake, Rupert, **The Sense of Being Stared At**. New York, NY: Crown Publishers, 2003

Shepard, Roger N, **Mental Images and their Transformations**. Cambridge, Massachusetts: The MIT Press, 1986

Wind, Yoram and Cook, Colin, **The Power of Impossible Thinking**. Upper Saddle River, NJ: Prentice Hall, 2006

Mysterium Cosmographicum
model instructions

BUSY HANDS ARE HAPPY HANDS

Model shown actual size

The Meaning Behind the Model

Why make a paper model?

Turning a mental model into a paper model is a centuries-old practice for testing and validation. Mental models, like other thoughts and ideas, are elusive and fleeting. To capture these ephemeral notions, it helps to use our hands to manifest them concretely. This projection into the third dimension gives ideas shape, substance and meaning.

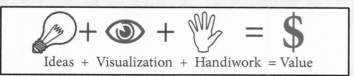

Ideas + Visualization + Handiwork = Value

Most 'normal' folks associate paper modeling with games and relegate it to the realm of child's play—something to grow out of, so they can get on with the business of being 'serious' adults. Silly people!

Making a model does involve play, delight, adventure, and other things we may give up as adults, but it's also a completely serious philosophical and spiritual exercise that is meant to enhance one's capacity for wisdom and provide a path to enlightenment.

No kidding!

As well as being fun to put together, this model is meant as an exercise in visualization, by fitting infinity into your mind and holding the cosmos in the palm of your hand. Making it is a method for exploring common cultural mental models (memes) that, in turn, will enhance one's capacity for creating personal mental models. It's a way to connect to the rest of creation by visualizing and testing the ideas that appear in the mind.

For better or worse, we see the world through our own mental models. So in order to gain a clearer vision and insight, it's helpful to externalize these abstract entities, testing and expanding their meaning by projecting them into the real world – and letting them feedback through our senses.

This paper model was inspired by, and takes its name from, another famous model, done by the astronomer Johannes Kepler. He described it in his influential book, Mysterium Cosmographicum, in 1596. Like his model, this one uses the five Platonic solids to represent the cosmos. Both are exercises in taking something vast, abstract and incomprehensible, and reducing it to something small, concrete, and comprehensible to delight our senses, and inspire further insights.

Kepler's model used the mysticism of the five Platonic solids to represent the orbits of the planets, nesting them and setting them in an armillary stand. Our model takes Kepler's version one step further. After additional study, Kepler realized that his arrangement of the five

The correctly nested polyhedra

polyhedra didn't really describe the solar system accurately, and he went on to other things. But that didn't stop others from being inspired by his model and use of sacred geometry to seek answers to the essential truths of how the cosmos is put together.

Kepler's original sketch of his cosmic 'punch bowl' from his *Mysterium Cosmographicum*, published in 1596

The nesting arrangement in this model was inspired by the work of architect and visionary Stephen Wilmoth. Stephen has spent a lifetime exploring the magic in geometry, and 'corrected' Kepler's configuration of the polyhedra. This new order also perfectly follows the rules of the Golden Ratio, also known as the Divine Proportion.

The Divine Proportion

The Divine Proportion, or Golden Ratio, is a term coined in the 15th century for a concept discovered by the ancient Greeks, who thought it was sacred. It's a mathematical relationship that decribes everything from quantum structures to cosmic configurations. There is a pattern inherent in these nested polyhedra models that follows the Divine Proportion. The same geometric progression can be found throughout creation, in everything from flowers to animals to galaxies to us.

A+B is to A as A is to B

So you can follow in the footsteps of fellow philosophers to find spiritual truths by sharing this mission to connect your mind to your body–and the beyond–by modeling the laws behind infinity. It's all here in this simple paper model.

To make a Golden Rectangle—take a square, then draw a diagonal from its midpoint to the corner. Rotate that line to the baseline to extend the square into a rectangle. The new baseline represents the Golden Ratio.

To make a Golden Spiral—draw a second square in the leftover rectangle. Then repeat, making squares in each smaller rectangle. Finally, take a compass and mark arcs from the inside corners of each square.

From ears to the unknown, the pattern formed by the rules the golden spiral is truly universal.

Assembly Instructions

On the following pages are instructions for the Mysterium Cosmographicum model. Assembling it matches your manual skills with your aptitude for visualization to further enhance your mental modeling abilities. In preparation for any method of meditation, you'll need to create a clean orderly space, free from distraction, to help clear your mind and focus your intent. Study the instructions and lay out your tools. Approach the work with joy and confidence. Have fun!

Tools & Techniques: SCORE ----- CUT ——— GLUE ▭ ALIGN ······

Choose a glue suitable for paper—we find a simple glue stick works just fine. Find an implement to score with—such as a dull knife. Use a straight edge to keep your scoring straight and centered on the dashed lines. Scoring all the fold lines before you cut out the shapes is very important for the success of your model, especially in this geometrically precise figure. After folding the card, crease the folds with your thumbnail to make sure they're nice and straight.

A Score all the fold lines, then cut out the pieces from the two base pages. The first parts you'll glue will be the reverse side of the bottom quadrants, which form the struts of the armillary. (shown shaded)

B Fold each of the four pieces 'up', along their verical axis, so the white insides face outwards. *You'll be gluing the 'B' quadrants of sides 1&2. and 'D' quadrants of sides 3&4 together.*

C Fold down the top arcs of each piece away from the insides of the faces you'll be gluing. *(This will make it easier to apply glue and position the pieces.)*

D Fold the bottom tabs up to help with applying glue and positioning. On sides 1&2, glue the 'B' quadrants together. On sides 3&4, glue the 'D' quadrants together.

E After gluing the two pairs of quadrants together, to make the two sphere halves, adjust the arcs and fold up the bottom tabs to make applying glue and positioning easier in the next step.

F Carefully apply glue to both halves. This time, you'll be gluing the 'A' and 'C' quadrants together. Align the halves at their corners, and along the rims of the quadrants. Once aligned, press together and secure.

G Finish the base by gluing all the bottom tabs together in the sequence outlined on the model. Finally, glue the outer tabs underneath the base of the figure.

H Now unfold the top arcs and carefully align each pair together. Glue one on top of the other.

I Find the 'Top Ring' on the Icosahedron page, and cut it out. To add extra stability, find some thin card, (like from a cereal box), and glue it to the underside of the top ring before cutting it out.

J Match up the 4 arrows on the top ring to the 4 struts the base. Align and glue together. (The top ring is slightly larger to help accomodate any possible misalignments.)

K After it's dry, cut out the 5 notches on the inside of the ring that will hold the Dodecahedron.

L Finished! Darken any unseemly edges of the paper with a dark colored pencil or marker. This sixteenth-century armillary is now ready to cradle the dodecahedron and the rest of the cosmos.

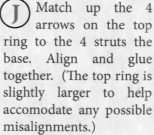

A Score, cut, fold, and crease edges from both sheets. Very carefully align the top and bottom pieces. (Notice the small red arrows on the corresponding edges where they join). Glue together. Glue the latch reinforcement to the inside of the top latch, and the latch catch on to the front side of the bottom square.
(Keep the center of the bottom catch free of glue by sliding a scrap of paper through the slot while gluing.)

B Glue the two tabs, on the triangular shapes next to the lid, to their adjacent edges.

C Fold in the tabs around the lid base inside and apply glue to both sides of the three joints. This is a 'blind' joint, so you'll need to put a bit more glue on the edges. Fold over the lid base and carefully position inside the top form. Carefully align and press together the edges, making sure the bottom is inside and flush, and slightly below the perimeter.

D Next, glue the tabs along the four top perimeter shapes to their adjacent edges. Match up the exterior patterns and slide the joints into position before pressing together.

E Now do the same with the lower four pentagon shapes — gluing the tabs to their neighboring edges — then bend down the sides of the inner square and glue together.

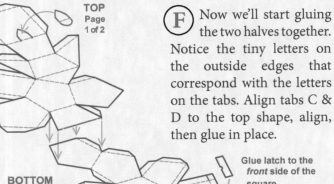

TOP Page 1 of 2

BOTTOM Page 2 of 2

F Now we'll start gluing the two halves together. Notice the tiny letters on the outside edges that correspond with the letters on the tabs. Align tabs C & D to the top shape, align, then glue in place.

Glue latch to the *front* side of the square

G The next step is tricky, as you'll have to apply glue to several tabs and press them in place before they dry. Notice the tiny letters on the edges of the shapes that match the tabs. Quickly apply glue to all four tabs and their associated edges then align and press in place. *You can stick your fingers through the opening to press the dodecahedron into shape from both sides simultaneously.*

FLIP SIDE

H Finally, glue the inner reinforcing square into place. It only makes contact with the inside at the two bottom corners, so you'll have to load these up with a good dollop of glue. Move the side reinforcing tabs out of the way for the moment. Insert the box to fit it inside without disturbing the glue, then press into place. Close the lid to help square up the opening while it dries.

I If you haven't done so already, curl the latch tip slightly and clear the middle of the latch catch with a toothpick to make it fit nicely. Close the lid and you're done!

Hexahedron construction (Cube) *figures shown upside down to start*

A Score, cut, fold and crease edges. Remember to cut the latch slit and the marked hole in the tab. Fold and glue tabs on the latch reinforcement, then glue it to the latch, with the glued tabs facing inside. Glue together the shared squares on the top and bottom halves. Match the tiny red arrows, to carefully align then press and secure.

B Fold up sides of cube, glue tabs and adjacent edges, then press together.

C Now attach the inner triangles. The top one you'll be able to align to the inside of the fold line, but the bottom ones you'll have to line up with each other and the opposite corner. These will be 'blind' joints, so you'll have to load the edges with glue and press them carefully together when positioning and securing.

TOP Page 1 of 2

BOTTOM Page 2 of 2

D Fold up and glue the joining square face to the tabs on the trangular bottom shape. Load the the edges with glue, carefully align and press together.

E Once dry, fold down the top half to its matching corner. Apply glue to the edges of these 'blind' joints as before.

F Quickly glue all the edges, carefully position, and adjust while pressing together before the glue sets.

G Close the cube. Your Hexahedron is done, and awaits the Tetrahedron.

Tetrahedron construction *figures shown upside down to start*

A Score, cut, fold and crease edges. Start by gluing the four reinforcing tabs to the inside of the shape. Make sure they're straight while they dry.

B Fold up the upper triangle and glue its tab to the adjacent edge to form a little pyramid.

C Next, fold up the lower side triangles and glue the bottom tab to its neighboring edge.

D Finally secure the two little corner tabs, one on top of the other, to complete the inner shape.

E To help keep a nice tight seam, bend the outer edges of the top shape inward slightly so they press against the inner shape.

Octohedron construction *figures shown upside down to start*

A Score, cut, fold and crease the figure edges, and don't forget to slit the latch slot. Glue the latch reinforcement to the inside of the latch, then glue the edge reinforcing tabs to the inside of the figure. Make sure to keep the tab over the slot free from glue in the center.

B Form the first pyramid by gluing the upper tab to its adjacent edge.

C Form the second pyramid by gluing the lower tab to its neighboring edge. Then glue the corner braces into their corners.

D Secure the two bottom corner braces to complete the shape. Be sure to press the top edges of the corner braces downward, so the braces sit below the rims of the pyramids. This will help create a nice tight seam when the shape is closed.

E Curve the latch to make it fit into the slot, and close.

Icosahedron construction *figures shown upside down to start*

A Score, cut, fold and crease the edges. This last litle figure rolls together just like a pill bug. Start rolling up from the upper edge (with no tabs), and glue the first two tabs to their adjacent sides .

B Continue with the next two tabs, adjusting the figure to match the outside patterns before each joint dries.

C Keep curling up the ball, gluing the next adjacent tabs two at a time. Let each pair dry before gluing the next two.

D The last three tabs will be a 'blind' joint, so load up edges on both sides with glue, then very carefully press into place. Let dry.

You're done! Now you're ready to do some nesting.

Finished Model Assembly *All of creation in the palm of your hand*

Expert Finishing Tip After the pieces are put together, use an appropriately colored pencil to darken the naked cut and folded edges. The wax in the pencil will fill gaps, and the colors will blend the edges with the rest of the model.

LID BOTTOM

Dodecahedron
Page 1 of 2

GLUE UNDER LATCH

latch
reinforcement

GLUE UNDER ADJACENT EDGE

GLUE UNDER ADJACENT EDGE

LET FLOAT - DO NOT GLUE
INNER RIM REINFORCING TAB

GLUE UNDER ADJACENT EDGE

GLUE UNDER ADJACENT EDGE

H

GLUE UNDER ADJACENT EDGE

D

E

C

match red arrows

GLUE

GLUE UNDER ADJACENT EDGE

NOTE: If you don't want to rip up the book and would like to build the model on coverstock, type 'Museum of Lost Wonder folios' in your browser's search bar, and click on the Mental Modeling folio.

Dodecahedron
Page 2 of 2

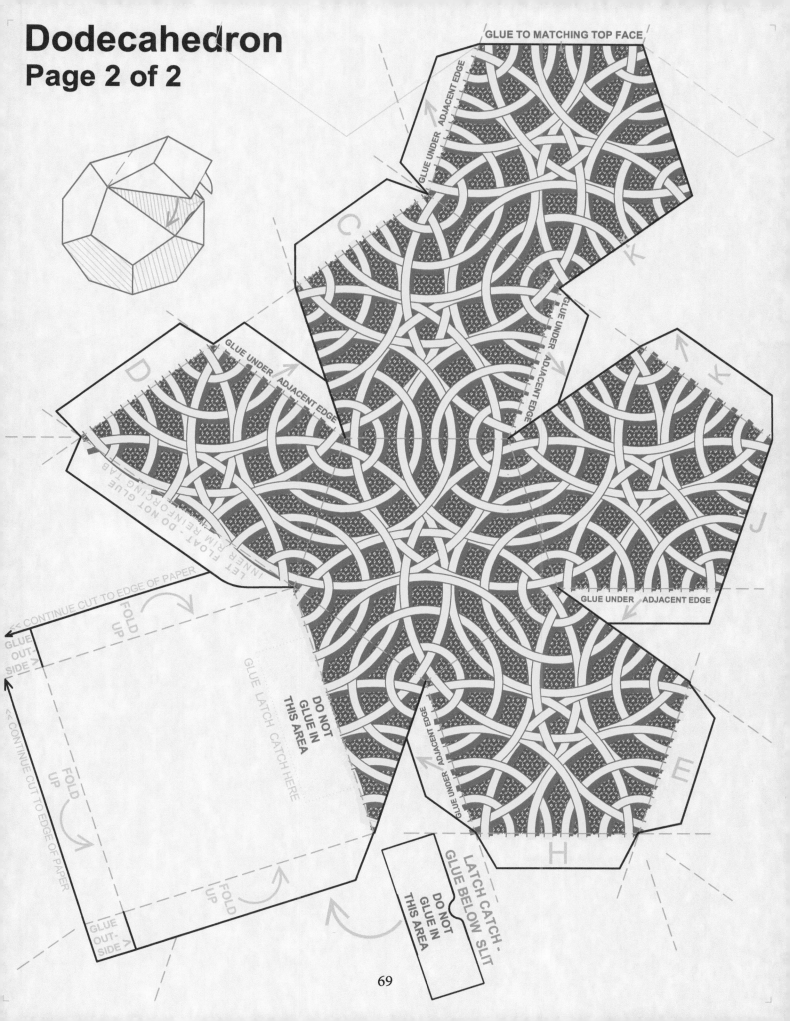

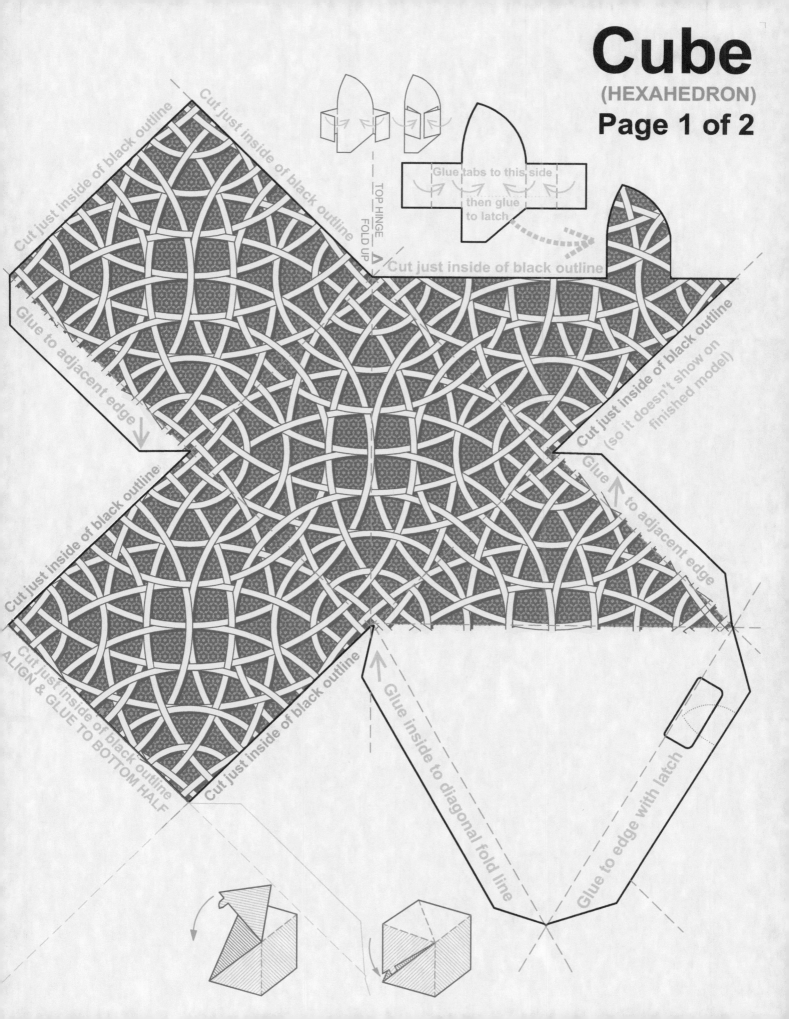

Cut just inside of black outline

Cut just inside of black outline

Glue to adjacent edge

Cut just inside of black outline

ALIGN & GLUE TO BOTTOM HALF

Cut just inside of black outline

Cut just inside of black outline

TOP HINGE
FOLD UP

Glue tabs to this side
then glue
to latch

Cut just inside of black outline

Cut just inside of black outline
(so it doesn't show on
finished model)

Glue to adjacent edge

Glue inside to diagonal fold line

Glue to edge with latch

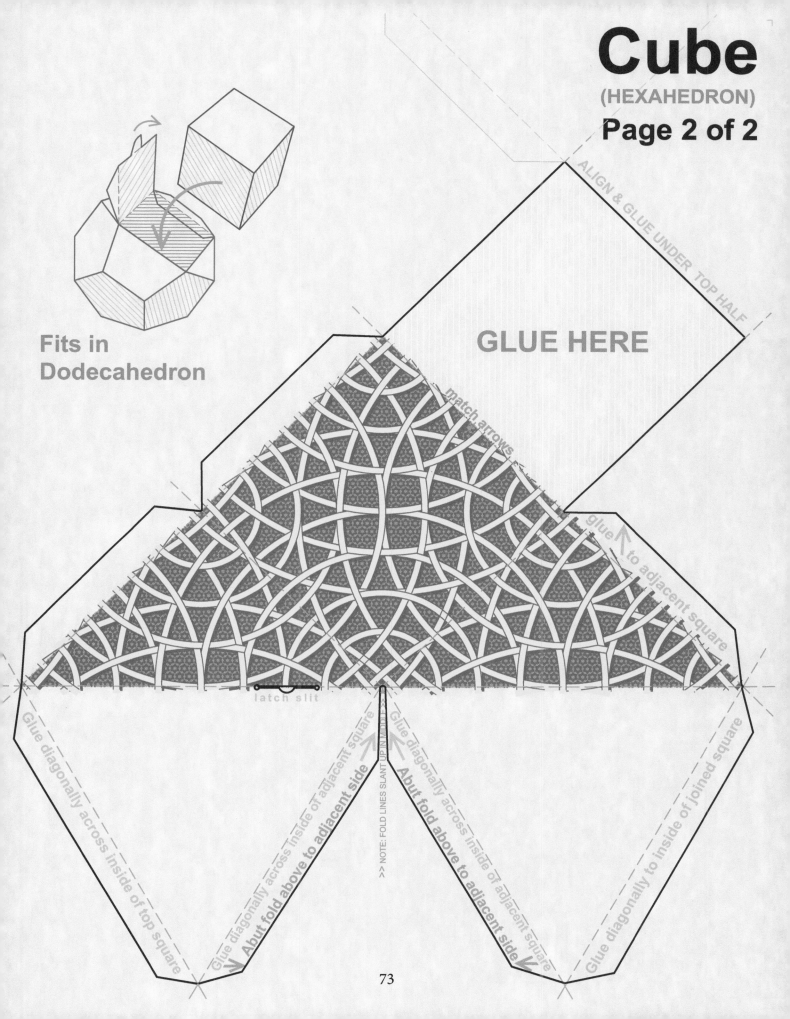

Fits in
Dodecahedron

GLUE HERE

ALIGN & GLUE UNDER TOP HALF

match arrows

glue ↑ to adjacent square

latch slit

Glue diagonally across inside of top square

Glue diagonally across inside of adjacent square

Abut fold above to adjacent side

>> NOTE: FOLD LINES SLANT UP IN MIDDLE >>

Glue diagonally across inside of adjacent square

Abut fold above to adjacent side

Glue diagonally to inside of joined square

Tetrahedron

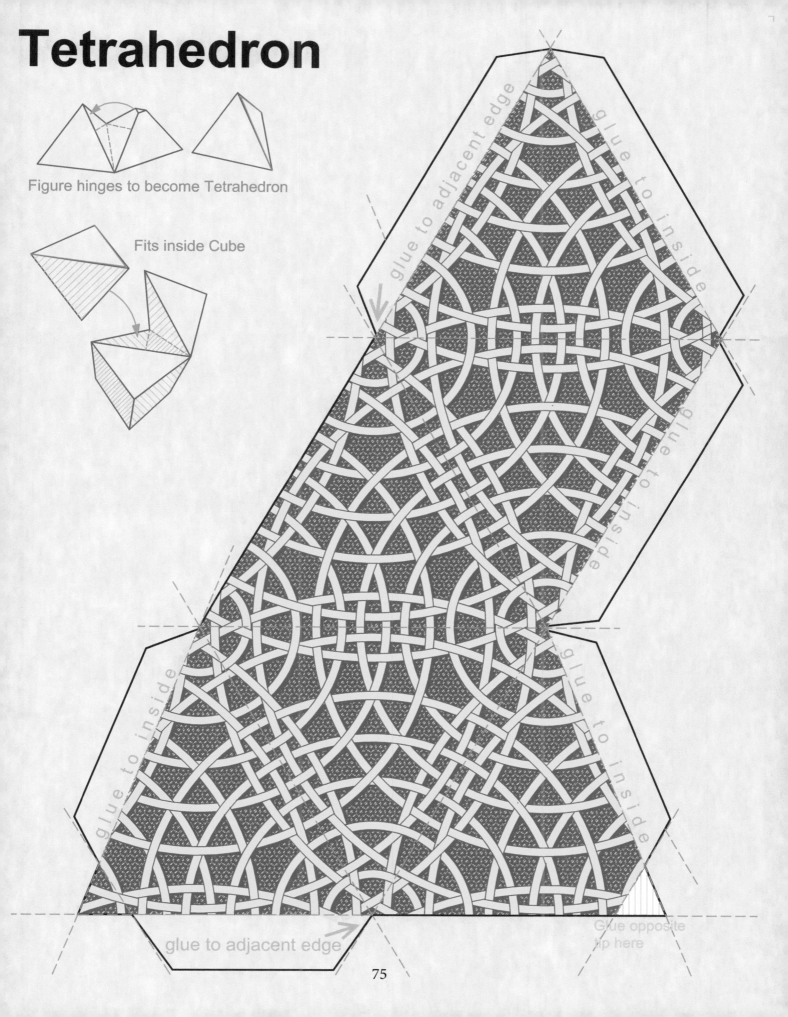

Figure hinges to become Tetrahedron

Fits inside Cube

glue to adjacent edge

glue to inside

glue to inside

glue to inside

glue to inside

glue to adjacent edge

glue to adjacent edge

Glue opposite tip here

75

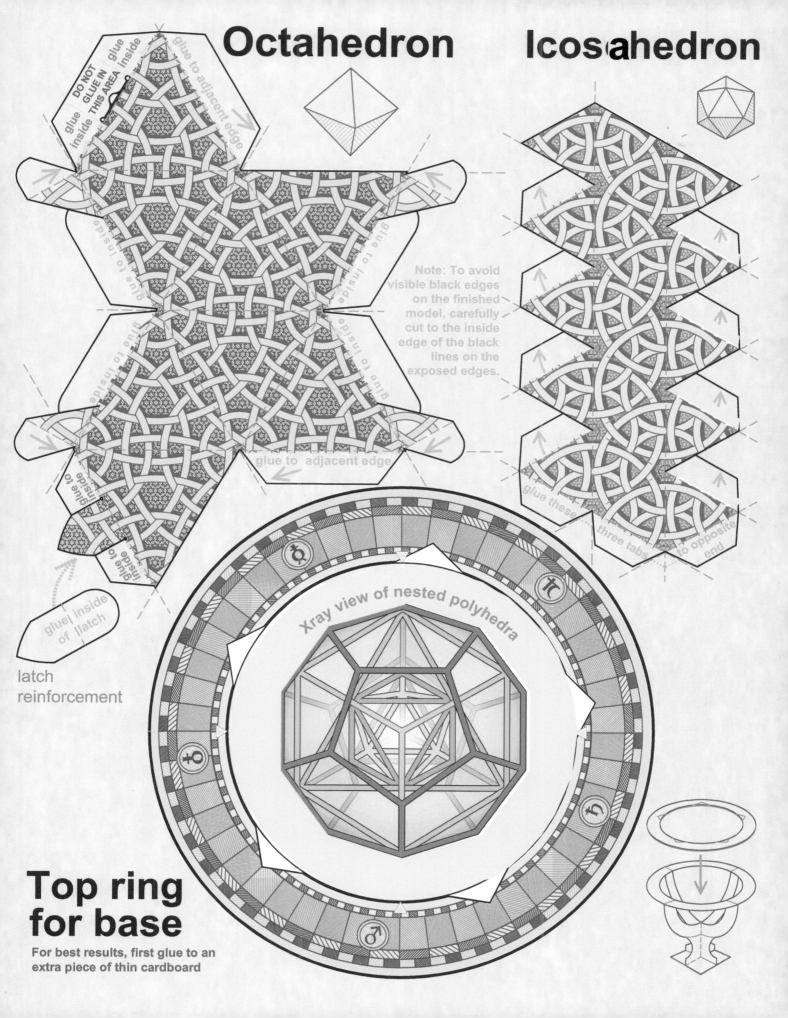

Octahedron

Icosahedron

glue
glue | glue
DO NOT GLUE IN
glue | THIS AREA inside
inside
glue to adjacent edge

glue to inside

glue to inside

Blue to inside

glue to inside

Note: To avoid visible black edges on the finished model, carefully cut to the inside edge of the black lines on the exposed edges.

glue to adjacent edge

glue to inside

glue these three tabs to opposite end

glue inside of latch

latch reinforcement

Xray view of nested polyhedra

Top ring for base

For best results, first glue to an extra piece of thin cardboard

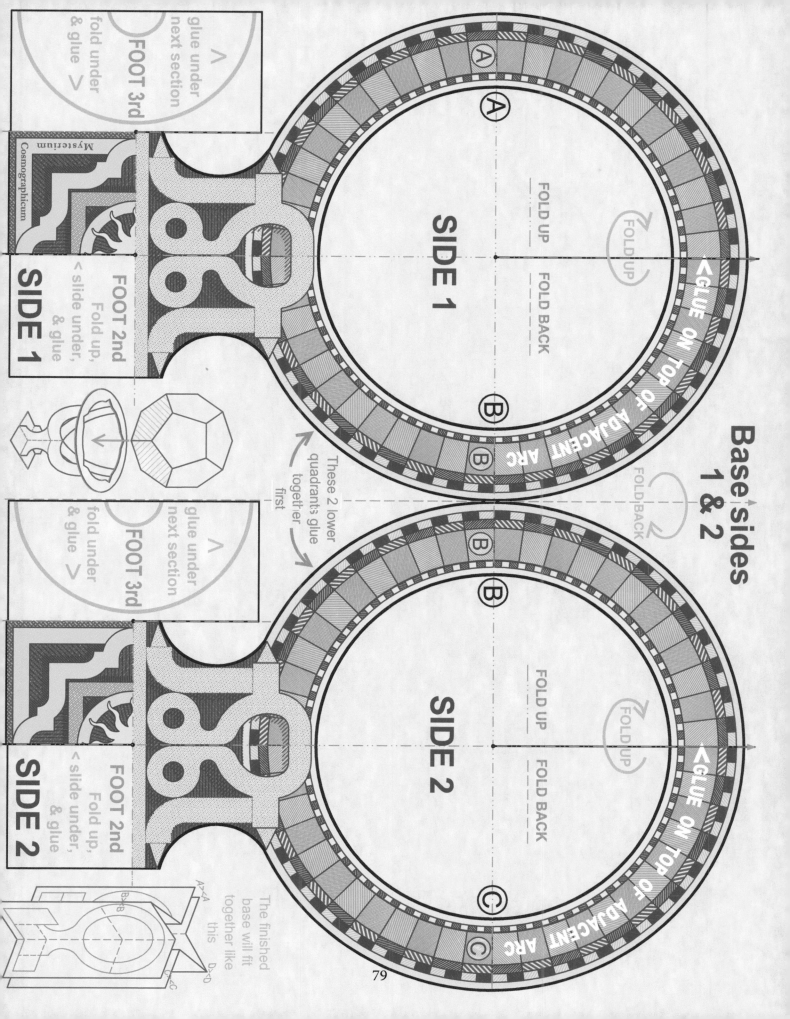

Base sides 1 & 2

SIDE 1

FOLD UP FOLD BACK

(A) (A)

(B) (B)

<GLUE ON TOP OF ADJACENT ARC

FOLD UP

FOLD BACK

SIDE 2

FOLD UP FOLD BACK

(B) (B)

(C) (C)

<GLUE ON TOP OF ADJACENT ARC

FOLD UP

These 2 lower quadrants glue together first

The finished base will fit together like this

A>>A
B>>B
D>>D
C>>C

SIDE 1

FOOT 3rd
fold under & glue >
∧ glue under next section

FOOT 2nd
Fold up,
< slide under, & glue

Mysterium
Cosmographicum

SIDE 2

FOOT 3rd
fold under & glue >
∧ glue under next section

FOOT 2nd
Fold up,
< slide under, & glue

Mysterium
Cosmographicum

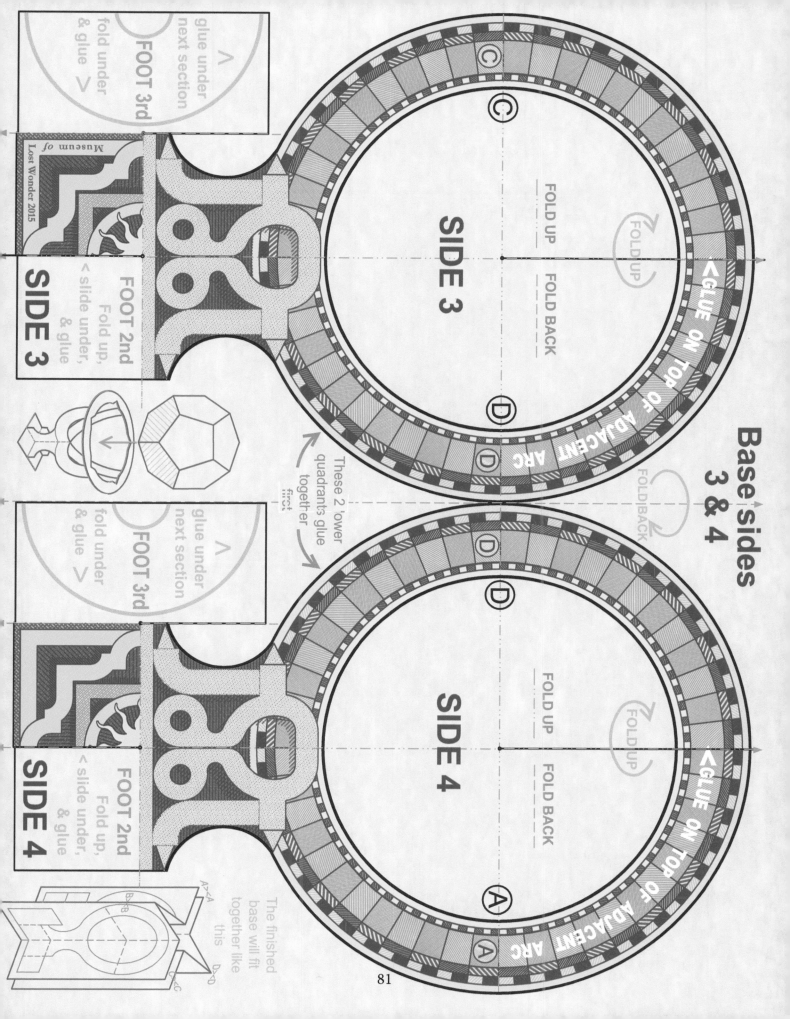

Base sides 3 & 4

81

Architecture of the Imagination

Where do ideas come from?

Architecture *of the* Imagination

MEMORY

TASTE CAFE

THALAMUS LOBBY

AUDIO HALL

HIPPO-CAMPUS

OL-FACTORY

AMYGDALA STAGE

"We can invent only with memory" —Alphonse Karr

Foundations of the Imagination

It's time we turn our attention to the shadowy depths of creativity and its source in the imagination. Where do novel notions come from? And how does inspiration just pop into people's heads? In modern times, we're lead to believe creativity is some mysterious talent that happens to the lucky few that are born with some mysterious gift. Poppycock! Inspiration is a process that starts with the imagination and leads to creativity for those intrepid enough to join the journey.

Follow along as we get our hands, heads, and hearts dirty. Creativity, imagination and inspiration do start in a mysterious place, the most mysterious place we know—the subconscious. But how ideas get there and how they come out is not so mysterious, just messy and illogical. But the process does form a pattern we can all follow. For to come up with something inspired and new, we must dive into something old and familiar—our well of memory.

True inspiration does not come down to us from some divine place above, it bubbles up from below. A below within ourselves that we can feed, nurture, fall in love with, and share stories with. The fuel and sustenance that drives this love affair is a conscious effort to create a wellspring of memories that the subconscious can feed from, enjoy, and use to love us back, by providing novel and unexpected answers to our queries and curiosity. Memory is a crucible that we feed by pouring our thoughts and feelings into it so they can ferment and grow new life in the forms of images and ideas.

To trek this path and process, we'll uncover some secrets of the mythical past and align them with the latest findings of science—combining the art of memory with the science of the brain. For myth stimulates the heart, and science the head. We can put them both together by using our hands. So let's get them dirty!

Mining Memory

Memory is a mysterious monster—fickle, infuriating, and kind. In the classical past, memory was a wild beast to be trained, coddled, and nurtured. The history of these early mnemonic methods is fascinating, and many techniques are still used today. But we won't bore you with the intricacies —the raison d'être of the Museum of Lost Wonder is to inspire the type of do-it-yourself adventure that those early philosophers also supported. So this won't be a memory tutorial, but a guide to spur the creation of your own memory wellspring—a source for your own originality that will facilitate your own creative process.

We'll do this by making a Mental Model of the mind. By constructing an architectural allegory of the brain's workings, we can better understand it. Imagination works best through analogy and metaphor, since the mind stores experience through associative pathways in our neural network. The mind loves matching up similar symbols and stories.

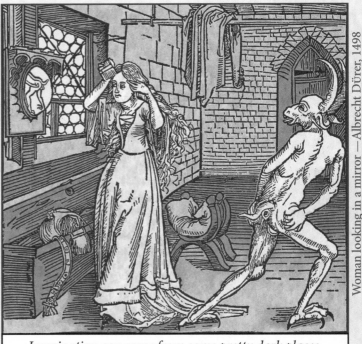

Woman looking in a mirror — Albrecht Dürer, 1498

Imagination can come from some pretty dark places.

Creativity is characterized by inventiveness, and facilitated by a vivid imagination. Imagination is defined as the "power to create mental images of what has never been actually experienced". So it's all about making intense, curious, and audacious imagery in the mind, and imbuing this imagery with emotion to make it memorable. Memory works best with dramatic, fantastic, and titillating mental pictures.

So come along as we combine architecture with the structure of the imagination. But first let's look at how this architectural metaphor was constructed. It's an ancient metaphor built up over successive centuries.

Metaphors and Monstrosities

METAPHORS FOR THE MIND

There've been many metaphors for the mind. In classical times, the mind was thought of as a 'Tabula Rasa' or blank tablet, referring to the wax tablets that were used as sketch pads at the time. One marked with a stylus and erased them by scraping the wax smooth.

A more modern metaphor sees the mind as a pan of Jello, with experience tracking across the surface like hot water, creating undulating rivulets that are deepened by further experience.

Electroshock therapy views the mind as a field of flags, all pointing in different directions. The sicker the individual, the more chaotic this arrangement of flags is. Electroshock, supposedly, makes all the flags point in one direction, so meaningful new pathways can be made.

We now know that the mind is never a blank slate, for evolution provides us with a pre-routed paths that we build upon with further experience. New memories build upon this basic maze to create new neural pathways.

CLASSICAL PHANTASMS

Aristotle called memory images phantasms. To him, all memory was made up of ghostlike visual imagery and every sense perception of experience transforms into a phantasm created by the imagination. The soul wasn't an ethereal double, but an organizing principle that gave these phantasms significance.

From Thomas Murner's 'Appeal to Fools' —1512

Aristotle's phantasms mix an image with an emotional charge. This medieval phantasm illustrates an age-old aphorism still used today.

Phantasms had both an image (made from sense perceptions) and an emotional tag (from our primal natures) that gave the phantasms meaning. These emotionally charged phantasms caused physical imprints on our brains called engrams. At that time, thoughts were seen to reside in the both the brain and the heart. The emotional charge of one's heart is what cemented thoughts in the brain, hence the saying 'knowing something by heart'. Today we give credit to our amygdala for this passionate procedure.

MEDIEVAL MONSTROSITIES

It's been known since classical times that the soul craves drama. The more titillating, grotesque, fantastic, outrageous, bizarre, curious, peculiar, scandalous, unusual, and ridiculous a phantasm was, the better it could imprint on our brains and be memorable. You might not remember what you had for lunch last week, but you'd certainly remember a fight you had or a power outage, or anything else threatening or out of the ordinary. This is why medieval cathedrals and illuminated manuscripts where filled with curious and grotesque figures. They made the church experience more meaningful, and in manuscripts they helped highlight certain passages and acted as visual keys to the text.

Gorleston Psalter, 1300s — British Library, London

Iluminated 'grotesque' marginalia

The complex designs weren't just for decoration, they were meant to be 'illuminating'. They were devised as mnemonic devices to instill wonder. That's why we use so many pictures here at the *Museum of Lost Wonder*. They act as mnemonic devices that shed meaning on the text. To give the text 'context'. The brain loves weaving words and images together to make them meaningful.

Memory Palaces

Memory Metaphors: Arks to Cathedrals

Associating memory with a storehouse has ancient beginnings too, spanning from pigeon coops to arks. Ark means enclosure in Latin. Noah's Ark and the Ark of the Covenant were both storage places for divine creations we were meant to save and remember. The grid of a pigeon coop was also popular, giving rise to the term being 'pigeon holed', or being judged in a restrictive category. In medieval times, these storage boxes grew into cathedrals and palaces, in order to accommodate the idea of a space big enough to hold the wealth of human knowledge and experience. Cathedrals in themselves became a form of architectural literature.

> "Memory is the cabinet of imagination"
> —Saint Basil, 4th century

Virtual memory palaces have their roots in Roman antiquity. In a time before teleprompters, books, print, or even readily available pencils and paper to keep notes on, people had to find ways to recall speeches, stories, or any long sequence of thoughts and words. So they created virtual arks in their heads to organize all their phantasms. It was an almost mystical practice known only to the initiated.

This practice peaked in the middle ages, when mystics came up with huge, complicated systems for tagging and storing knowledge in more memorable and accessible ways. The basic premise was to imagine an architectural space in your head—a place that you could picture yourself walking around in. You would personalize your 'palace' by placing memorable objects and images in the rooms. These curious objects would be personally chosen to encapsulate abstract ideas, and act as shorthand for concepts you wanted to remember. You would then order them in the space, so when you walked from room to room and saw them, they would prompt recollection of the sequence of thoughts or ideas you wanted to remember.

> "Memory is the treasure house of the mind wherein the monuments thereof are kept and preserved"
> —Thomas Fuller, circa 1650

We won't belabor you with the details of how to create and imagine such complicated imaginary architecture to remember things like shopping lists. (*We do have pencil and paper today, anyway.*) What we do want to explore is the architecture that makes this all happen in our minds. Through exploring the ethereal electrochemical mechanics of the brain we hope to get a better comprehension of how creativity works using the biological architecture of our own brains.

We wouldn't have imaginations if it wasn't for our memories. Memory is the fuel the feeds the fire of inspiration and is the source of our creativity. The ideas that mix, match, and explode into occasional flights of fancy are extruded from the storehouse of what we've already seen and sensed before. Memory is made up from the bricks of experience we've laid in place that are melded with emotion to give them meaning.

Next we'll dive into the bio-mechanics of memory to see how it can enhance our ingenuity. But in the meantime, take a tour of the little memory palace on the next page to see how you can use this arcane practice today.

Medieval ark as Memory Palace

Giulio Camillo's memory theater from 1510

The Memory Palace Path & Practice

④ Could frame thy fearful symmetry?
Mirrored tiger heads

③ What immortal hand or eye,

② In the forests of the night,

① Tyger, tyger, burning bright,

⑤ William Blake
Logo in bathtub

⑥ 1794
1) *Spear through eye*
7) *Crutch*
9) *Tadpole*
4) *Door*

Tyger, tyger, burning bright,
In the forests of the night,
What immortal hand or eye,
Could frame thy fearful symmetry?
—William Blake, 1794

A Memory Palace doesn't have to be a castle. In fact it's better if it's a familiar place, like your own home. Above is a mini memory mansion, akin to the model that goes with this folio. Use this as an example to remember any long list of forgetable facts. The basic idea is to visualize the architectural space in your mind, then place unusual objects in the rooms, with a path that strings them together in a sequence. The art of it is to come up with striking imagery, to place on the path that matches the things you want to remember. Above we've laid out the first stanza of poem by William Blake. You can create longer paths, but this shows the basic 'Method of Loci' used for ages.

CATHEDRAL AS MEMORY PALACE

This is a floorplan of a typical Catholic church showing positions of the twelve stations of the cross. Like a memory palace, the cathedral shows graphic images in a specific sequence, (in this case the crucifixion of Christ.) Grotesque imagery has been used to be memorable to the masses for millennia.

Architecture of the Imagination

The mind is a mansion of organic galleries and hallways. A network of interconnected organs with multiple pathways between them that make up our thoughts, memories, and emotions. Memory is the key to creativity and is fundamentally associative. New experiences are better remembered and retrieved when they have multiple connections to previously stored experiences. An emotional charge to a recollection is what cements it in place.

Memory itself is a creative act, as it must be actively reconstructed from elements scattered throughout the brain every time it is retrieved. Recall replays a pattern of neural activity originally generated in response to a particular event, but never activates identical pathways to the original experience. Every time a memory is retrieved, neural corridors are changed and new associations are made. That's why memory is the mother of ingenuity. Retrieval always brings up new ideas. Think of these neural pathways as hallways, with traffic running around to different storage areas every time information is needed, with possibly surprising results.

Association is better than repetition if you want to remember something. The more varied the associations you have with a particular memory the richer the recall. Pictures reinforce words, as do sounds, smells, and touch. The different sensory modalities build upon each other to create more links and multiple triggers, making it easier whenever you want to 're-collect' something.

> "Memory always obeys the commands of the heart"
> —Antoine Rivarol

To see how this is works, let's look at the edifice that houses and links our senses to the Mansion of the Mind. *(See next page.)* Picture it like one big shopping mall or emporium. Central to the process of programming and retrieving is our limbic system, which is housed in the middle of our minds. It's an evolutionarily older part of the brain, the central core underlying our more modern cerebral cortex, and lies on top of our earliest 'reptilian' brain stem, which only processes more primitive stimulus/response survival actions.

There are no storage rooms where memories are kept in library-like vaults. Memories are compiled through the pathways from the limbic system that branch out in a neural network of axons (wiring) and dendrites (connecting fuse boxes). This wiring makes up the majority of our large, folded neocortex—the imaginative ceiling vault of the mind.

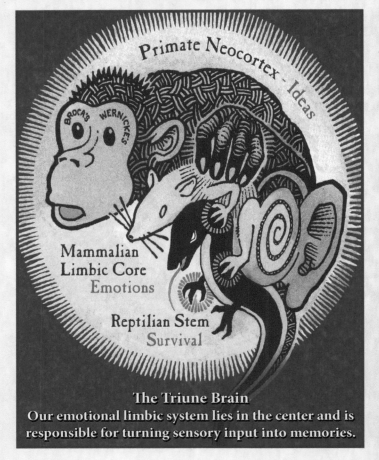

The Triune Brain
Our emotional limbic system lies in the center and is responsible for turning sensory input into memories.

This central limbic terminal controls our basic drives, moods, and emotions, which play a pivotal role in the formation of memories. There are numerous rooms (organs) in this area, but we'll focus on the three of the basic ones—the Thalamus, Hippocampus and the Amygdala.

Limbic system and sensory terminals

SENSORY EMPORIUM

The picture on the next page shows the sensory brain as a building. If the eyes and ears are windows to the soul, then smell is its doorway and taste its stairway to delight. Touch is the foliage that envelops and surrounds this emporium, grounding all the senses.

SENSORY EMPORIUM

"Truth…offers itself…through the translucent spheres of the eyes, passing through the vestibule of common sense and the atrium of imagination, it enters the bed-chamber of the intellect, laying itself down in the beds of memory, where it cogenerates the eternal truth of the mind." —Richard de Bury, 1345

The Limbic Lobby

Thalamus

At the limbic core is the thalamus, or central sensory lobby. The thalamus takes input directly from our sense organs and routes them to their appropriate sensory centers upon input, then to other parts of the neo-cortex to create meaningful associations. The maze of circuitry corridors inbetween terminals is what makes up our memories. The 'rooms' just route and process experience, they don't store them. Doesn't the most memorable gossip always happen in hallways? The thalamus' advantage to the older reptilian stem survival circuitry is that it pipes sensations to other parts of the brain for comparison to past experience first, allowing us to think before we act. It routes all sensory input for evaluation and editing, except for smell, which goes right to the amygdala. The thalamus is key to memory and creativity by nature of its ability to create new corridors for thought and new associations to previous phenomena.

THALAMUS

Hippocampus

Surrounding the thalamus are the branching wings of the hippocampus. Hippocampus is Latin for seahorse, as that's what it was originally thought to resemble. This is a another sorting center where new sensations are compared and connected to previously recorded ones within the hippocampus itself. By shuttling sensations back and forth and strengthening pathways, it helps solidify sensations and builds them into a single conscious experience. It's the primary space where new associations are made that help us create unique thoughts in the future.

Short term memory lies here. Apparently if no new associations are made within two years, the memory bundle is dumped and forgotten. But when experiential episodes are remembered and re-associated, the hippocampus acts as the vital vestibule that reinforces our memories by association to others throughout the neural network.

HIPPOCAMPUS

Amygdala

The amygdala is made up of two little rooms that sit at the ends of the hippocampus. The word amygdala is ancient Greek for nut, because the amygdalae look like almonds. Their function is to encode and retrieve emotionally charged memories. They play a major role in what, how, and where memories are stored in the brain, but their key function is matching and charging our memories with the emotional triggers that make them meaningful. It's the source of the emotions that compel us to think and act based on previous associations. It's why we're drawn to emotionally charged stimulus, and why dramatically charged memories stay with us longer and are easier to remember. Of all our senses, smell can be the most evocative, as it is wired directly to our amygdalae. Some people swear they can activate creative inspiration just by imagining they are tickling the amygdalae with a feather.

AMYGDALA

The Universe is Made of Pictures

The limbic system, and its three main components—the thalamus, hippocampus, and amygdala—route, mix, and match all the sensory input that eventually ends up in the great lofty neocortex above. The neocortex is responsible for storing most of our memories and flights of fancy in its vast neural network. But to be creative, you first have to input information through the senses.

Let's see how the different senses mix with each other to provide rich and ingenious associations in the brain.

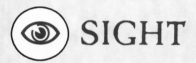 SIGHT

The mind finds more meaning in imagery than in words. The idiom 'a picture is worth a thousand words' attests to the powers of association that images have in the brain, and a picture's tremendous power as a mnemonic device. After all, many written words derived from little pictures—consider cave paintings, pictograms, hieroglyphs, and Chinese characters.

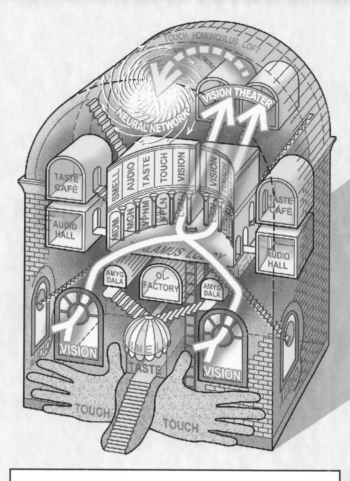

This Emporium diagram shows the visual path from the eyes that travels through the thalamus where it is routed to the vision centers then up to the neocortex. From there it is routed to other memory centers to add to the richness of recollection by association.

The emotional nature of these images reinforces that the more evocative or disturbing an image is, the more memorable it is. Emotion plays a great role in memory, which is obvious when you consider the 'grotesques' in medieval manuscripts and the haunting symbolism used in alchemical etchings to convey multiple meanings and rich psychic interconnections.

Medieval 'grotesque'

It's the associative power of imagery that gives it the ability to light up endless neurons in our cerebral networks. Even simple sketches have the power to bring about new connections and meanings which is the key to creativity.

Today we even delight in turning abstract written symbols back into pictures to convey a greater meaning by using emoticons. These are often automatically perceived as emoji.

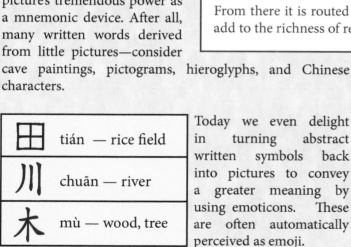

田	tián — rice field
川	chuān — river
木	mù — wood, tree

:> :/ :< ☺ ☹ ☹

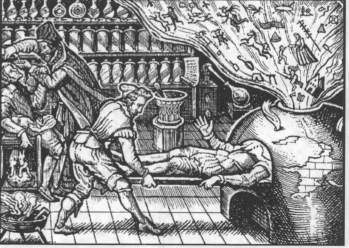

'Athanor of the Mind' —alchemical etching

91

The Universe is Made of Stories

SOUND

Stories help us to put thoughts and imagery together by giving them emotional drama in a predictable sequence. The rhythm and pitch of sound has been used to string together stories in song since time immemorial.

Before mass media, people would get news of the world through traveling bards and minstrels—singers who could remember and recite events by memorizing them through music. Thoughts and words could be recalled by associating them with the tune and tempo of a particular score, allowing the bard to narrate long passages of events made even more dramatic by the tenor and timing of a song. The performance of this prose could conjure imagery in the minds of listeners, making it even more memorable.

Today, music as a mnemonic technique has been used to help memorize everything from the alphabet to sales jingles. Many of these ditties, once they are installed in the brain, are terribly hard to get rid of. The tune tells a story and the story evokes the tune. Imagery associated with them makes a network of neural connections that can last a lifetime.

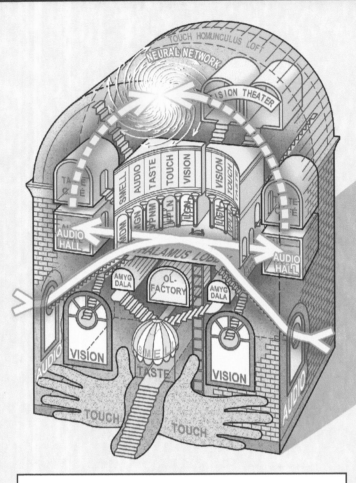

This Emporium diagram shows the auditory input from the ears that travels up through the thalamus, where it is routed to the audio halls before traveling up to the neocortex. From there it is routed to other memory centers and is added to the mix of sensations that reinforces our recollections.

BINGO LINGO

Another vintage mnemonic technique, which combines both rhyme and imagery, is the chant that bingo callers use to call numbers out during a game. Invented in 1929 from an Italian game dating to the 1530s, bingo still enjoys loyal followers who delight in hearing the caller's rhymes designed to help the listener identify and remember numbers in a dizzying grid of numerals. Some examples are:

Number 1. Nelson's Column

Number 2. Me and You

Number 3. You and Me

Number 4. Shut the Door

Number 5. Man Alive

Number 6. In a Fix

Number 7. Slice of Heaven

Number 8. Sexy Kate

Number 9. Dinner Time

Number 10. Big Fat Hen

Most of the above depend on rhyme to be memorable, but some also provide an image. The examples below show memorable visual parodies of the numbers.

Legs-11	Two little ducks-22	Two little fleas- 33
Duck & crutch-27	Snakes alive- 55	Two fat ladies- 88

TOUCH

Our physical bodies are the touchstones of our souls. Sight and sound can be rife with illusory fantasies, but by connecting them to our bodies and grounding those phenomena in a physical space, they become more meaningful. We do this by matching the sense of touch, proximity, and our physical affiliation to things around us with the associations to our other senses. The web of associations is what makes things memorable.

> "We can invent only with memory"
> —Alphonse Karr

The sense of ourselves in space is key to making and using a Memory Palace, for the physical body is essential to comprehending architectural forms and our place in relation to them. Rooms and their objects can become extensions of our bodies by their position and purpose. Our relationship to their functions can reflect the psyche. Kitchens mirror

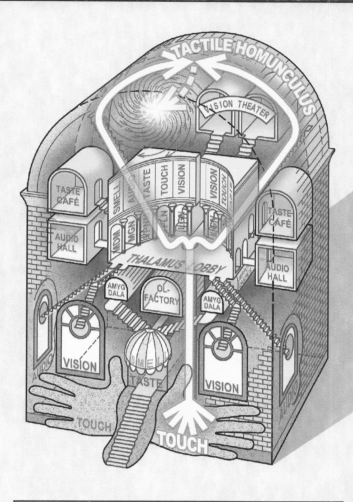

This diagram shows the tactile sensory path. It includes input from the entire body which travels up the spine, then through the thalamus where it is routed to the tactile humunculus that crowns the center strip of the neocortex. From there it is channeled to other memory centers and combines with other memories.

our appetites, bathrooms catch psychic refuse, living rooms reveal our social selves, and bedrooms expose our more intimate thoughts and feelings.

Our physical sense of space ties us to the world around us and helps organize all our memories of that world. That's why we love making 3D paper models so much at the *Museum of Lost Wonder*. Touch ties us to the ideas in a way that no other method can match. The models start with a one-dimensional idea and turn it into a 2D picture, then manifests that image into a 3D

> "Touch has a memory"
> —John Keats

reality to touch and absorb. It's an inter-dimensional exercise that allows all the associative powers that the brain can bring to an idea to make it into a visceral reality.

Make the model that goes with this chapter to see for yourself. *It can also be used as a spatial plan to make a mental memory palace, as seen on page 87.*

SOMATOSENSORY HOMUNCULUS

This curious little figure represents the relative number of nerve fibers and neural connections to the brain in proportion to the size of its body parts.

MINI MEMORY PALACE MODEL

Making the little model that accompanies this chapter will combine the sense of touch with all the other sensory phenomena that go into memorization.

The Universe is Made of Smells

SMELL

By the nature of its primal wiring in the brain, smell can be one of our most immediate avenues to unlocking hidden memories (We'll treat taste as an extension of smell here, as most of this faculty is really sensed through our noses. *That's why food is so tasteless when we have a cold.*) All our other senses get routed through the central lobby of the thalamus first, where they are unconsciously sorted, compared, and edited according to previously laid neural pathways before becoming conscious.

> "Memory is the mother
> of all wisdom"
> —Aeschylus, 500 BCE

Smell is the only sense that doesn't get subconsciously modified by the thalamus, as it's directly wired to the emotionally based amygdalae, which can immediately stir up moving memories from other parts of the brain without revision. That's why smells can be so evocative and bring up haunting events that have been long forgotten. It's our most primeval faculty.

Through smell we get all sorts of hunches about others through our unconscious reading of their pheromones. They can alter our mood and outlook without us even knowing why. That's why perfumes can be so effective and incense is used to inspire our more spiritual faculties.

> "I think it is all a matter of love: the more you love a memory, the stronger and stranger it is"
> —Vladimir Nabokov

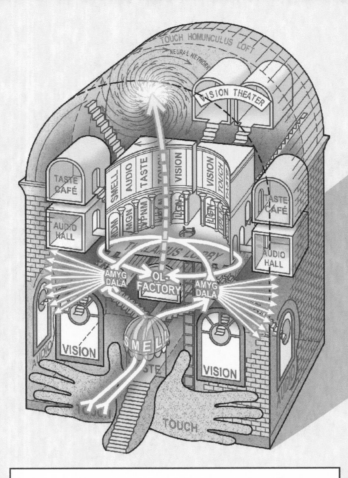

This diagram shows how our sense of smell comes through our nasal cavities, then travels directly to the amygdalae where it immediately reaches out to other parts of the brain. It is then routed to the olfactory terminal and up to the neocortex. From there it is added to other memory networks.

To experience this firsthand, try putting your nose to some rotting garbage or a sewer. See if that doesn't alter your mood in the next few minutes. Then inhale the aroma of vanilla or jasmine, or any other olfactory opulence that you like, and see if that doesn't change your mood for the better. The word smell usually has negative connotations, but using this faculty can also raise us to heights of inspiration. There's an old Hebrew saying that goes, "You may not ever see God, but you might smell him."

> "...as long as my breath is in me, and the spirit of God is in my nostrils"
> —Job 27:3 (ESV)

Our early little mammalian ancestors developed an acute sense of smell to find food at night, when the dinosaurs were sleeping. It's funny how one of our most primitive faculties is now one of our most divine.

The Divinty of Smell

Incubating Your Associations

The mind is a swirling storm of possibilities, full of emotionally charged memories that are drawn to each other by their similarities. Before you begin a creative endeavor—when wanting to court the muse—prime the flow of inspiration by surrounding yourself with things associated with what you want to evoke. You want to create an appropriate mental magnet of materials to draw out fresh ideas that lie inside your head.

> The Brain — is wider than the Sky —
> For — put them side by side —
> The one the other will contain
> With ease — and You — beside —
> —Emily Dickinson

👁 **SIGHT:** Visual memory is the richest source of associative tools we have to prompt reveries and inspire unusual original visions. Gaze at pictures and photos analogous to what you want to create, then look over notes and sketches you've made. Pour over these, absorb them, and let them wander through your neural network to spark fresh ideas. Let them percolate in your subconscious. Even overnight. Allow things to appear the next day.

> "Curiosity is as much the parent of attention, as attention is of memory" —Richard Whately

👂 **SOUND:** Put on music that manifests the mood you want to conjure up. Scary and dangerous, funny or elevated, sad or serious. Your mood is a magnet that will draw other similarly charged thoughts and images from memory. It doesn't even need to be traditional music to capture your imagination. Soundscapes can be equally conducive to the atmosphere you want to conjure. Think of birds chirping, wind blowing, waves crashing, crowds murmuring, footsteps echoing in empty hallways, etc.

> "Time and memory are true artists; they remold reality nearer to the heart's desire"
> —John Dewey

〰 **SMELL:** As we have observed, smell can be the most evocative mnemonic provocateur. Use it to arouse an inspired environment that has the ability to suggest meaningful associations. Surround yourself with scents of emotive times and places that inspired you. Incense, food, flowers, garbage, bleached floors, dusty hallways, fresh clipped grass, fireplace smoke, car exhaust, etc.

> "Intelligence is the wife, imagination is the mistress, memory is the servant"
> —Victor Hugo

✋ **TOUCH:** If all else fails, get out of the house and put yourself in a different environment. Wandering in different spaces can bring unexpected

A 15th century 'Blemmye'

sensory experiences and associations. Getting the blood flowing through your body will boost your brain's ability to come up with new ideas. Try extreme spaces to trigger thoughts—natural and unnatural, open and airy, closed and claustrophobic. Memory can also reside in different parts of your body, and be released by extreme exertion, unusual positions, pressure points or deep repose. The absence of physical sensations can be a surprisingly evocative activity too, by freeing the body and the mind to release the unusual.

'The Incautious Gaze'
—Theadoor Galle, 1601

On the following pages are a number of ancient exercises to quiet the mind, prime the pump, entice your vision, and inspire the creative cacophony that is the nature of the mind. Feel free to experiment, mix and match procedures, and just play.

> "Almost all creativity involves purposeful play"
> —Abraham Maslow, psychologist

Napatation Exercise

They say the emotions are the body's response to our mind, and 'where the mind goes, the body follows', but a reciprocity is also in effect, where our body can help control the mind.

If you want to relax the conflicts in your brain, relaxing the body can have a symbiotic effect on your mind. Relaxing key areas can quiet your thoughts and help stop the internal dialogue, allowing space for more creative thoughts to arise.

Let's explore a simple mind/body exercise, which we'll follow with a purely mental one. Just concentrating on the body can quiet the mind. For this you need to lay comfortably and relax your body sequentially— while counting down from 10-0.

THE BODY QUIETS THE MIND

People hold tension in different parts of their bodies at different times, but there are three key areas that are most linked to the stream of conversation in our heads: one's eyes, jaw, and bottom orifices. You'll find these areas tense up whenever you're in the middle of some inner verbal drama.

As you count down and relax each body part, breathe slowly through them. As you inhale, imagine a warm, glowing stream flowing through those parts from above. As you exhale, imagine this flowing from below. Try to feel this stream as a slight tingle that will stay in that area after you've moved on.

START HERE

10 **FEET~** We'll start at the bottom and work our way up. At each stage, you can start by twitching the body parts to make sure your mind has a good connection to those particular muscles. You can also tense up the muscles, then relax them, to really see the difference. As you get better, you'll probably only need a slight twitch to make sure you're on target. Scan for any muscle tension in your feet, and relax them.

9 **LEGS~** Relax the calves and thigh muscles. Tense and twitch if you need to at first. After a while, just picturing the number 9 will trigger leg muscles to relax. You can also repeat the number with each breath, until you've loosened all the muscles in the area.

8 **TRUNK~** Relax the buttocks, and focus attention on your sphincters. They can hold a lot of tension, and are paired to the verbal drama going on in your head. Breathe a warm glow through here and let them open wide.

7 **CHEST~** Let it drop, and and push out your stomach instead. This will pull more air down into the lungs.

6 **LEFT ARM~** Relax the arm from your bicep to your forearm, then down to your hand and each individual finger. Tense and let go, or twitch as necessary.

Remember to slowly breathe a warm glow flowing through these parts, flowing one way during inhalation, the other way during exhalation.

5 **RIGHT ARM~** Repeat the relaxation sequence with your right arm—working from your bicep all the way down to the your fingers.

Breathe through the parts of your right arm as you repeat the number 5 in your head. Imagine a tingling glowing sensation in your arm and fingers.

4 **SHOULDERS, NECK & BACK~** Drop your shoulders, relax your neck, then search down your back for areas of tension and relax them. Allow your slow breaths to course up and down your spine. At the bottom, check for tension in your sphincters again.

3 **JAW, TONGUE & THROAT~** This speech muscle cluster is intricately linked to the voices in your head. You'll notice them tense up whenever you silently talk to yourself. Unclench your jaw, and relax your tongue and throat. Watch this area whenever the words in your head wander. Relaxing these muscles will help to quiet the verbal thoughts running wild in your brain.

2 **EYES~** This is the third key area whose muscles are connected to the images you may be picturing in your mind while your inner narrator voices its dramatic scenes. Relax all those eye muscles. Breathe through them. Imagine them as empty holes, and let the tingling glow flow through them.

1&0 **ENTIRE BODY~** Breathe the 1s from the top of your head to your toes. Then imagine the 0s as rings that travel up and down your body with each breath—confirming the clarity. Focusing on the body, breath, and simple numbers should quiet the mind so some more creative conjuring can bubble up from below, and is sure to enhance your imagination.

The Tyranny of Words

Now that we've explored the walls and wiring of the Architecture of the Imagination, let's take a look at the ethereal empty spaces of the rooms in our mysterious memory palace.

Memory loves the weird, fantastic and dramatic. It's good for input, but if you want to come up with something new you have to downplay the drama, or else you'll just dig up the same old silly stuff you just may want to forget. To come up with something novel and creative, you have to clear the playing field for different neural pathways to fire up from the subconscious.

> *Silence is the sleep that nourishes wisdom*
> *Francis Bacon*

What you want to try and do is quiet the mind from its usual self-absorbed perturbations of wants and hurts, and just stop it thinking once in a while. To be precise, the trick is to stop talking to yourself. You may not know it, but you do this all the time, even in your sleep. You might think this is a good thing—thinking makes you smart, doesn't it? But not all thought is productive. In fact, most of the time, it's downright silly projections of our primitive, everyday, boring fears and desires. *At least that's what keeps us busy, here at the Museum, most of the time.*

Our Unruly Attentions

Ever have long stretches of time, driving, walking, or sitting, where you forgot where you were or what you were doing, or even what you were thinking? Was it really *you* who was choosing your thoughts?

If you don't choose your thoughts, who or what does? From an evolutionary point of view, it seems advantageous to remember and review emotionally

> *Silence is better than unmeaning words*
> *Pythagoras*

dramatic situations—ones that trigger the 'Four F's: fight, flight, food, and fornication—to learn from our past mistakes and increase our chances of survival.

As abstract language took over from purely sensory feedback, our social egos replaced our physical bodies as our primary selves. And both had appetites and needs for protection. Language, like sensory input, could also stir up emotional memories, triggering the flight/flight response and flooding our bodies with adrenaline and other hormones to prompt us to action in case of emergencies. But they do this at a heavy cost to the brain and body in terms of stress. They were meant for physical emergencies, not day-to-day gob nobbling. With language now protecting our egos, as primitive sensory triggers once protected our bodies, this flood of emotions seems infernally endless, and useless.

So who the heck needs 'em? What good does adrenaline do when we remember a slight from second grade? What's the evolutionary advantage of unconsciously craving crazy conflicts that needlessly stress and hurt us?

> *Much wisdom often goes with the fewest words*
> *Sophocles*

Try stopping your thoughts for a minute. Just a minute. Can you do it? Can you actually sit without voicing a single word in your head? Watch your mind to see if you can. Most of us will find nagging narratives keep intruding—excuses, defences, things to do and crave, etc. Things you really don't need to mull over at the

moment. If you can't stop the words, who *is* putting those passionate little ideas in your head, even when you're consciously trying to stop them? Some evolutionary protection mechanism, or is it something else?

We'd be remiss at the Museum of Lost Wonder if we didn't balance boring science with the marvelous mysteries of mythology—if only because they're more fun and frightening. It's what we really crave, isn't it?

Ancient Extraterrestrial Farmers

There's a variety of myths out there that propose there are any number of ethereal entities that feed off our emotional thoughts and energy. They crave them, and need them for growth. These foreign entities have no bodies, so they have nothing to feel with. No bathos, no pathos, no passion, no feelings. No fun at all—making the heavens rather boring. One of these tales has it that the earth was made as a garden to grow beings that could create this type of energy for harvesting. Apparently, our emotional energy is quite rare, and in great demand in that vast dreary emptiness out there. So from plants to animals to humans, we were bred to produce passion to feed other creatures in the cosmos. Regret, remorse, embarrassment, love, hate, anxiety, etc. Something seems to love them all—at least that what some modern mythologies tell us.

> **Can't see the forest for the trees?** *Has your stream of consciousness turned into a torrent of niggling doubts?* Peruse the following picture and see if it matches the mayhem in your own mind. Towards the bottom, the picture becomes clearer with some helpful hints to restore your 'vision'.

> Many of the phrases were inspired by the book *10% Happier,* by Dan Harris.

It's not easy to stop that incessant stream of trivial tales that invades your brain. But do you really want to be a victim of some primeval urges or foriegn farmers? It might be worth halting the thoughts once and a while, to see if they'll go away long enough for something more marvelous to come through.

MAKING SPACE

To enhance your creative thinking, and add some roominess to the rooms in your Memory Palace, you'll first need to create more space, so that something new can come through. Try this little exercise to see if it doesn't work for you.

Sit comfortably, close your eyes, and clear your head for a moment. Tell yourself to save all those little nagging thoughts for later. Focus on physical sensations instead. Relax. Focus on your breath, but breathe naturally. Feel your chest rising and falling. Feel the air swooshing through your nostrils. In…out…in…out…in…out.

To keep words from entering your head between breaths, go back and scan for previously tense spots. Especially your jaw, tongue, and eyes—the parts that want to produce words. Check your posture—relaxed but straight. Listen to the sounds around you, but don't let them trigger any thoughts of what they might mean. Just note them. Focus instead on physical sensations.

See what happens in the blank space in front of your eyes. There are plenty of fun non-verbal things you can do that don't take words to be diverting.

Watch the colors change when you close your eyes. Or picture something simple, like a blue horizon or ripples of water fading into nothing

The trick is not to get caught up in the drama of the verbal narrative that wants to invade your brain. When pesty thoughts come up, just notice them. They'll really be begging for recognition, so just note them for what they are; a worry, a care, a regret, a hurt, a defense, a revenge scenario, what you should have said when someone upset you, etc, etc, etc. Don't get caught up in the conflict that let these little scenes spin out of control. Just note them and tell them you'll get to them later. Try to set up a 'watcher'—a piece of your mind that'll will remind you when nagging thoughts creep in. It will help remind you to let them pass and get back to your breathing. This is a matter of intent. Intend to notice the nattering of words when they happen, and the 'watcher' will remind you to stop them.

Our souls seem to crave drama. It's the backbone of our arts, entertainment, and news industries. Conflict and criticism somehow seem meaningful to us. But are they really useful *all* the time?

Practice Makes Perfect

The mind may crave drama, and memory may love fatuous foolishness, but to come up something new and creatively useful, you'll need to break the primitive habits your mind has given you and find a place for novelty to play. Try stopping the the internal dialogue for just five minutes a day, just

to see how invasive and unncessary many of our thoughts can be. Doing it daily will increase your awareness of the 'wretchedness of words' and help you appreciate the peace and creativity the free space offers. The mind responds to exercise just like the body. Increasing the length and frequency of your sessions will bring better results. But you don't need to get religious about it—you also can practice wherever you are. At a stoplight, in the grocery line, waiting for anything is a great time to get in gear. You don't need to go blank, your senses and awareness will actually be heightened when they're not distracted by the usual disruptive mental mish-mash. It can be especially helpful when trying to fall asleep at night—when you're plagued by the concerns of the day.

You don't need to tie yourself in knots. Just sit or lay comfortably, where you can let all your tensions go without falling asleep.

So do as best you can to clear some room so new ideas can bubble up. Occasionally, the words that break in may be helpful, insightful ones, *This is why 'noting' your thoughts is a good practice.* The voice will be different. It won't be the usual rush of senseless stories, but short concise ideas or directives. You can even ask it questions. You may find the answers surprising. And isn't that what creativity is all about?

Mining the Dream

If the previous exercises put you to sleep, that's OK. Sleep is when the brain ferments, incubates, and re-cogitates the day's input and obsessions to come up with new ways of seeing the world. It's the deepest well of inspiration we have. So another tool in our arsenal of creativity exercises is dreaming. Dreaming is another age-old maneuver to mine the subconscious for unexpected and novel ideas, dramatic stories, and visions that are particularly personal.

☑ Charge your thoughts before you go to sleep. Ruminate on ideas and images you want to summon. Ask for dreams about your current passion, then clear your head and go to bed. Let those nascent notions incubate. The two emotionally based amygdalae go ballistic during the dream state and charge our dreams with drama to make them more memorable.

☑ Keep a notepad by your bed to catch any snippets of dreams that occur. Don't try to describe the dream, just write short word titles in the dark, so you don't have to fully wake up. These notations will help stir your memory in the morning.

☑ Upon sensing you're awake, stay in, or return to, the position you woke up in. This is your dreaming position, and another associative link to the world you were just in. See what dream memories come to you then.

☑ Before getting up, focus on your dream and try to remember as much as you can before getting up and writing it down. Be careful not to go back to sleep. This hypnopompic state is very a fragile one.

☑ Once up, write down as much as you can remember, and sketch what you've seen. This will bring up other associations that you should write down too, plus thoughts on what might have inspired the dream.

☑ Wait for other ideas to bubble up in your morning bath or shower. Focusing on physical feelings for the moment will stop the onslaught of nattering thoughts, and clear your head so things can simmer up from the subconscious.

The next time you court the muse, remember that memory is the mother of the muses, and creativity draws upon our past for its inspiration. Memory works best by association, not by repetition. The more sensory modalities you have to a memory, the better you'll be able to retrieve, re-associate and create with it. The more emotionally charged a memory is, the more it will be able to inspire you. The most inspired memories are not in words, but in images charged with feeling.

The verbal cerebral cortex could not exist without inspiration from the emotional limbic system at its core, and it couldn't survive without the reptilian brain stem or a nervous system sending signals from the senses throughout the body that supports it. Our souls would be boring wandering waifs without the visceral sensory input that provides us with emotion and inspiration.

Mnemosyne is the mother of the muses. She is the personification of memory and creativity.

SUGGESTED READING

The Art of Memory: Yates, Frances A. 1966, University of Chicago Press, Chicago, IL

The Book of Memory: Carruthers, Mary. 2001, Cambridge University Press, Cambridge, UK

Committed to Memory: How we remember and why we forget: Rupp, Rebecca. 1998, Crown Publishers, NY, NY

In the Palaces of Memory: Johnson, George. 1991, Random House, NY, NY

Tickle your Amygdala: Slade, Neil. 2012, Brain Book Books & Music, Denver, CO

Mansion of the Mind
model instructions

BUSY HANDS
ARE HAPPY HANDS

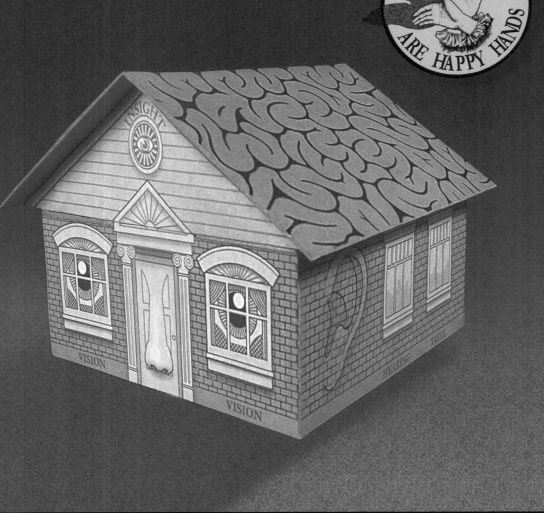

"The hand is the cutting edge of the mind ... The most powerful drive in the ascent of man is pleasure in his own skill."
~ Jacob Bronowski

The Meaning Behind the Model

This little paper model embodies a lot of big ideas—it is a map of the mind, a key to the subconscious, and a minute Memory Palace, as well as a physical object to help you visualise your imagination.

Use it as a Dreaming Key

As a map of the psyche, each room in the house represents an aspect of one's personality:

The Living Room deals with daily life and your attitudes towards casual friends, work associates, acquaintances and strangers. It's the greeting area where you invite in the outside world.

The Dining Room addresses more intimate relationships between close friends, family, and partners.

The Kitchen highlights changes in your life, and how you deal with, prepare for, and nourish those adjustments.

The Bedroom is where your most intimate issues and relationships are exposed and experienced.

The Bathroom unearths frustrations you need to let go of.

The Stairs connect your conscious and unconscious selves.

The Basement is where your hidden fears and foibles hide.

The Attic holds your higher thoughts, hopes, dreams, and aspirations. It is home to the imagination and where one's muses reside. You'll need to call on these when you design a Memory Palace to conjure your creativity.

Use it as a Memory Palace

The model also creates a framework for a mental house tour—you can create a path from room to room, adding your own symbols and distinctive imagery to the spaces. This technique is called the Method of Loci, and a useful tool for remembering a sequence of words or events. You can use your own home's layout, or adopt the room sequence shown in the model—the key is to picture the rooms as life-size and put yourself into the environment.

Decide on a series of words, thoughts, or events you want to remember. Then visualize a curious, even outrageous, object/image that encapsulates each one. The more unusual and striking the symbol, the easier it will be to recover later. Acronyms can be helpful, too. For example, if you wanted to remember the Department of Defense (DOD), you might picture a dodo bird, as the spelling and image trigger the acronym.

Place these symbols in the rooms of your Memory Palace, then create a path between them that follows the sequence of thoughts you want to recall. Place your objects on furniture or hang them on the wall. Finally, take a tour along your pathway and visualize the objects as you walk through the house. As you 'see' the objects you've placed, the thoughts they represent should pop into your head.

ASSEMBLY INSTRUCTIONS

1 Score all the fold lines first, using a dull blade and a straight edge. Then slit both slots and finally cut out the shape.

2 Fold and crease fold lines, making sure to crease the roof hinge line well, (indicated in diagram), so it bends up freely.

3 Flip sheet upside down, fold and crease the eave tabs, then glue them in place to their adjacent roof panels.

4 Bend up the right roof panel **with the ridge tab**, and glue in place to the front gable. (Use a pencil to push the tab to the inner corner, and secure.)

5 Bend up the second roof panel, and glue in place to the front gable, as well as the ridge tab. *Note: You'll have to do this quickly, before the glue dries. Be sure to load up tabs with glue beforehand.* For good adhesion, push a pencil inside the roof to secure the tabs in the front and top.

6 Bend down the left rear gable and glue to the rear of the house. *Note: Make sure to align the bent dashed lines evenly.*

7 Glue the right rear gable to the rear of the the house on the opposite side, along the dotted 'place line'. To ensure alignment, crease the glued fold before it dries.

8 Bend and glue the side walls together, one at a time. *Be sure to glue both sides of the end tabs, and wall edges.*

9 When the side walls are dry, glue the house front to the side walls. *Be sure to glue both sides of the end tabs.*

10 Align the two back basement pieces. Glue the left one to the back first, then glue the right one on top of that.

11 Fold down the roof and secure the front tab into the top slot. The tab should be snug. If it's too large, worry the tab edges a little with your thumbnail. You're done!

ASSEMBLY DIAGRAMS

1

2

3

5a Sheet shown
 upside down 4

5b

6
7a

7b

8

9

10

11

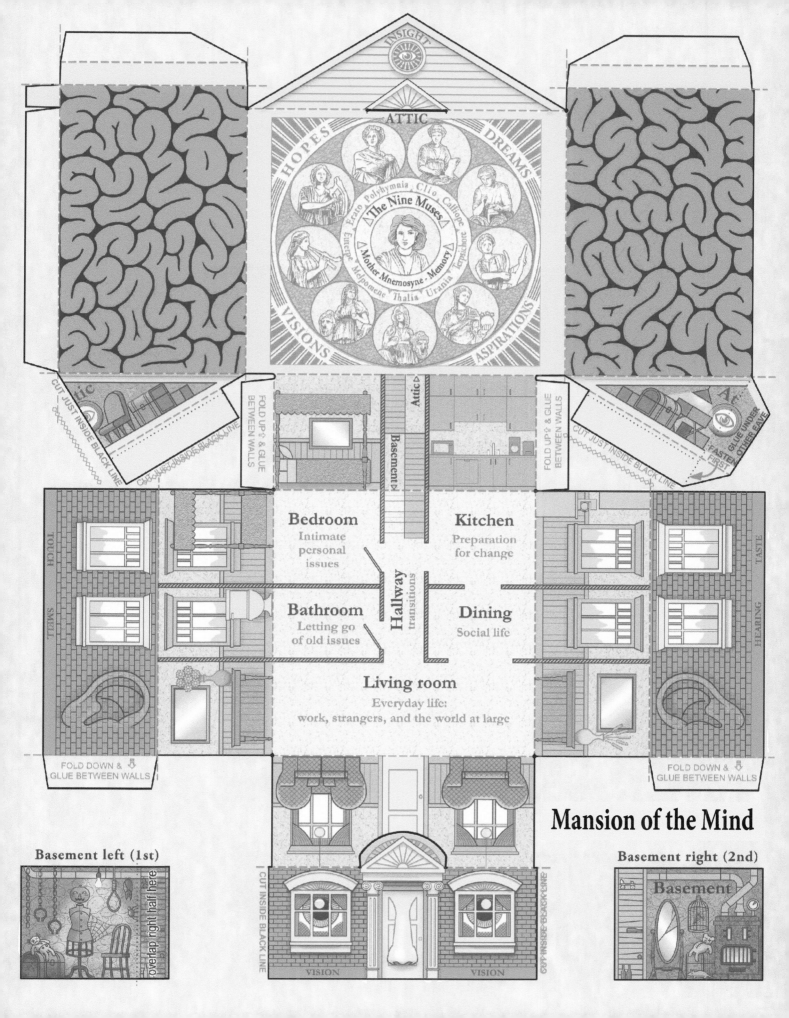

INSIGHT

ATTIC

HOPES

DREAMS

△ The Nine Muses △
Erato Polyhymnia Clio Calliope
Euterpe Terpsichore
△ Mother Mnemosyne - Memory △
Melpomene Thalia Urania

VISIONS

ASPIRATIONS

CUT JUST INSIDE BLACK LINE

Attic

FOLD UP↕ & GLUE BETWEEN WALLS

Basement

FOLD UP↕ & GLUE BETWEEN WALLS

GLUE UNDER OTHER EAVE
FASTEN FIRST
CUT JUST INSIDE BLACK LINE

TOUCH

SMELL

Bedroom
Intimate
personal
issues

Kitchen
Preparation
for change

Hallway
transitions

Bathroom
Letting go
of old issues

Dining
Social life

TASTE

HEARING

Living room
Everyday life:
work, strangers, and the world at large

FOLD DOWN ⇩
GLUE BETWEEN WALLS

FOLD DOWN ⇩
GLUE BETWEEN WALLS

Mansion of the Mind

Basement left (1st)

overlap right half here

CUT INSIDE BLACK LINE

VISION

VISION

Basement right (2nd)

Basement

Dream Palaces

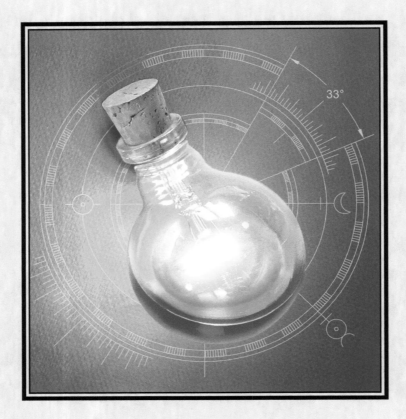

How is an idea idealized?

Dream Palaces

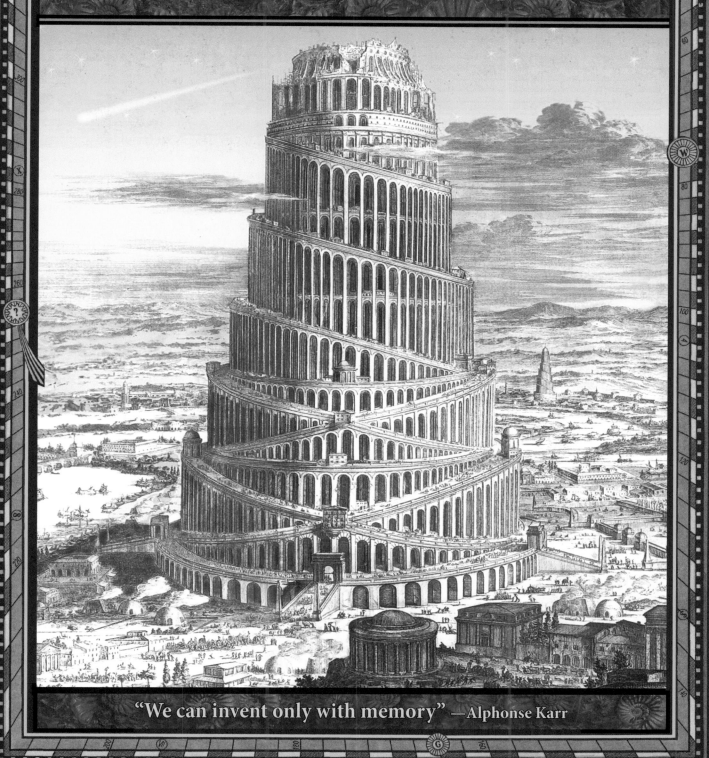

"We can invent only with memory" —Alphonse Karr

Dream Palaces

This is the realm of myth, not science, though it's said we need both to survive. Myth is not where science ends up, but where it begins—as an inspiration to figuring out what might be out there and why. We'll use the 'soft' sciences—history, philosophy, anthropology and psychology—as tools to help us understand the need for myths that move people to visualize better lives and connect them to something greater. Myth is the art of storytelling. To make stories memorable, they must have drama—this takes our doubts and fears and transforms them into something positive and meaningful that connects us to the unknown beyond ourselves.

At times, we all fear the unknown or the future, but our imaginations can also bring us hope. We use the pains of our past experiences to help us imagine a better present. That's what Dream Palaces were meant for—to help us construct a better future from our pasts. We build an edifice out of the ideas we know will protect, comfort and inspire us to embrace the unknowable.

People have been creating Dream Palaces since time immemorial, using myths as a springboard for their own narratives. To be memorable, these imaginary palaces have to be rooted in the experience of the physical senses. Visions start from a desire to connect the 'above' with the reality of one's experience 'below'. Thus, Dream Architecture is an expression of our physical needs that is projected into a mental model of an ideal world for them to dwell in—acting as both as a buffer and a way for us to integrate with the world beyond. Dream Palaces feature in both Eastern and Western traditions. Some are romantic, some religious, some practical or fantastical, while others are scientific or even satirical. So we'll explore a range of Dream Architectures to discover the universal connections between them.

Dream Palaces are three-dimensional metaphors, linking the microcosm and macrocosm. They endeavor to find parallels between the human body and the cosmos, using the geometry of architecture as a method of binding these together. This divine geometry has its source in antiquity, and has been used for centuries to measure man and organize his ideas while connecting him to the geometry of the universe.

Da Vinci's Vitruvian man
Man—nature—architecture

As creative constructions, Dream Palaces are inextricably linked to Memory Palaces, since both mental imagery and creativity have their source in memory. Because of this intimate relationship, we'd be remiss if we didn't start our exploration with the first recorded Memory Palace, said to have been created by the poet Simonides of ancient Greece. His story was told by the Roman orator Cicero. Before it was common to carry around paper and pencils to jot down notes and sketches, speakers like Cicero had to memorize a vast range of complex ideas and hold long stories in their minds alone. They found that visualizing a palace and linking ideas to the architectural features of the interior with visual metaphors, then mentally walking through the space, helped them remember information in a specific order.

> "Memories are the key not to the past, but to the future"
> —Corrie Ten Boom, *Dutch Author and Holocaust survivor*

Simonides' story is especially relevant, as it shows the importance of employing the human form in dramatic situations when constructing a Memory Palace. Linking the body to the ethereal beyond through architecture is key to many Dream Palaces, too. Both structures have their roots in mythic metaphors that make life meaningful.

ABOUT THE IMAGE : Tower of Babel by Anthanasius Kircher—1679

This colossal edifice is the granddaddy of all Dream Palaces. A veritable stairway to heaven, the Tower of Babel was built by the descendants of Noah to connect the world below to the heavens above. Like all Dream Places, its architecture is an expression of how people view their place in the world and how it connects to the worlds above.

The First Memory Palace

BEFORE

Simonides' dinner before the calamity. Here we see your typically raucous Greco-Roman dinner party, with guests rolling around on their bellies while stuffing themselves.

AFTER

After the destruction of the dining hall, Simonides had to recreate the geometry and people placement in his mind in order to identify the completely disfigured bodies within. This first Memory Palace must have looked something like this. >>>>>>>>>>>>>>>>>>>>>>>>>>>>>>>>>>>

DINNER OF DEATH

In the colorful tale told by Cicero, the poet Simonides is invited to a typical Greek dinner party by a patron. He recites verse about his favorite mythological heroes, Castor and Pollux—the divine twins from legend. His drunken patron doesn't care for the verse, and casts aspersions about the twins supposed heroic deeds. Soon after, Simonides is called outside by two mysterious figures. While outside, the roof of the dining hall collapses, raining rock and rubble on everyone within it. The bodies are so crushed and disfigured that the authorities find it impossible to identify any of the remains. To help with the investigation, Simonides reconstructs a model of the dining area he was just in, along with the exact position of the guests he entertained. This allows the authorities to identify the remains so they could be returned to their families.

Castor and Pollux spirit Simonides away before bringing down the house

Simonides' mental model of the tragic event—and the first Memory Palace

Simonides' visionary creation, born out of necessity, became the first Memory Palace on record—and also made Castor and Pollux the patron saints of performers who have to bear the rants of drunken patrons.

Distinctive characters and direct drama are crucial building blocks of a good Memory Palace.

Theater of the World

DaVinci's Vitruvian man

Memory and Dream Palaces have their origin in the imagination, but it is drama that keeps them alive in the mind. A clear example of this is Shakespeare's Globe Theater. Although built of bricks and mortar, the function and form of the theater reflect a foundation in myth and mysticism. William Shakespeare saw the stage as a microcosm of the world, where mythic forces affect the actors on the stage.

The Globe Theater in London has its beginnings in 1599, but its form owes a debt to the machinations of one mystic's design for a Memory Palace.

was seen as a median between man and nature, and its proportions reflected both the measure of man and the order of the universe. Sacred geometry was the principle that linked them both.

After the first incarnation of the Globe Theater burnt down in 1613, the English hermetic philosopher, Robert Fludd, recreated the design from contemporary accounts and his own knowledge of esoteric geometry. He found its

Globe Theater today
This paper model demonstrates the theater's classical geometry

The Globe's Sacred Geometry
As based on the writings of the visonary Robert Fludd

The Renaissance saw a resurgence of neo-Platonic mysticism from centuries before. Human proportions were reflected in classical buildings, especially theaters, whose productions were thought to embody moral tales between deities and humans. Renaissance builders took inspiration from classical architecture, particularly the works of Vitruvius, a Roman architect. It was Vitruvius who inspired Leonardo da Vinci to create his famous Vitruvian Man (above). Vitruvius had a particular affinity for the sacred geometry of Pythagoras and Plato—as did the astronomer Johannes Kepler, who saw it in the structure of the solar system. To Vitruvius, architecture was an imitation of nature, and he believed the workings of the human body were an analogy for the workings of the universe. Architecture

Rennaissance magic man

symbolic design elements were perfect for creating his own Memory Theater to link the microcosm of the mind with the macrocosm of nature though patterns of geometry. Memory Palaces function best when constructed from something familiar to their maker's mind, and the dramatic function and form of the Globe Theater suited Fludd's needs perfectly.

After the fire, the Globe was rebuilt—influenced by Fludd's ideas—from the astronomical ceiling above to the layout of the stage below. The theater was pulled down in 1642 and not seen again until 1997. Although it was rebuilt using elements from many sources, its present day form still owes much to classical divine geometry and Robert Fludd's Memory Palace.

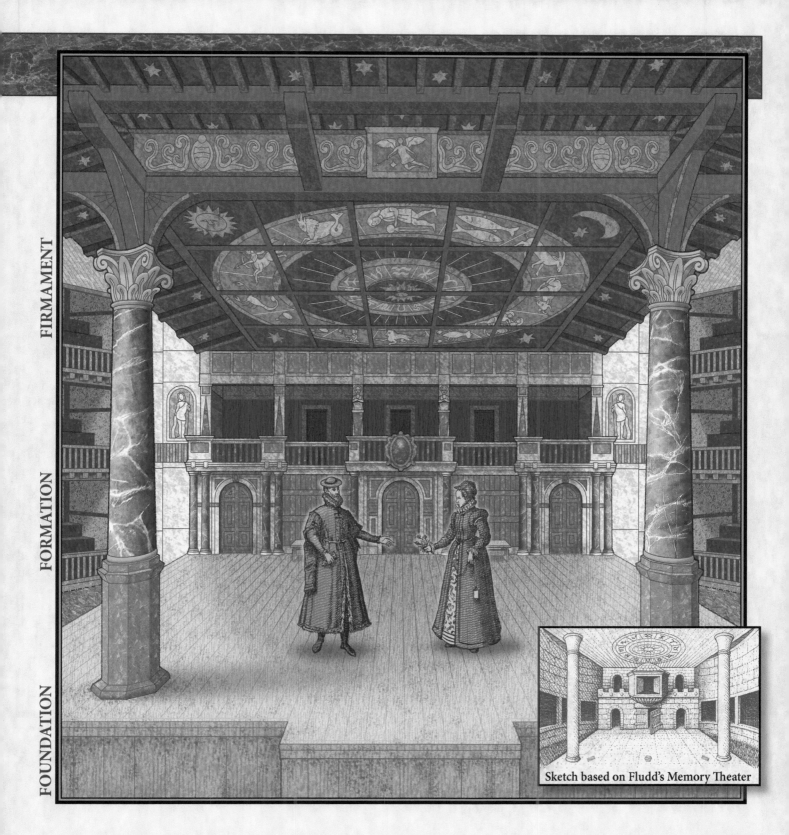

FIRMAMENT

FORMATION

FOUNDATION

Sketch based on Fludd's Memory Theater

"All the world's a stage...

...and all the men and women merely players." Shakespeare's quote has real resonance here, especially if we rephrase it as 'the stage is all the world'. For this is what was in the mind of the Renaissance architects who built the Globe when they took inspiration from sacred geometry of antiquity.

This view of the Globe's stage represents the world, or *Foundation*. The ceiling represents the heavens above of *Firmament*. In the middle is all of human activity, or *Formation*, that seeks to bring heaven and earth together. The two columns that hold up the Firmament echo the twin pillars, Jachin and Boaz, of King Solomon's Temple, which we'll look at next in our tour of Dream Palaces.

Heaven on Earth

In the West, Dream Palaces have their beginning with the building of King Solomon's Temple, a divine structure created in the memory of Moses, 3,000 years ago. The result of a divine revelation, it was conceived as a microcosm of creation and the confluence of heaven and earth—a symbol of corporeal perfection. Its layout has been employed for ritual purposes by Western mystics for ages.

A less well-known facet to the story of Moses picking up the ten commandments from God in the 13th-century BCE is that he was also given detailed architectural plans to build a comfy place for the creator to reside, should he decide to visit sometime. The building was also to be a home for the tablets the commandments were inscribed on, held in the Ark of the Covenant—another memory vessel.

Wandering around in the desert for decades, Moses' folks didn't have much in the way of construction materials, so they used the tent fabric and poles they had to create a structure called the Tabernacle—a portable tent dwelling for the divine presence. Three hundred years later, the Jews finally got to build their Dream Palace in Jerusalem under King Solomon. Built according to the same floorplans they'd been carrying around for centuries, King Solomon's Temple replaced the humble Tabernacle as a dwelling place for the deity.

The Temple was destroyed by Babylonians in 586 BCE but, to gain favor with Jerusalem's Jewish population, the Roman King Herod rebuilt it around 20 BCE. It was destroyed by Romans again about 70 AD, but one of its walls remains. It's known as the Western Wall or 'Wailing Wall' after the people of many faiths who come to pray next to it. Many wait for the third Temple, a New Jerusalem, to be built on Mt. Zion at the Dome of the Rock, the place where Abraham is said to have been told to sacrifice his son. This spot has been the site of an Islamic palace since the 8th-century AD,

King Solomon's Temple

Built from 3,000-year-old floorplans, this temple forms a template for creation—from our bodies below to the heavens above

so negotiations still continue about the floorplan. It may take a while, considering the real estate has been fought over since the Crusades.

Moses' original plans have been one of the most popular sacred layouts in the Western world, and they have been re-created in various forms by secret societies ever since. The Freemasons base their temple plans on them, and many use the two emblematic columns that are part of the design—Jachin and Boaz.

Symbolically, Solomon's Temple represents a geometric re-creation of the Garden of Eden—the world's first sanctuary and a meeting place for the divine. Architecturally, it is a way to re-create an ideal world—a replica of God's heavenly abode and a physical representation of the entire cosmos. Its pattern matches the 'above' with the 'below', as its plan also contains associations with the human body. The architectural floorplans were a symbolic link between the structure of our bodies and minds and the geometry of the cosmos. As a Memory Palace, it holds a secret link from our subconscious to our collective consciousness.

NEW JERUSALEM

The Biblical book of Revelation describes the third Temple of Solomon as an entire city called the New Jerusalem. It's envisioned as an impossibly large cube–half the size of the United States – that reaches past our atmosphere into space. The largest Dream Palace ever imagined!

TEMPLE AS BODY

Searching for a connection to the world outside ourselves and beyond, we have used the human body to understand the pattern of creation from the beginning of time. Architecture has always been an intermediary for expressing our connection to the cosmos—matching the mystery of our own bodies to the mysteries of the universe helps us better understand both.

EAST MEETS WEST

This Indian temple plan shows how many ancient Hindu sites translated the human body into architecture to create a symbolic representation of the cosmos.

BODY AS TEMPLE

This diagram is an extension of the temple plan on the left. The numbers on the body correlate to those on the different sections of the building plan. The correspondences are similar to Eastern Chakras, but instead of energy centers, the parts of the temple relate to parts of the body that sense or are similar to the function of the temple objects they refer to.

Palace in the Sky

Western traditions of Dream Palaces travel to the East in the tale concerning the travels of St. Thomas. 'Doubting Thomas' was the apostle who doubted Jesus' resurrection until Jesus re-inhabited his corpse to let Thomas stick a finger in his wounds. Thomas had no doubts after that neat little trick!

'The Incredulity of St Thomas' —Carravagio (1602)

When the apostles disbanded, St. Thomas was sent to the far East to evangelize India. He arrived along the east coast of the country in 52 AD. Even today, Goa still boasts a large Christian population that is said to have been founded by St. Thomas.

Famous as a carpenter, Thomas was brought before King Gondophares, who commissioned him to build a palace. But Thomas put down his carpenter's square and hammer, and instead took the lucre and purportedly gave it to the poor. After a good deal of time, King Gondophares asked Thomas where the palace was and where the money went. Thomas said it had been finished, and was awaiting the King's arrival in heaven. Furious, King Gondophares put Thomas in a nasty prison and planned to flog and burn him. (A typical thought had by anybody burned by contractor's excuses, even today!)

St Thomas — visionary carpenter

That evening, the King's brother, Gad, died while Thomas was in prison. The angels showed him the local real estate in heaven, and asked him where he'd like to live. Gad saw the palace that Thomas had built for his brother, and said he'd love that heavenly piece of property. But the angels said it was not available, because it was built for Gondophares and awaited his arrival when the time came. Gad entreated the angels for help, so they revived him when king Gondophares went to visit his brother's body. Reinhabiting his body, (just as Jesus did for Thomas years before), Gad asked Gondophares if he could buy the palace from him. Overjoyed by his brother's revival, Gondophares forgave Thomas, and he and Gad were baptized by Thomas and became Christians. Their story ends there, but we hope that, when his time came, Gondo shared his sacred abode with his brother.

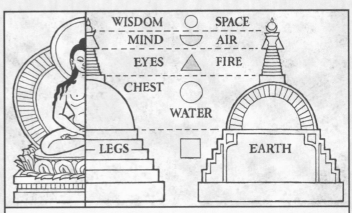

Indian sacred architecture from the 1st-century AD, reflecting the microcosm and macrocosm of the cosmos

Being a good carpenter and wanting to cater to his clients' tastes, Thomas most likely would have built something similar to the local sacred architecture in 1st-century India—the stupa. Stupa architecture dates back 1,500 years, and can be seen reflected in everything from pagodas to mandalas. Like other Dream Palaces, the stupa is based on sacred geometry, symbolizing the structure of the cosmos (the macrocosm) and the related structure of the human body (the microcosm). Stupas varied in shape and size, but all shared elements of specific layered shapes reflecting their relationship to the basic elements of the worlds above and below.

As mental constructions, Dream Palaces are meant to be symbolic of things greater than bricks and mortar and a comfy place to live. As architecture they are intermediaries between our bodies and the universe beyond, often exemplifying how we fit in the scheme of things.

King Gondophares' portrait lucre that he used to buy the palace below.

Coin courtesy of the British Museum

Doubting Thomas' Palace in the Sky

Nobody knows what kind of palace Thomas might have built for King Gondophares, but we assume he would have built something in the local vernacular of sacred architecture. The vision above is based on the great Stupa of Sanchi—a marvel of construction that was built 2,000 years ago and still stands today. Like Tibetan Mandalas, stupas were constructed on sacred geometry, and were chock full of cosmological symbolism.

Portal to Other Dimensions

The East also has its own tradition of ethereal palaces, as seen in Tibetan Mandalas. The word mandala literally translates 'wheel of time', but in practice it is a graphic embodiment of an entire realm, or dimension, to discover.

Different mandalas embody different teachings and realms to explore. The basic form of most mandalas is a series of concentric squares with four 'gates' into them, surrounded by circular auras. The thangka paintings of mandalas we're used to seeing are actually floorplans for palaces that house deities with specific teachings.

At the core of tantric mandala practice is using these floorplans as a focal point to mentally construct these palaces in the mind and visualize them in the third dimension. When the practitioner can mentally project them at life size, it is possible to enter the intricate structures and journey through the rooms and corridors to meet the deities that reside there. The deities confer knowledge and their own spiritual teachings to each initiate who encounters them.

One of the most sacred mandalas is the Kalachakra, which embodies ancient mystical teachings that are still practiced today. The present Dalai Lama hosts a public festival every year in different places around the world. Over the course of a number of days, initiations and teachings are conferred. It's a tradition that goes back 2,500 years.

The Kalachakra Mandala

This is a sand mandala created by Tibetan monks over a period of several days at the Field Museum in Chicago in 1991. The monks' signatures appear in the corners. The outer rings of the mandala symbolize the five elements that surround the ethereal realm and include the names of the deities that lie within. In the center is the floorplan for the temple, along with other details you would find in the temple when it was built and visualized in the mind.

Kalachakra Mandala in 3D

This 3D Kalachakra mandala was built by the Tibetan monk Arjia Rinpoche. Its five levels represent the body, speech, mind, bliss and, at the tip, wisdom—where the principal Kalachakra deity resides.

116

The Sangwa Dupa Mandala

This is an extremely rare photo of the Sangwa Dupa mandala, which represents one of the highest tantric practices. Its tradition focuses on the primordial Akshobhya Buddha, and symbolizing the essential unity of all Buddhas (enlightened ones).

This marvelous 3D mandala lives in the Dalai Lama's main temple in McLeod Ganj, northern India, the capital for the Tibetan government-in-exile. It was shown to me by my monk friends who made the sand mandala at the Field Museum shown on the previous page. It's kept in a tiny storeroom, so the picture above was assembled from 30 separate close-ups taken from different angles–much as practitioners would build up a picture of a mandala in their minds from multiple views.

This precious metal mandala is brought out for ceremonies to honor the deities it contains and to help the initiated visualize.

The Interior Castle

Sexy St. Teresa by François Gérard—1827

East meets West in the visionary palace described in a book by St. Teresa of Ávila written in 1577. Like Tibetan mandalas, it pictures a spiritual journey by imagining a grand citadel that one travels through to reach enlightenment. This journey is taken in seven successive stages, as one enters the first level and then travels inward to finally reach union with the Spirit at the castle's core.

St. Teresa was a Spanish mystic born in Ávila in 1515. She was a very normal and ordinary little girl of fourteen when her mother died. Grief stricken, she buried herself in popular fiction about handsome romantic knights having adventures in medieval castles.

At sixteen, she entered a Carmelite convent school and within the first year became seriously ill—plagued by intense pain and malarial fevers. During these episodes she started having visions. The pain became 'ecstasies', which were often erotic in nature—she imagined these ecstatic visions as a courtship with God, with dreams of a final 'spiritual' union. In one of her visions, she experienced an exceedingly handsome little angel piercing her heart with a phallic golden spear, its iron tip sending her swooning into an ecstatic trance. She wrote, "The pain was so great, that it made me moan; and yet so surpassing was the sweetness of this excessive pain, that I could not wish to be rid of it."

The Inquisition was still in full swing at that time, and Teresa's divine visions were denounced as demonic by jealous local clergy. After practicing mortifications, including self-flagellation, the charges were commuted... Kinky. These visions continued throughout Teresa's life, along with apparent miracles. On more than one occasion she was witnessed levitating during mass. Embarrassed by these public displays, she asked her fellow nuns to sit on her to keep her from floating away.

In later years, Teresa wrote about her spiritual path, recounting it as a heroic journey through an imaginary castle —just like the pop fiction she read as a teen. She published her book, "The Interior Castle", in 1577. In it she described the path to enlightenment in seven stages. Just like Tibetan mandalas, these stages are reached by entering successive concentric mansions in a mentally visualized palace. One gains entrance to the palace by prayer and meditation. As the journey inward and upward continues, each stage of the practice is met with trials and tribulations, but also teachings and mystical abilities. One graduates to each level by intensified trance-like prayer and meditation. Teresa saw this as a romantic journey, with love and devotion growing at each stage. She also saw it in erotic terms, where one's pains in the practice of 'dating' the deity are gradually transmuted into swooning ecstasies.

'St. Teresa in Ecstasy' by Bernini—1652

In the beginning of the Relationship, one works hard to gain the attention of the beloved. In later stages, a courtship develops and deepens into a passionate marriage. The final stage is symbolized by an intimate 'union' that culminates in ecstasy. How romantic!

Teresa died in 1582 and the local clergy immediately gathered up her belongings, and even body parts, to show off as relics to the faithful. Her rosary beads, the whip she used to flagellate herself, and even her little finger were enshrined and put on view in the convent in Ávila named after her. Years later, the local bishop even dug up her body to cut out her heart with an iron blade, just like the erotic angel once did. Her heart and arm can be seen in the Carmelite convent in the nearby town of Alba de Tormes. Guess you can never have enough body parts to help bring in the tourist dollar!

St. Teresa's transverberated heart is still on view today

St. Teresa's Interior Castle was made of seven concentric rings. Each ring brought one closer to ecstasy, with the deity at the center. It's a progressive spiritual journey in seven stages:

1. Entrance level for the novice initiate, where one is still attached to worldly affairs
2. Regular practice of prayer and meditation begins in earnest.
3. Daily practice continues and becomes easier and deeper. Confidence is gained by feedback from the beyond.
4. Sudden growth occurs. Beginnings of deep contemplation and the first mystical states are achieved.
5. Mystic contemplative states become normal. One feels like a stranger in the world. Dreams of final union begin.
 Teresa describes this as a courtship.
6. Extraordinary phenomena begin to occur. Great courage and sobriety are needed to continue on the path.
 This stage is seen as the marriage with the Spirit.
7. Raptures are replaced by a clear understanding, and moments of merging with the Spirit.
 The final stage is seen as an ecstatic spiritual union.

Palace of the Stars

This Dream Palace was not just a heavenly dream, but a vision to see into heaven itself. It was built in a time when astronomy, astrology, and alchemy were inseparable, and was the first observatory of its kind. These were heady days for astronomy, before the telescope was invented, when the heavens were accurately charted using only ancient devices. The palatial buildings themselves were astronomical instruments and, like the surrounding gardens, were laid out according to esoteric geometry that sought to resonate with the heavens.

Brahe's eccentric 'geo-heliocentric' universe

Uraniborg was built on a Danish island in 1576, and named after Urania— the muse of astronomy. It was the dream of Tycho Brahe, a Danish nobleman said to be the 'greatest naked-eye astronomer in Europe'. Without a telescope, Brahe charted the positions of hundreds of fixed stars, and made the most accurate observations up to that time. Tycho rejected the geocentric universe and the new Copernican heliocentric one. Instead, he came up with his own 'geo-heliocentric' mix, which kept the earth and moon at the center, but put everything else revolving around a sun that orbited the earth. Both an alchemist and astronomer, Tycho was an incredible character, who sported a brass nose after losing his own in a sword fight at 20, over a math quarrel with a fellow student. At Uraniborg, he also kept a little psychic jester named Jepp, and a prized elk that met its end by falling down some stairs after drinking too much ale.

Uraniborg was Europe's first astronomical observatory and research institute, bringing

Uraniborg showing its divine symmetry and alchemical gardens

Brahe with brass beak

together over a hundred researchers over its 21-year lifespan. It had two structures—a palace surrounded by gardens and an adjacent underground observatory called the Stjerneborg, or 'Star Castle'. It was the NASA of its time, and cost 1% of Denmark's total budget to complete. Though lacking a proper telescope, it incorporated huge armillaries, astrolabes and multi-storied quadrants that were built into the buildings themselves. Uraniborg also had its own alchemical laboratory, which used botanical specimens from the surrounding gardens. The gardens had an esoteric geometrical layout to resonate with the mathematical harmonies of the universe. In fact, all of Uraniborg was built on ancient principles of sacred geometry to mirror the heavens.

Just like the Globe Theater, Uraniborg's Renaissance architectural proportions reflected the order of the heavens, the earth, and the related harmonies of the human body. Like Da Vinci's Vitruvian man, it was built on Platonic geometry of circles and squares to symbolize the overlapping spheres of matter and spirit. The designs were a cosmological model meant to evoke beneficial astral influences intimately linked with the purpose of the observatory complex. It was a microcosm of the macrocosm it was created to explore.

Uraniborg was destroyed after Brahe's death in 1601. He died from a ruptured bladder after a night of heavy drinking and was buried, along with his brass nose, in Prague. Portions of the magical Uraniborg still exist today on the island of Hven, now in Sweden.

STELLÆBURGUM ſive OBSERVATORIUM SUBTERRANEVM, A TYCHONE BRAHE NOBILI DANO IN INSULA HVÆNA, EXTRA ARCEM URANIAM, EXTRVCTVM CIRCA ANNVM M D LXXXIIII.

Uraniborg's Star Castle

This nifty little park was adjacent to Brahe's palace and was called the Stjerneborg or 'Star Castle'. It was a subterranean complex that used only ancient instruments to chart what were the most accurate measurements of the cosmos of its time. *Notice the freestanding quadrant at the bottom right, with a sundial above it.* The magical arrangement of circles and squares was built on principles of classical esoteric architecture. Its sacred geometry sought to mirror and gain beneficial influence from the astrologically controlled universe it hoped to discover.

1600 Map of the cosmic complex

Castle in the Air

As Dream Palaces go, what would fantasy be without a little farce? As we have seen from Tycho Brahe's geo-heliocentric universe, scientists didn't always get it right —and, according to Gulliver, they can get things terribly wrong. It's time to visit Laputa, the legendary 'castle in the air' found by Jonathan Swift's Gulliver. Swift was an Irish clergyman who published Gulliver's Travels in 1726. It was a satire of British intellectuals and the monarchy that oppressively lorded over Ireland at the time, and Swift had to publish his now famous work anonymously to avoid persecution. We're all familiar with the little Lilliputians and the Brobdingnagian giants, but often overlooked was the kingdom of Laputa, lorded over by silly scientists. Swift employed Laputa as a parody on the shortcomings of the Enlightenment's Age of Reason. There were great scientific advancements during this period—in physics, astronomy and philosophy–that began to separate reason from religion. But it was also a time of great imperial expansion abroad with its spread of slavery and colonization over indigenous peoples, along with great social injustice and indentured servitude at home.

Laputa was a technologically magical place—a floating circular island, 4.5 miles in diameter, that could maneuver in any direction within the confines of its home island of Balnibarbi below. It used magnetic levitation devices to keep itself above the cares of the world. Like England's relationship with Ireland, Laputa dominated, but depended

The Great Lodestone that kept Laputa in the sky

Skew-headed Laputian astronomers with eyes on the prize

on Balnibarbi for resources. Unruly regions might have rock bombs dropped on them, or even be crushed by the entire floating island landing on them. The Laputians' technology made them supreme, but their elitism made them monsters. Laputa itself was inhabited by servants and ivory-tower academics, who were only interested in the abstractions of astronomy, math, and music at the expense of practical concerns. So skewed was their lifestyle that they were constantly cross-eyed and bent-necked from staring through astronomical devices. They literally couldn't see their nose in front of their faces, as one eye was always looking inward in speculation and the other up to the heavens. Because of this malady, each academic had a servant called a 'flapper', who carried a flail-like bag on a stick and prodded the self-absorbed rulers so they wouldn't bump into things and to prompt them to talk or listen to each other once in a while.

The Laputians' main preoccupation was the threat of terrorism from far-off forces, which drove them to paranoid delusions. The marvels and delusions of Laputa are as recognizable today as they were in the 18th century—and certain people with cell phones could certainly use a flailing 'flapper' to keep them from bumping into things.

The Legendary Laputa

A veritable castle in the air, Laputa was a vision of scientific marvels cursed by scientific blundering—a lesson for all ages.

Library in the Sky

Of all the Memory Palaces ever invented, the idea of mythic, multi-media library in the sky steals the show. The tradition of an ethereal library, where the history of everything is recorded, goes back thousands of years in both the East and the West. Early incarnations tended to hold rather punitive records for use in judgment on the newly dead. But later, the library became much more fun—a place where everything was recorded so one can explore the knowledge of the universe.

The Egyptians had their Book of the Dead that described the soul's passage into the afterlife. The Babylonians had Tablets of Destiny, which recorded one's transgressions. Judaism adopted this tradition, too, in the Book of Remembrance, and Christians called theirs the Book of Life. All were concerned with recording deeds in one's life that would be used to pass judgment after one's demise, deciding where you'd go in the afterlife.

In the East, Hindus had Yama, Lord of the Dead, but he admittedly had a hard time keeping track of every little thing that every soul did, so he went to Brahma, Lord of Creation, for help. Brahma meditated on this hefty issue, and out of him popped Chitragupta, the world's first librarian. His magical instruments where the first pen, ink, and paper. His documents record the actions of each person from birth to death, and were said to contain every action taken in the universe. The name Chitragupta translates as 'secret coded pictures'.

Akashic Library Book
Some library explorers claim to have seen books that show 3D movies of every little detail of their lives

In Victorian times, the newly organized Theosophists, mixing Eastern and Western mystery traditions with the newly popular idea of science, borrowed this concept to create the idea of an ethereal library containing 'Akashic Records'. In Tibetan, 'akasa' means a 'place unseen in the sky'. In Sanskrit, 'akasha' translates as 'aether', the traditional, other-worldly fifth element—where this hidden picture-palace is located. To early scientists, aether was used to explain everything from light to electromagnetism. Later, mystics saw it as the invisible dimension closest to our own.

Theosophists claim that 'the soul emits energy with every thought, action, or event that it engages in during its lifetimes'. This energy leaves a permanent energetic record in the aether. So an Akashic Record is sort of like flypaper that catches every energetic emanation from all living beings. This remembrance takes the form of a multi-dimensional holographic recording of all the events, thoughts, feelings,and actions that the soul experiences. The history of the whole universe is recorded in this hologram. They say 'everything that has ever happened, is happening, and can happen is recorded in the Akashic Records'. They contain every personal, even embarrassing moment in one's present and past lifetimes.

Victorian Theosophists saw this library as a less judgmental place than their predecessors, and viewed it as the wellspring of universal knowledge that one could access with the proper training. More than just a memory storehouse—it was an interactive space that changes, (like our own brains). Jungians later picked up on this idea of a collective memory storehouse and called it the 'collective unconscious'.

Made up of our common mythic ancestral memories, this collective record contains all of our shared basic instincts and is populated by universal symbols and archetypes. It's similar to the realms symbolized in Tibetan mandalas. (Jung liked these, too.) Access to the Akashic Library is through one's subconscious mind, and modern mystics claim to be able to access it by inducing trance states. So apparently everybody has a library card and can access it whenever they want. Proponents advise using various methods—including prayer, meditation, ritual, and self-hypnosis—to engender a trance-like state. A steadfast motivation and focused questions are said to be necessary to being able to pick up sounds and images that contain answers. It's not for the squeamish, but the benefits include learning from past mistakes and gaining creative clarity to achieve future goals.

Not sure, but think we may have a few overdue books there, and wondering what the fines might be. If the librarians are anything like the ones from antiquity, the fines could be pretty stiff.

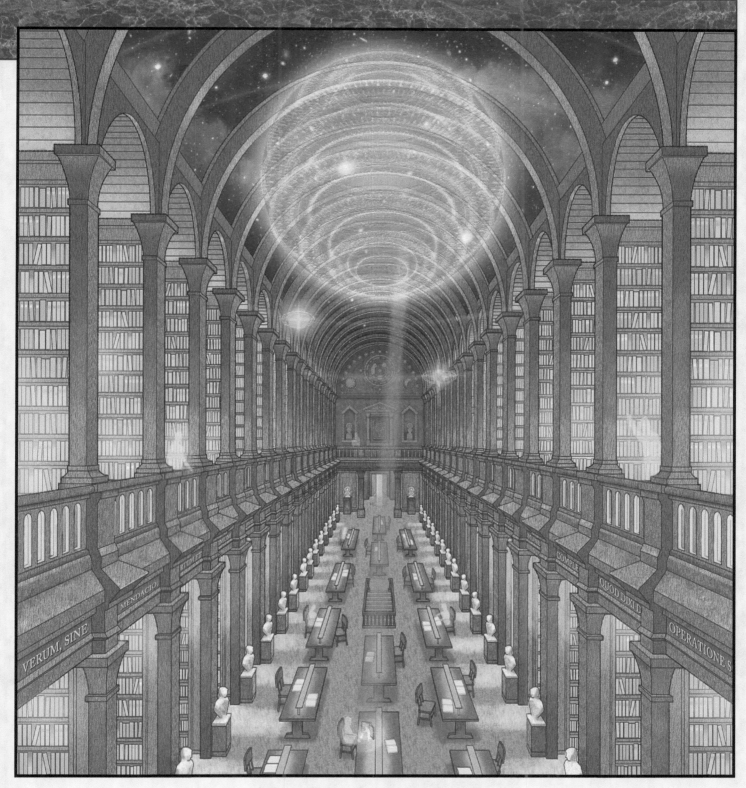

THE AKASHIC LIBRARY

There is no one definitive description of the Akashic Library. Most mystics are only able to grasp mental snippets of information about it, and the descriptions vary for those that have claimed to have gone inside this great Library in the Sky. If information about it all filters through the subconscious, then by necessity, any description would be a projection of the viewer's subconscious expectations. Modern folks like to describe it as like an ethereal 'cloud' computer server. The more romantic among us hang on to the vision of a neo-classical library. And why not? A Library in the Sky a very romantic notion, after all. It's the greatest Memory Palace ever conceived, and the most universal of all Dream Palaces.

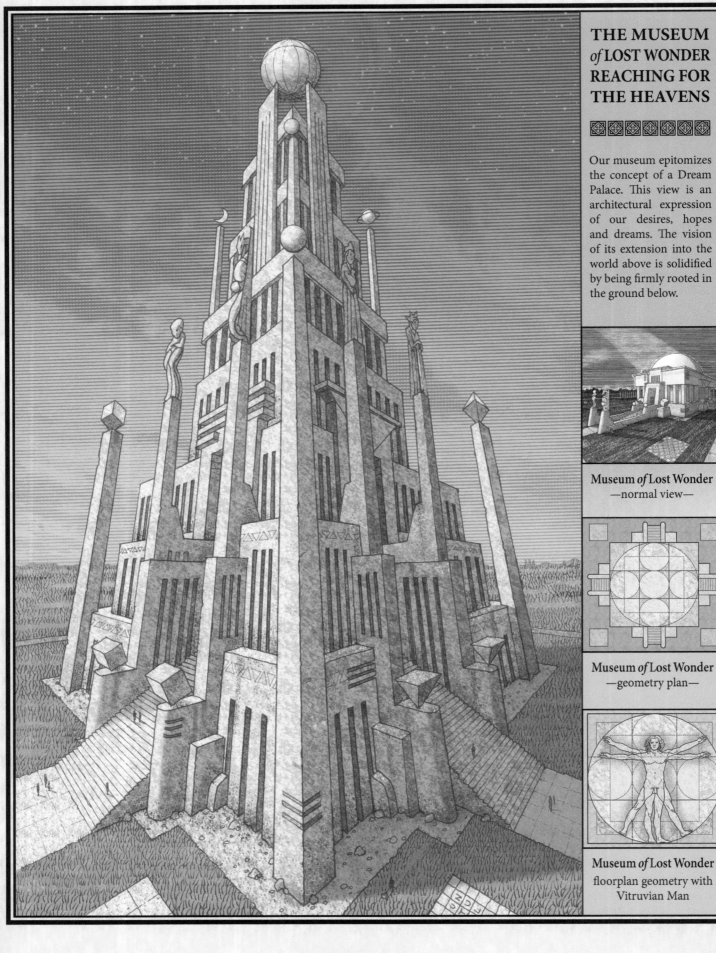

THE MUSEUM of LOST WONDER REACHING FOR THE HEAVENS

Our museum epitomizes the concept of a Dream Palace. This view is an architectural expression of our desires, hopes and dreams. The vision of its extension into the world above is solidified by being firmly rooted in the ground below.

Museum of Lost Wonder
—normal view—

Museum of Lost Wonder
—geometry plan—

Museum of Lost Wonder
floorplan geometry with Vitruvian Man

Interior Castle Pop-up
INSTRUCTIONS

Tools and techniques: CUT ——— FOLD DOWN – – – – FOLD UP –·—·– GLUE ⬦⬦⬦⬦⬦⬦

Choose a glue suitable for paper—we find a simple glue stick works best. Then find an implement to score, with such as a dull knife, a letter opener, or a dead ball-point pen. Use a straight edge to keep your scoring straight and centered on the dashed lines. Scoring all the fold lines before you cut out the shapes is very important for the success of your model. After folding the card, crease the folds with your thumbnail to make sure they're nice and sharp.

1 Score all the fold lines with a dull edge. You may need to go over the lines a few times to make sure the folds will be nice and supple. Score hard enough so you can see the raised lines on the back of the paper, but not so much that you puncture all the way through.

2 Cut out all the little windows. Be careful to stay within the black lines, so you won't lose the thin paper strips in between some of the cut-outs.

3 Now slice all the rest of the cut lines. *It's preferable to cut on the outer edge of the black lines on the perimeter towers so you won't see any lines on the background when the model is done.*

4 Gently tease up the castle from the page to make sure all the sections have been cut thoroughly. If they haven't, re-cut them. Tease up the castle's center line, taking note that the top and bottom edge of the background will eventually fold the opposite way, forming a valley.

5 Fold the paper back, creasing along the castle's center line. Take care to leave the top and bottom border uncreased, as they'll soon be folded in the other direction.

6 *THE TRICKY PART* Unfold the paper and carefully crease down the folds along the edges of the castle with your thumbnail, simultaneously pushing up on the fold with the fingers of your hand from underneath the paper, to form a valley. Be patient and take care to crease only along the length of each fold line.

7 Do the same with the other sections and stages of the castle, using both hands to carefully ease the folds back or forward into mountain or valley shapes. Again, be careful to fold only along the length of each fold line.

8 Once you've got all the folds creased, take the paper in both hands and start to fold it together, persuading each section to fold correctly with your thumbs and fingers on either side of the creases. Go back and re-crease any problem areas where necessary.

9 When everything is lined up and folding in the correct direction, slowly fold the paper together completely so it lies flat against itself. Re-crease folds and straighten any parts as necessary. When the figure is flattened, rub over the hidden folds with your thumbnail, to ensure they are nice and sharp. Open the figure up again to celebrate your new pop-up!

10 Score and fold the backing sheet, then glue it to the pop-up sheet, one half at a time. Be sure to apply glue to both sheets and align the outside corners of the papers first. Once aligned, press the sheets together from the inside outwards towards the edges. After the first half is attached, glue and press together the second half in the same manner.

11 At this point, you should have a magical fold-out booklet to amaze your friends and impress your foes. The castle will appear to float when it's opened, but for extra effect, you can cut off all the cream borders.

St. Teresa of Ávila's
Interior Castle

This pop-up model was inspired by the vision of the 15th-century Spanish mystic St. Teresa of Ávila. This Western transcendental tradition mirrors Eastern practices in using architecture to manifest a mental pathway. Like traditional Tibetan mandalas, she describes a palace in two dimensions to be constructed in three dimensions in the mind. Once envisioned, the palace is entered to acheive teachings on one's spiritual journey.

The Seven Stages

In her book from 1577, St. Teresa envisioned a castle of seven concentric tiers, representing the stages one goes through on the path to enlightenment.

1 Entrance level for the novice initiate, where one is still attached to worldly affairs.

2 Regular practice of prayer and meditation begins in earnest.

3 Daily practice continues and becomes deeper. Confidence is gained by feedback from the beyond.

4 Sudden growth. Beginnings of deep contemplation and first mystical states are achieved.

5 Mystic contemplative states become normal. One feels like a stranger in the world. Dreams of final union begin.

6 Extraordinary phenomena occur. Great courage and sobriety are needed to continue on the path.

7 Raptures are replaced by clear understanding and moments of merging with the Spirit.

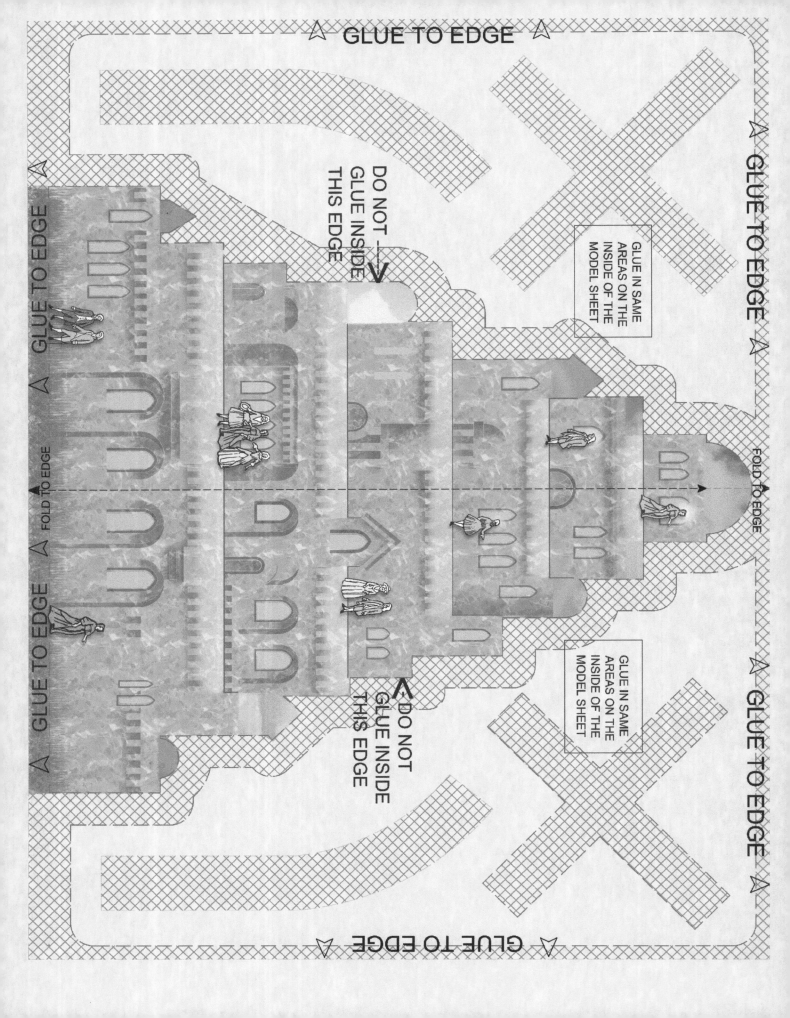

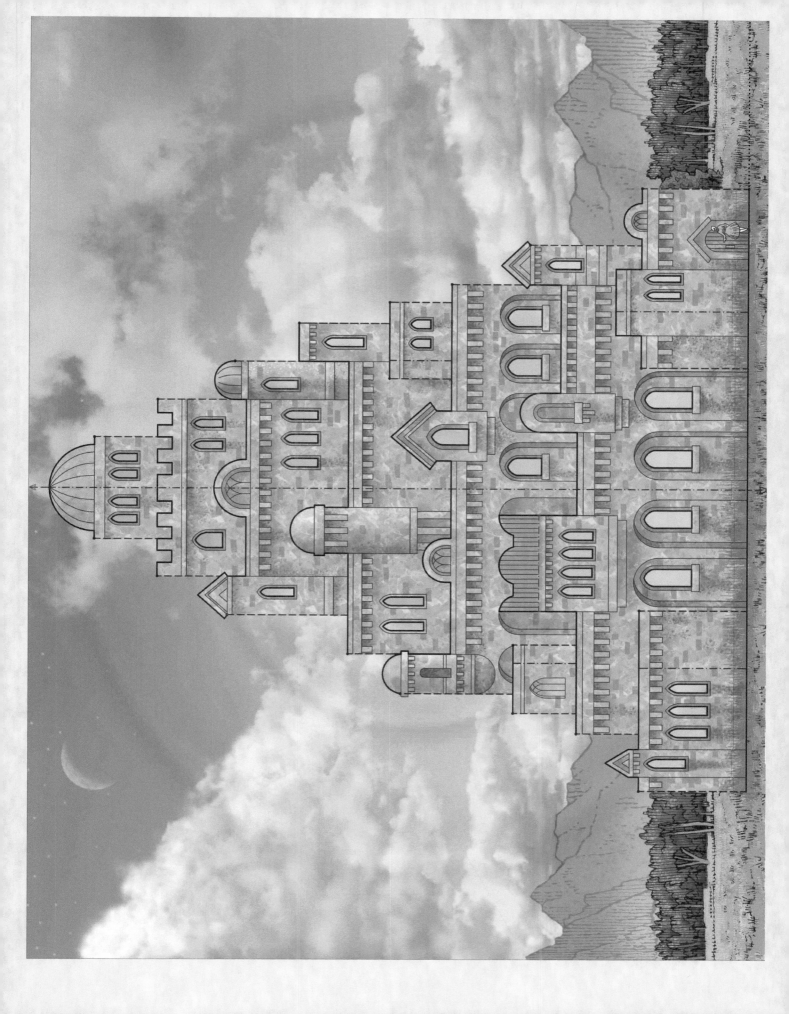

Tomb of Illumination

How do ideals become real?

THE MUSEUM OF LOST WONDER

TOMB of ILLUMINATION

The tale of the little crypt that changed history

UNCOVER SECRETS FROM A LOST ERA

"History would be a wonderful thing — if it were only true." LEO TOLSTOY

This is the story of a lost tomb, one mentioned only in whispers, one said to be filled with treasure that promised to unlock the secrets of the ages. The fabled tomb was discovered at a time when there was no separation between science and magic, between reason and the mystery of being alive. The secrets enshrined in it fueled the dreams of visionaries, but they also led to fear, panic, even war. In time, the mysteries of the heart and soul contained in the tomb were lost again. With this chapter, you have the chance to rediscover these long-buried secrets.

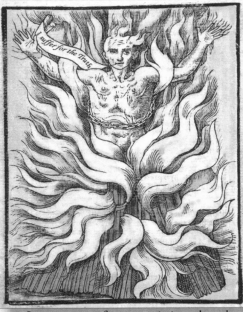

It was an age of secret societies, when the Inquisition loved to host barbueques.

It was the dawn of the 17th century. The flourish of the Renaissance had revived forgotten knowledge and brought the world out of Dark Ages, but it was not quite yet the Age of Reason. In this shadowy time, magic and superstition still ruled the imagination and science was but a promise. The Church and the Holy Inquisition dominated the day, their doctrines enforced by fear, persecution, even death. Democracy was but a dream. This was a time of brilliant minds and sacrilegious manifestos. The revolutionary astronomer Copernicus published only after his death, and Galileo was under house arrest. Cosmologist Giordano Bruno had recently burned at the stake, convicted of heresy. It was the height of the war between dogma and truth, with no less than the hearts and minds of humanity—even the structure of the universe—at stake.

In 1604, a band of European brothers—the last remnants of a secret society, went looking for the hidden past of their mysterious order. Their explorations led them to an underground location containing what they described as a "great naile" driven into the wall. As they pulled out the spike, plaster and stone fell away to reveal a massive door hidden in the wall. On the door was an inscription: POST 120 ANNOS PATEBO—1484. ("After 120 years I will open—1484.")

Opening the door, the explorers discovered a sacred vault sealed and lost to the world for over a century. This tomb was the last refuge and final resting place of the great mystic they sought. Within its peculiar seven-walled structure lay the tale of his journeys, as well as secret knowledge which promised to bring the world into the Age of Enlightenment once and for all. The brothers realized they were not only exhuming the founder of their secret order, but also the lost dreams of a forgotten cabal, ideas that would inspire modern science and democracy—ways of thinking that would change the world forever.

Inside the Tomb

Prying open the heavy door, the awestruck men were blinded by an unexpected light. When they recovered, they saw an intimate space, measuring eleven feet across and eight feet in height. The seven-walled room was illuminated from above, light streaming from an ever-glowing lamp. The ceiling and floor were inscribed with great seven-sided sigils, and every wall was adorned with ten mysterious figures accompanied by strange inscriptions. A cabinet at the base of each wall held a chest filled with marvelous tools, instruments, and other objects. The brothers found magic lamps, lenses, bells, and transcriptions of songs as well as ancient tomes—

The geo-magical vault was shaped like a heptagonal crystal.

volumes containing the essence of secret wisdom gathered from all over the world in ages past. In the center of this oddly shaped vault stood an altar of brass, its surface similarly etched with arcane signs and symbols. Moving the altar aside, the brethren discovered another secret chamber, this one the actual burial place of the tomb's founder and sole inhabitant—Christian Rosenkreutz. He lay at rest, preserved and clothed in ceremonial regalia. In his arms was cradled the book *T*, which would become the brotherhood's most prized treasure, as sacred as the Bible.

But who was this incorruptible figure, an unknown thinker buried in a glorious tomb and surrounded by the secrets of the universe?

The Adventures of Christian Rosenkruetz

The book Christian Rosenkreutz held in his grave was a window into the life of the mysterious scholar. Born in 1378 of "noble parents...of a strong Dutch constitution," little Christian was left at a cloister in Germany at the age of five. Here he "indifferently learned the Greek and Latin tongue." Bored and anxious for adventure, Rosenkreutz set off to see the world before the age of 16. He traveled to Cyprus and then Damascus where he gained favor with the Turks and Arabs and "beheld what great wonders they wrought." For three years, the scholar studied Arabic, mathematics, and medicine from the wise men there. He also translated the book *M*, which was purported to be a mythical book of nature uncovering the laws of the universe.

Traveling to Egypt, Rosenkreutz stayed a time studying in the temples. Afterwards he set sail eastward over North Africa to Fez. There he befriended more Arabian adepts and learned the secrets of medicine, magic, and Kabbalah. After two years of study, Rosenkreutz sailed "with many costly things" to Spain. He conferred with the "Learned" and showed them the "Errors of their Arts." The sages viewed this upstart's knowledge a "laughing

matter... fearing their great name should be lessened." Rosenkreutz left Spain to roam Europe, where his arcane wisdom received a similar reception.

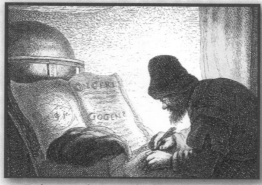

Father Rosenkreutz gathering lost knowledge.

Rejected and weary, Rosenkreutz made his way home to Germany. His dream was to set the stage for the creation of a society of more attentive brethren, and built a refuge to store his collection of wondrous things gathered during his travels. In this *Sancti Spiritus*, Rosenkreutz meditated and created scientific instruments to further the study of the world of nature and other realms, always carefully cataloging his findings. After years in seclusion, Rosenkreutz found and initiated other illuminati, starting a brotherhood of enlightened minds to keep these ancient secrets alive.

The odyssey of Christian Rosenkreutz parallels the journey of ancient knowledge from around the world to Europe during

the Renaissance. In the 4th century BCE, Alexander the Great traveled the known world, subjugating kingdoms and collecting the great books of every country he occupied. Better known as a conqueror, Alexander was also one of the greatest librarians in history. While in India, he also brought back Hindu philosophy and Buddhism. As early as 300 BCE there was a school of Buddhism in Egypt started by the philosopher Ammonias Saccas. When Alexander returned home to the city named after him, he confiscated the books from every ship that came into this international port. These all went into his famous Library of Alexandria.

For nearly six centuries his library-museum amassed all the knowledge of the known world.

Alexander's scholars learned many fascinating truths—even discovering that the world wasn't flat—but this knowledge was soon to be lost. Around 300 CE, the library at Alexandria was destroyed by Christian zealots, who viewed this heretical information as a threat to the dogma of their nascent religion. The earth went flat again for most of the world, but Arab intellectuals managed to secret much of this wisdom away. As Moslem culture grew over the centuries, it spread across North Africa and into Spain. Moslem Spain became an intellectual haven outside Christendom, one that harbored some of the greatest minds of that era.

The Travels of
Christian Rosenkreutz
circa 1400

The odyssey of young Rosenkreutz mirrors the trail of how ancient knowledge was recovered during the Renaissance.

During the Renaissance, Italian adventurers spread out across the Mediterranean to recover this lost wisdom. They trekked to the Middle East and Egypt, North Africa and Spain. They returned with books for the insatiably curious minds of Europe, a place deprived of all knowledge beyond church dogma for hundreds of years. From these Arabic sources, the Western world received the concepts of zero and modern mathematics. It also recovered secrets of astronomy and navigation that allowed Columbus to sail to the New World. Ancient knowledge was also kept by Jews, who found tolerance in Spain and published under Arabic names so their wisdom would be accepted by the rest of the Christian world. From these writings sprang the secrets of the Kabbalah, a poetic tradition outlining the origins and structure of the mystical universe. Kabbalah used a symbolic language where every letter was a cipher for a deeper meaning and wider truth.

Secrets of the Tomb

Father C.R.C.'s tomb was filled with marvels both scientific and holy. The wisdom contained within the vault originated in ancient times and came from all over the known world. It blended Buddhist thought with Hebrew, Moslem, and the western philosophy of Hermeticism. These secrets revealed the structure and purpose of the entire universe around us (the macrocosm), and uncovered the make-up and meaning of the world within ourselves (the microcosm). The arrangement of Rosenkreutz's tomb and all its contents sought to symbolize the unity of creation and gave directions on how people could make a personal connection to the grand scheme of the cosmos.

Its Sacred Geometry

The shape of the vault was very special. Its seven walls and heptagonal floor and ceiling had a particular purpose and made spatial connections between a host of symbolic elements in the

tomb. The floor and ceiling—the above and the below—were in themselves great intricate icons. These mathematical, magical mandalas encompassed and charged the scared space. Their figures resonated with the emblems elaborated on the seven walls, which were ruled by the seven "Inferior Governors" or planets. The multitude of diagrams on the walls detailed the correlation between physical and ethereal realms, using examples including everything from metals to mental states, deities to days of the week, chakras to colors of the rainbow. These magical maps showed how to turn abstract notions into concrete realities and control them through consciousness. Rosenkreutz had developed an early theory of everything whose emblems explained how to convert mass to energy, light to love, and matter to personal meaning.

Dee's Divine Science

Much of the symbolic language of the tomb, particularly the geometric figures on the floor and ceiling, is thought to stem from the works of the English intellectual John Dee. Dr. Dee had the greatest library in all of England, and was typical of the genius from that time. He was a polymath who straddled the worlds of science and magic just as they were becoming distinguishable. Master of mathematics and magic, astrology and astronomy, and alchemy and science, Dee was also a consultant and spy for Queen Elizabeth I. As a visionary mathematician, he set the

stage for future cosmologists, notably Isaac Newton. Applied to navigation, his genius enabled the British Empire to chart the unknown lands of the world and spread around the globe. He also explored the world of magic, where he discovered the Enochian alphabet—the language of Angels.

Dee's greatest work was called *Monas Hieroglyphica*, or universal symbol. This encyclopedic tome condensed all the world's language, ciphers, codes, and symbols to one unified icon. This figure is a derivation of the symbol of Thoth, the Egyptian god of wisdom; the Roman messenger-god Mercury; and the Greek god Hermes, from whom we get the term Hermeticism.

Dee's Monad - the universal symbol

Dee traveled widely on his missions for the Queen, and for a time became the court scientist of the Holy Roman Emperor, King Rudolf II of Bohemia. Immune from the pressures of religious Rome, Prague became the center of scientific and Hermetic research, a think-tank that held the hopes of progressive philosophers throughout Europe. Among those in Rudolf's refuge were scientists such as Tycho Brahe and Johannes Kepler, astronomers who delved into sacred geometry and pioneered theories that led to the discovery of the celestial mechanics of the cosmos.

JOHN DEE — *The Real 007*

Dee was an English Renaissance man of many talents, and had one of the greatest libraries in Europe. His navigational mathematics led the British to conquer the world. As court spy, he signed his secret missives to Queen Elizabeth 007, symbolizing his job as the Queen's eyes, covered by the sacred number seven. He was an early influence on Francis Bacon. His magical geometry is reflected in Rosenkreutz's tomb.

The Techno-Magical Tools in the Trunks

The sacred geometry figures inscribed throughout Christian Rosenkreutz's tomb were roadmaps to enlightenment. Father C.R.C. had also stocked his vault with devices and numerous books to help people navigate the figures. Some historians think these gadgets were mechanical metaphors for inner spiritual phenomena, learned from the gymnosophists (wise men) of India. Others imagine that these instruments actually activated inner energies. Contained in the chests were:

LAMPS: Radiating warmth and brightness, these lights were also meant to illuminate hidden wisdom. Mystically, they were meant to manifest the inner glow that emanates from our chakras, the visceral centers of luminosity that link the physical body to the soul.

LENSES: In Rosenkreutz's time, lenses were a relatively recent invention. Their development made possible the telescope and microscope, tools that let us examine the macrocosm and microcosm. They opened the universe beyond and the endless miracles of the infinite worlds within ourselves. Metaphorically, they referred to inner visionary experience, focusing the beams of wisdom into revelations.

BELLS: When rung, the chimes found in the chests would resonate sound and sensations that could be heard in the head and felt in the body. Some say these bells were a physical manifestation of astral chimes, whose heavenly vibrations can be experienced in meditation. It's thought that the reverberations stimulated latent vitality in the chakras.

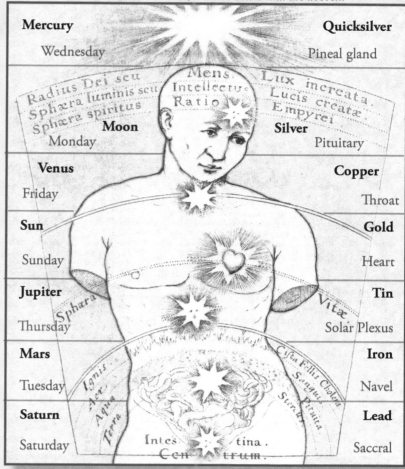

The Sacred Seven Correspondences

"The above is as the below, and the below is as the above..."

Mercury	**Quicksilver**
Wednesday	Pineal gland
Moon	**Silver**
Monday	Pituitary
Venus	**Copper**
Friday	Throat
Sun	**Gold**
Sunday	Heart
Jupiter	**Tin**
Thursday	Solar Plexus
Mars	**Iron**
Tuesday	Navel
Saturn	**Lead**
Saturday	Saccral

Adapted from Robert Fludd's "Utriusque Cosmica" 1619

ARTIFICIAL SONGS: When these words of power were sung from sheet music, they made visceral vibrations meant to connect one with higher realms. Music was seen as a physical expression of mathematical perfection. The harmonic vibrations of the bells and chanting made a spiritual resonance to the scared geometry expressed in the architecture of the tomb. Esoterically, these songs refer to chants or mantras.

Many of the books found in the chests were Christian Rosenkreutz's own research writings, while others were translations of ancient texts and works of other illumined personalities. Father C.R.C. celebrated one 16th-century Swiss physician in particular. This alchemist-doctor called himself Theophrastus Bombastus Paracelsus von Hohenheim. Paracelsus traveled extensively, published widely, and revolutionized medicine. His teachings rebelled against the dogma of church's scholasticism, which was comprised simply of memorizing and repeating the centuries-old writings of Galen and Aristotle. Instead, Paracelsus taught those who would listen to "read the book of

PARACELSUS

Theophrastus Bombastus Paracelsus von Hohenheim

He's the father of modern medicine and an alchemist. Derided by his peers, he used to spout his philosophy in taverns. We get the word "bombastic" from him. He collected herbal remedies from traditional women healers (who were considered witches at the time), and added minerals to our modern pharmacopia. His esteemed writings were found in the tomb.

nature"—to study and learn by direct observation of natural phenomena. His method instructed others to test discoveries in the laboratory, then extract or "exalt" natural essences to increase their effectiveness. His techniques were based on alchemy, but his system—of observation, experimentation, testing, and then publishing his findings—led to the foundations of modern science and medicine. A born iconoclast and dedicated do-it-yourselfer, Paracelsus' motto was, "Let no man that can belong to himself be of another."

Under the Altar

Hefting aside the central altar, the explorers found a hidden chamber with a coffin containing none other than the incorruptible Christian Rosenkreutz. In Rosenkreutz's arms was nestled his sacred tome— the book *T*. Apart from telling of his life and travels, *T* also outlined the rules of the secret brotherhood of Illuminati he established. There were six articles that bonded the brotherhood together:

Secrets of the Order

First: That none of them should profess any other thing than to cure the sick, and that gratis.

Second: None of the posterity should be constrained to wear one certain kind of habit, but therein to follow the custom of the country.

Third: That every year, upon the day C., they should meet together at the house Sancti Spiritus, or write the cause of his absence.

Fourth: Every Brother should look about for a worthy person, who after is decease, might succeed him.

Fifth: The word R.C. should be their seal, mark, and character.

Sixth: The Fraternity should remain secret for one hundred years.

The second rule let the brothers blend in and led to the idea that they were "invisible."

The Key to the Cosmos

Searching the sepulcher, they also uncovered another smaller shrine, one known as the *Minutum Mundum*, or miniature universe. This little wonder is said to have been a geometrical replica resembling the heptagonal tomb—a model of both the spiritual geometry of the human body and a map of the mechanisms of the universe. The little shrine was of crystalline shape—a master key to unlock the gateway between the self and the cosmos. It was a representation of the tomb as a Memory Palace, a model to remind those who used it of the connection between the wonders of the world and the mysteries of the soul.

Minutum Mundum

After carefully noting its contents, the brothers tidied up the tomb, then "shut the door, and made sure, with all our seals." A chosen few were charged with keeping its secrets, which have since remained underground for more than 400 years. No one else has ever found the final resting place of Christian Rosenkreutz. We only know of its contents and the history of its owner by its description in a pamphlet published in 1614.

The Pamphlet Wars

The pamphlet came out at a time of secrets and secret societies. Up to this time, truth had been the province only of those invested with a crown or a pulpit, but with the advent of affordable publishing, print could now empower the oppressed. Although the printing press had been around for 200 years, it was the invention of mass-produced paper that made the medium an outlet for individual voices contrary to authoritarian rulers. The greatest advantage of putting thoughts in print was that writers could publish anonymously, touting tirades without fear of persecution and death at the hands of those in power.

Unlike today, printed matter was something very special, something cherished. Until the rise of printing, news was spread by storytelling travelers who whispered wonders in markets and taverns. However, information spread by word of mouth could be nothing more than opinion and rumor. The same words gained authority by appearing in print, and could be taken as truth. Books were dissected, rebound, and even sold as individual pages to be pored over at home for an evening's enlightened entertainment. For the first time, literature, learning, and truth became something anyone could afford.

Many of the major printers were also members of long-established heretical religious groups, and their shops became centers for obscure religious movements. Printers became the media giants of the era, a time when a simple pamphlet could stir a revolution. To mount a rebellion, one could write a manifesto in leaflet form. The Reformation of the Christian church was fueled in part by Martin Luther's simple act of nailing a sheet of paper to a church door.

The pamphlet wars were viciously fought in public, but could be secretly enjoyed by anyone in the comfort of their own home.

The Fama Fraternitatis

Three Pamphlets that Started a Revolution

In 1614, a peculiar pamphlet was published. It was named the *Fama Fraternitatis*, a Latin title meaning "a report from the Brotherhood." Its full title was *The Fama Fraternitatis of the Meritorious Order of the Rosy Cross, Addressed to the Learned in General, and the Governors of Europe, for the General Reformation of the Whole Wide World.* This ambitious little booklet outlined a heretical utopian plan whose words ignited a wildfire of controversy.

Fama Fraternitatis described the life and journeys of Christian Rosenkreutz, as well as his tomb and the brotherhood that discovered it, all in a space smaller than the chapter you're reading now. It called for a new world order guided by mystically enlightened scientific minds. The miniature manifesto was Protestant in flavor, flying in the face of papal authority. It advocated the practice of a new spiritual alchemy, scorning "false alchemists" who sought material gain. Instead, the *Fama* championed "the true philosophers of another minde,

esteeming little of making Gold...for besides that they have a thousand better things." At its conclusion the pamphlet called for others to join in the cause. The brotherhood swore to remain secret to the general public, but promised to be in touch with sympathetic and sincere figures of the day.

The *Fama* first appeared in Germany and was immediately printed in five different languages. It ignited the imaginations of legions of thinkers, and the wildfire spread as the booklet was copied, republished, and distributed even further. In 1615 came a second Rosicrucian pamphlet, the *Confessio*. This "Confession of the Fraternity to all the Learned of Europe" elaborated on the philosophy introduced by the *Fama*. The members of the fraternity confessed they would "addict our lives to true philosophy." They promised "wonderful things" and a "great treasure" from "the meditations, knowledge, and inventions...from God's revelation." The brotherhood again entreated others to join and offered to democratically share this knowledge to any worthy soul for free. Anyone who sought this knowledge for the betterment of humanity was considered an ally. Those who coveted their secrets for profit and power would search in vain. This second pamphlet also defended its views from those who accused the previous pamphlet of heresy.

Nobody ever confessed to writing

JOHANN ANDREAE

This German minister was thought to be the author of all three manifestos. He later refuted these charges, saying it was all a "ludibrium." In Latin this means a toy game, but to Andreae it meant a metaphorical drama played out on the stage of the world theater.

the *Fama* or the *Confessio*, but a third analogous work—*The Chymical Wedding*, an allegorical alchemical tale published in 1616—was admittedly written by the German theologian and alleged alchemist Deacon Johann Valentin Andreae. A prodigious writer, philosopher, and Protestant reformer, young Johann was said to have been kicked out of theology school for posting a scandalous placard to the door of the chancellor when he heard he was to be married. (As Martin Luther proved, there's nothing like a well-placed poster to rile up the authorities.)

These tiny treatises caused quite an uproar, instilling fear and wonder wherever they spread. Those whom they inspired published supporting works and entreaties to join the brotherhood. Those who felt threatened published papers damning the followers of Christian Rosenkreutz, accusing the Rosicrucians of heresy, sedition, and devil worship. Authorities issued edicts against them. The pamphlet wars had begun!

The Rosicrucian Rumpus

By 1600, Germany had been a hotbed of anti-authoritarian thought for hundreds of years. German tribes ensured the fall of the Roman Empire when the Visigoth Alaric sacked Rome in the year 410. The Catholic Church was driven to Constantinople, unable to re-establish itself in Rome for centuries. Church power was eventually shared with pagans by establishing German lands as the Holy Roman Empire, but it was an uneasy alliance. Aside from their own political potency, Germanic royalty enjoyed the privileges conferred by papal power. Germany was generally more tolerant of new ideas, and over time became a haven for free thinkers from all over. This culminated in Bohemia, where Rudolf II created a central sanctuary for revolutionary philosophers and alchemist scientists. Today, the term "bohemian" is still a moniker given to all things counterculture.

Bohemia was a refuge for thinkers from a witch-hunting craze that gripped the rest of Europe. The publication of the Rosicrucian pamphlets was used as an excuse by the established powers to stir up public sentiment against contrary minds they sought to destroy. Once the manifestos hit France, the country was struck by a hurricane of excitement. This

RENÉ DESCARTES

He's the father of modern philosophy and was accused of being a member of the Rosicrucians. He denied being part of the "Invisible Brotherhood," but on his gravestone is the epitah, "He who hid well, lived well."

commotion was further enflamed by placards appearing on Parisian walls in 1623, where the "Brethren of the Rosy-Cross" vowed to teach "every science to extricate our fellow men from error and destruction." Fierce countermeasures ensued, and the fearful published more pamphlets accusing the brotherhood of Satanism and demonic possession.

Typical of the Frenchmen caught up in the furor was René Descartes. As a youth, he had a dream of a mysterious mentor pointing the way toward truth and wisdom. After this dream he searched for the brotherhood's secrets of nature and disappeared for two

ISAAC NEWTON

The father of modern physics and one of the last alchemists of science, Isaac kept a secret alchemy lab in his dorm room, and later a collection of Rosicrucian literaure, but never admitted any involvement.

years. When Descartes' path led him to Paris, he was accused of being one of the feared "Invisible Brotherhood." Denying the charge he responded, "But you can see me, can't you? So how can I be a Rosicrucian?"

In England the furor spread further, stirring the souls of other intellectuals. Physicist Isaac Newton secretly practiced alchemy and kept copies of the manifestos. Another English philosopher, Robert Fludd, published a treatise expressing admiration for the Rosicrucian cause and asking to join. Fludd never admitted to receiving an answer, but he continued to publish Rosicrucian-style Hermetic writings and symbols the rest of his days.

Francis Bacon, the originator of the scientific method, is rumored to be one of the Rosicrucian founders. His 1605 treatise, *In the Advancement of Learning*, certainly inspired the Rosicrucian

ELIAS ASHMOLE

Elias was an alchemist, Freemason, and one of the founders of the Royal Society, the first scientific organization. England's initial museum bears his name. His work was inspired by the Rosicrucians, and he defended their movement.

manifestos. In this work he encouraged alchemical methods of research by "following in the footsteps of nature," and called to establish a "brotherhood of learning that transcends national boundaries." He supported the movement in Bohemia to establish a capitol for what he called "learned magicians." Bacon's final work, *The New Atlantis*, is a metaphorical journey to a utopian kingdom led by mystic scientists who meet yearly in a temple, heal the sick without charge, and wear the signs of the rose and cross.

The famous historian and alchemist

FRANCIS BACON

Founder of the modern scientific method, his writings inspired the Rosicrucian pamphlets and the creation of the Royal Society. Proported to be Queen Elizabeth's son and even the real William Shakespeare, his scientific method is reflected in the writings about the tomb.

Elias Ashmole also published a petition requesting to join the Rosicrucians. No response was ever recorded, but Ashmole became the first recorded member of another secret society inspired by the Rosicrucian dream—the Freemasons. His interest in ancient knowledge caused him to found Britain's first museum, the Ashmolean. His drive to uncover the secrets of nature led him to become a founding member of "The Royal Society of London for the Improvement of Natural Knowledge" in 1660. Known today as the Royal Society, this group was the first institution in the world devoted to the advancement of science. It embraced Newton and Bacon as its guiding influences.

What is a Rosicrucian?

Because the brotherhood was so secretive, history is hazy about the existence of any actual group of people called Rosicrucians. In their beliefs, Rosicrucians were anti-authoritarians with democratic dreams, as well as healers who advocated scientific research. At their core they were alchemists, claiming to have Hermetic wisdom in an unbroken chain from Egyptian antiquity, and they were rumored to have accomplished the transmutation of metals. They had gained the knowledge to see and hear events in distant places, the capacity to detect hidden objects, and the means of prolonging life. On the surface, the symbols of the Rosicrucians

were the rose and cross. The cross symbolized the body and the physical world. A multi-petaled rose was fixed at its center, symbolizing the many dimensions of the soul and the spiritual universe beyond.

Historians seeking a deeper meaning in these symbols point out that the word *ros* is of Eastern origin and is equivalent to the English word "dew." According to the alchemists, transmuted dew was the most powerful of all substances, and was said to have the ability to dissolve gold. The cross comes from the word *crux* and was identical with "light", or *lux*. Eighteenth-century Lutheran historian Johann Mosheim summed up a Rosicrucian as "a philosopher who by means of dew seeks for light, that is, for the substance of the Philosopher's Stone." This formula appears like an early version of

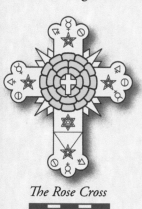

The Rose Cross

$E=MC^2$, where matter (or "dew") is exalted by light ("crux") to produce the energy of transformation.

There are many groups today claiming to be the real Rosicrucians, a lineage with links to ancient Egypt. However, no mention of this name is known before the 1600s. Historians denounce the idea that any real society ever actually

Campanella's idyllic City of the Sun

existed. Instead, they support the notion of a certain style of thinking, a type of Hermeticism pursued by scores of philosophers and emerging scientists, one which epitomized the mix of science and esotericism that came to fruition in this time period.

Utopian Visions

The Rosicrucian manifestos declared that opening the door to Father C.R.C.'s tomb was similar to "opening the door to Europe." They promised the recovery of secrets of the past to illuminate an ideal future. Historians claim they were part of a larger political movement of dissident dreamers whose goal was to build an ideal kingdom and a refuge from Rome. This secular society would be based on free thought, individual rights, cultural tolerance, and universal health care, all guided by spiritual scientists. This utopian movement inspired a host a hopeful visionaries throughout Europe. Utopian movements get the name from Thomas More's book *Utopia*, meaning "no place." More was a humanist scholar, and wrote his 1516 book as a satire of English society. Publishing political spoofs was a dangerous thing in those days, and More's views eventually got him beheaded by Henry VIII. More's *Utopia* and Francis Bacon's 1626 book *The New Atlantis* were but two titles in a larger utopian tradition.

✠ The last of the three Rosicrucian pamphlets, *The Chymical Wedding of Christian Rosenkreutz*, inspired many of the utopian writings of the period. In this work, Johann Andreae created an allegory of the seven-stepped alchemical process that takes place during a sacred marriage of a new king and queen destined to rule a utopian kingdom. It secretly alluded to contemporary events in Bohemia.

✠ The Italian scholar Tommaso Campanella, who endured torture for defending Galileo, wrote *City of the Sun* while imprisoned by the Inquisition. Published in 1623, this parable espoused a theocratic communism guided by Hermetic thought.

✠ In due course this utopian literary tradition inspired Reverend Jonathan Swift to write the ultimate social satire, *Gulliver's Travels*. This lampoon was told through the eyes of an adventuresome doctor who witnesses several idealistic communities, including Laputa—a floating kingdom built by scientific dreamers. Though written years after the Rosicrucian rumpus, Swift was for political reasons compelled to publish anonymously.

The floating scientific utopia of Laputa from Gulliver's Travels *(1726)*

The Dream Too Good to Be True

The utopian movement surrounding the Rosicrucian manifestos was real, and its focus was in Bohemian Prague. For years, Prague had provided sanctuary for mystic scientists patronized by Holy Roman Emperor Rudolf II. After Rudolf's death, thinkers all over Europe put their hopes in the union of the sympathetic Princess Elizabeth of England and Prince Frederick of Germany, who was destined to take over from Rudolf II. This is the marriage that *The Chymical Wedding* alluded to. It was a dream of a new world order guided by "Natural Philosophers".

In the fall of 1619, the "sacred" marriage was celebrated with great pomp, and hopeful idealists were delighted that their dream had come true. But the dream was short lived. Mere months after the new king and queen began their rule of Bohemia,

Prague Castle—*the final refuge for scientific dreamers.*

German Hapsburgs backed by Rome launched an attack to crush this pagan scheme. The conflict culminated in the Battle of White Mountain, outside Prague, in the spring of 1620. Dreams of democracy and hopes for holistic science died. The battle started the Thirty Years' War—a fight for the hearts and minds of Europe with royalty and Rome on one side and Protestants and other dissenters on the other. It was a sad period in history and ended with the Catholic conquest of Protestant Germany. For thirty years the fighting and the witch craze raged, ultimately burning the magic out of science.

The international witch craze turned into hysteria.

The Dream Dies

The Thirty Years' War fanned the flames of the witch craze into hysteria. Fearing persecution and death, dreamers dispersed and went further underground. Johann Andreae, thought to be the author of all three Rosicrucian pamphlets, denounced alchemy and, claiming the Chymical Wedding was a "ludibriu", called the whole thing a joke. Scores of sympathizers followed Andreae and were forced to deny any interest in anything but the status quo. Isaac Newton, along with most other promising scientists, dropped all mention of his mystic leanings. Francis Bacon separated himself from any alleged sources of sorcery and denied any ties to the Rosicrucians. His visionary book, *The New Atlantis*, was published only after his death.

Roaming philosopher René Descartes was on his way to Prague looking for Rosicrucian wisdom, appearing just in time to witness the battle of White Mountain. After his arrival at the battle, Descartes mysteriously disappeared for two years, surfacing only to reject any association with the Rosicrucians. In fearful response to accusations of associating with "devil worshippers", Descartes continued to condemn all Rosicrucian-like thought, and was compelled to create an entire philosophy separating science from suspected sorcery. This separation became so extreme that Descartes went so far as to part the mind from the body—dividing our souls from nature. Matters of the soul were left to the church, with science left to study the body as a meager machine.

Descartes later became the tutor to the idealistic Elizabeth of Bohemia, who escaped the battle which cost her the throne. He remained a closet dreamer for the rest of his days. We know his head—in fact, it is mounted in a museum in Paris today—but we'll never know Descartes' heart. On the tomb of his separated body reads his motto—"He who hid well, lived well."

Publicly, science was forced to denounce its mystical roots, and other philosophers were obliged to follow in Descartes' footsteps. They extracted the alchemy from chemistry, plucked the astrology out of astronomy, dug the geomancy out of geometry, and zapped the magic and music out of math. Artists could no longer be scientists, and there would never be another Leonardo da Vinci. Quality became mere quantity, wonder was banished from the world, and the mystery that made us one with nature was lost. In its place, we inherited from Descartes a disconnected dualism that pits the mind against the body. Descartes was the father of modern philosophy, and his materialistic axioms are followed by science to this very day.

The Misfortune of Modernism

In many ways the separation of science and faith was inevitable, and a good thing. The division of church and state led to our modern idea of democracy, and allowed the rise of individual freedom. But it's worthwhile to think about what is lost when separation isn't followed by reunification.

In alchemy, for example, the distillation process of *Separatio* was the key to success. To find the essence of truth, alchemists divided ideas and objects into their respective pieces, then refined these elements before recombining them to unveil a higher understanding. In its day, alchemy was seen as both a science and an art. It was an early unified field theory that combined romance with reason—hearts with heads—to connect us with the rest of the cosmos.

Today, alchemy is often reduced to a naïve precursor to chemistry. As scientists' findings began to throw doubt on divine doctrine, these thinkers were obliged to disconnect their holistic dreams and focus on purely materialistic pursuits. To protect themselves from the power of the Church (the Spanish Inquisition didn't disband until 1834), they became their own inquisitors, denouncing any aspirants to their fraternity who had ideas outside a reductionist agenda. As a result, the institution of science became so compartmentalized that now it often misses the magic that happens when ideas mix across disciplines. Along the way, doctors became mere mechanics, and the mystery of our connection with nature—something essential to our humanity—was lost.

Francis Bacon's* New Atlantis *(1626)
All is well in this agrarian techno-paradise. Looks like the little guys below have invented an early telephone, and the guy at top an early airplane.

and rule by royalty. Countless dreamers followed and America became the new promised land. It held a renewed hope that a utopian society might be possible. Many of the founding fathers were Freemasons whose dreams of democracy, secular social mores, freedom of the press, cultural tolerance, and individual rights were inspired by three little Rosicrucian pamphlets first published long ago and far away.

These humble pamphlets called for a do-it-yourself philosophy that led to the founding of America and the Bill of Rights. America today might not be exactly like what they envisioned. The original movement to create an ideal society is dead, and the pamphlets are now antique curiosities. The tomb is a Memory Palace whose ideas we've forgotten. Its discoverers found an early scientific vision of holistic harmony that saw the planet, the cosmos, and ourselves as one great interconnected whole. It contained a dream that saw people as part of nature, not separate from it, and envisioned a way to make life meaningful through a feeling of connection to the beauty and mystery of everyday experience.

Was It *All* a Joke?

The same year the Bohemian dream was crushed at the Battle of White Mountain, the Pilgrims landed at Plymouth Rock. These fleeing idealists intended to invent an idyllic society of their own, free from Rome's rituals

Was it all a joke, like Johann Andreae said? Even if it was, what a lovely ludibrium—and couldn't we all use a little more magic in our lives?

The paper model associated with this chapter is a mock-up of Father C.R.C.'s Tomb of Illumination. By making it, you can follow in the footsteps of those early philosophers and reconnect with the vision that was forgotten.

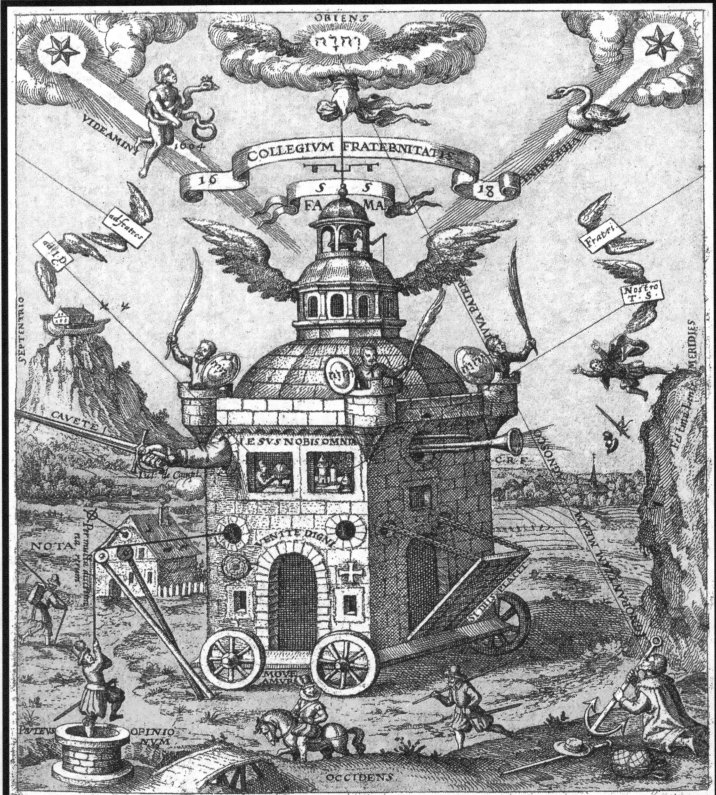

"The Invisible College" of the secret brotherhood, by T. Schweighart (1618). This vision inspired the British Royal Society, the first scientific institution.

THE MUSEUM OF LOST WONDER
TOMB *of* ILLUMINATION
MODEL INSTRUCTIONS

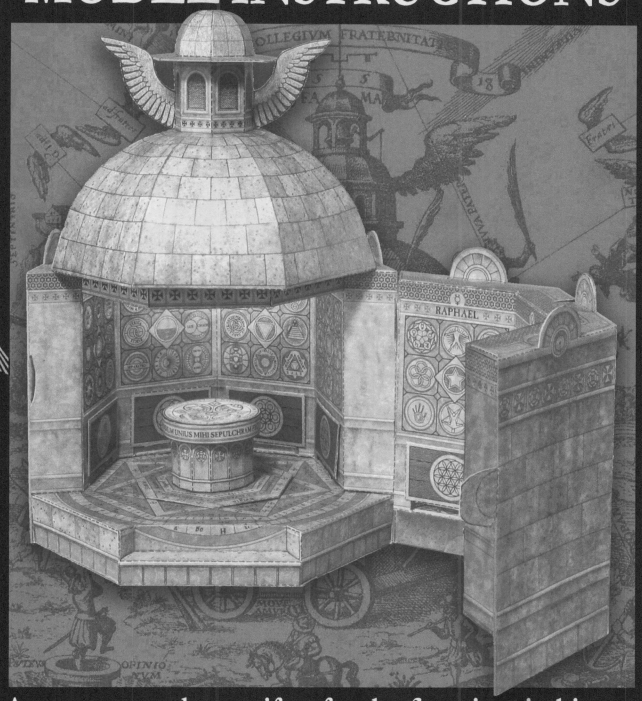

A mystery made manifest for the first time in history

MODEL INSTRUCTIONS

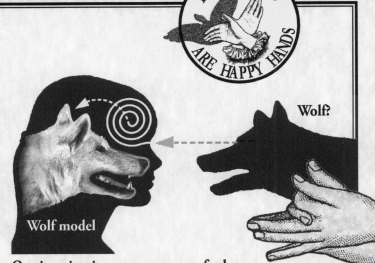

WHY BUILD A MODEL?

WYou'd probably be surprised to know that you actually build models all the time—but only in your mind. Psychologists say we have no choice—that we don't see the world as it really is, but only through reconstructions our brains make. The hardwiring of evolution has kept our senses separate from our thoughts through the mechanism that makes memories. In this way, evolution gave us a gift that helped us survive. It gave us the ability to take shadowy clues and imagine whether they were a threat or not, based on past experience. This gift of the imagination gave us the ability to think of things before they happened, either to avoid danger or to imagine new and novel things and make them real (like airplanes and iPads).

Wolf?

Wolf model

Our imaginations can save us or fool us.

The Magic of Inter-dimensional Manifestion

If we use our hearts and hands, our imaginations can help us make things never before seen in this world.

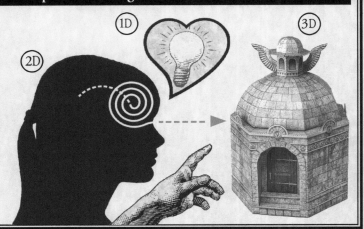

Before dreams become realized they start out as ideas. But ideas are nothing unless acted upon. To become real, an idea must be visualized then manifested. This is the foundation of all art, magic, and goal-setting in general.

There is mysterious power we invoke by taking a one-dimensional idea (like the tomb description in the *Fama*), making it into a two-dimensional plan (like the paper cut-outs), and manifesting it in the third dimension while building it (like constructing the model).

Take charge of your unconscious model making and make it a conscious choice! Making this paper model is an excercise in making any of your dreams come true.

THE TOOLS

Scissors, X-Acto, straight edge, scoring tool, glue stick, and glue

The scoring tool is one of the most important tools in your kit. It can be the back side of a kitchen knife, a butter knife, or a letter opener. Anything with a thin dull edge will do.

GLUING: A glue stick will work perfectly for 99% of the model. But you might want to use white glue for reinforcing fragile areas and for sneaking into troublesome seams.

This is real building, so like a true craftsman,
BE SURE TO GLUE BOTH SIDES OF ALL JOINTS.

SCORE, CUT, FOLD, then CREASE

The four things you must do, in that order, before gluing.

SCORING: Carefully score all fold lines *before* cutting.
CUTTING: Cut outlines with scissors and slots with a blade.
FOLDING: Use the diagrams to see which direction to fold.
CREASING: Place on table top and flatten the folds.

CUT LINES ——————	FOLD LINES - - - - - - - -
PLACE LINES · · · · · · · ·	*Meet tabs to these when gluing.*

Creating the model as an initiation into a secret society of dreamers

Most secret societies have gradual degrees that allow members a step-by-step way to achieve mastery over their vision and higher self. Some also use the metaphor that building one's spiritual acuity is like building a temple to your inner aspirations, a place to be the best you can be. Making this model is no different. This is an ancient temple to the imagination—a dollhouse of dreams. Building this model is an excercise in bringing an abstract idea to life—of realizing one's aspirations. We've married the journey of building this model to the steps of progressing through the traditional Rosicrucian grades from the Zealator (the excited beginner, committed to the work ahead) all the way to the Ipissimus (a title given to someone who has realized their true Self).

If you don't build the model, just absorb visualizing the diagrams. This is a traditional way to realize dreams. We hope that if you excercise your imagination by gazing at these little pictures, they will breathe life into your visualizations and help in making all your dreams come true. *Metaphors be with you!*

Floor & Crypt ✿ Grade 1—Zealator ✠

Approximately 40 minutes
Score fold lines first, cut out shapes, then crease all folds.

FLOOR (1 PIECE)

1) Glue the sides together, being sure to meet the arrows on adjacent tabs. Position the tabs by covering the dotted lines before pressing together. Press the assembly to your table top while gluing, to ensure it's true and flat.
2) Glue front bottom ends to the sides and floor.
3) Fold and push the steps in. Meet bottom edge.
4) Glue tabs and fold the steps backing over, pressing the back to the top riser, and the end tab to the floor.
5) Make sure to meet the bottom tab arrows.
6) Glue and press inside ends together.
7) While glue is still wet, square the whole assembly by pressing against your table top. Adjust tab position, and keep turning over to make sure the steps are square.

CRYPT (1 PIECE)

8) Fold crypt assembly up, and glue tabs to its outside.
9) Glue both floor tabs and crypt sides. Keep level by pressing against table while gluing. Turn over to check that its top edge is level, then adjust and re-check.
10) Make sure to adequately glue the top edges and keep the edges even, then burnish the crypt top edge against the floor to round it over and make a tight seal.

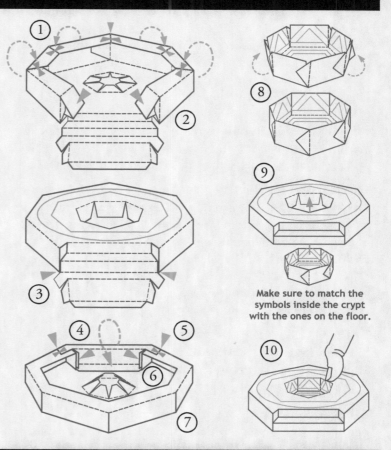

Make sure to match the symbols inside the crypt with the ones on the floor.

Door & Walls ✿ Grade 2—Theoricus ✠

DOOR (1 PIECE — *Approximately 20 minutes*)
1) Fold sides forward and glue steps over the bottom tabs.
2) Glue archway together by starting on the left side and work your way around to the other side. Be sure front joints meet together. Press face to table top while gluing, to keep squareness and flatness of the face arch.
3) ATTACHING DOOR TO FRONT WALL: When you've finished the front wall assembly, *(see next page)* simply fold the wall flaps in, then glue door frame to the face of the wall. Then glue the bottom interior wall tab to the underside of the top tread.

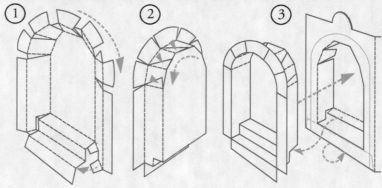

Door & Walls *continued*

WALLS (4 PIECES — *Approximately 90 minutes*)

WALL DETAILS

1) Glue the 3 chest cavity upper tabs to the back of the walls. *The loose bottom tab becomes a spring catch to secure the chests.*
2) Glue latch together on the back of the right front wall.
3) Glue striker *on the left side of the back inside wall* to back of the wall. Be sure to align with corner, by folding the end flap.
4) Glue exterior wall sides to each other at their tops. Make sure to align top tabs to the the neighboring wall section.

INTERIOR TO EXTERIOR WALLS (same for both)

NOTE: It's important to line up all the edges, for the walls to keep their geometry and fit to the floor and dome later. Conform wall assemblies, while drying, to the floor to ensure angles are true.
5) Glue the tops together first. Pull the top tabs through the openings, but align and secure interior edges first. Next, secure the exterior inside tabs *using a pencil to poke inside from bottom.* Finally, match and secure top circles.
6) Glue the bottoms together by first inserting the interior wall tabs into the slots in the exterior walls. *Make sure the interior flaps are square to the exterior folds.* Next, glue the exterior flaps over the interior sections, then glue the small circular tabs.

FRONT WALL ENDS

7) **HINGE END:** Glue exterior flap into the wall cavity. *(Press tabs together by poking inside with a pencil and secure the edges.)* Then glue the interior end flap with the hinges over this.
8) **WALL LATCH END:** Glue the interior end inside the wall cavity. (*Use a pencil to poke through the chest cavity to press the pieces together.*) Then pull the latch through the slot into the exterior end flap and glue in place.

BACK WALL ENDS

9) Latch striker end—make sure to glue and press edges.
10) Slotted hinge section—same as above.

ATTACHING BACK WALLS TO FLOOR

11) Glue bottom sides of both the walls and floor (except for right hinge end), insert wall tabs, then attach. Turn over, then glue and bend bottom tabs underneath the floor.

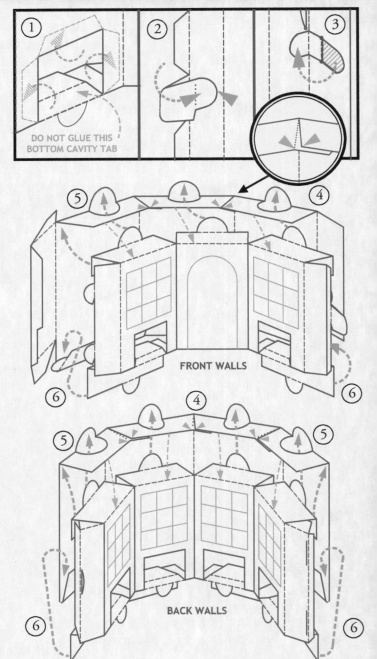

FRONT WALLS

BACK WALLS

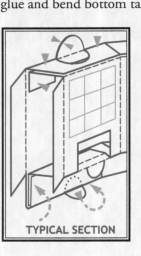

TYPICAL SECTION

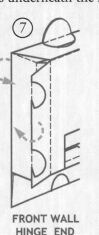

FRONT WALL HINGE END

FRONT WALL LATCH END

BACK WALL LATCH END

BACK WALL HINGE END

BACK WALL TO FLOOR

Approximately 45 minutes
Carefully score fold lines, cut out shape along the curves, then crease tabs to ensure the dome will keep its roundness.
DO NOT CUT BOTTOM CENTER TABS UNTIL DOME IS DRY.

DOME (1 PIECE)

1) Pre-curve dome sections by lightly scoring with your thumbnail along their length in multiple passes.

2) Crease folds with thumbnail, especially at the tiny tabs at the top of each seam.

3) Assemble dome sides to each other. Work one seam at a time, and glue both sides of seam. A glue stick works well as it allows re-positioning as you work the seam. Start from the bottom of each curve, press that bottom corner with your thumbs on the outside, then carefully curve and position the seam as you work up its length with your fingers on the inside. Align and hide the dashed lines with the edge of next side. It's best to let each seam dry before continuing to next one.

4) Fold and glue the bottom tabs in. Do not glue the end tabs; they simply act as a seat for positioning the ceiling. *Reinforce the seams, inside the top of the dome, with white glue.*

CEILING (1 PIECE)

5) Fold exterior pieces as indicated in the diagram.

6) Make sure to meet 'place lines' when gluing sides together.

7) Glue perimeter tabs to dome. Align and press together.

8) Once the dome assembly is dry, cut the top slits with an X-Acto blade. Fold the tabs down to accept the cupola.

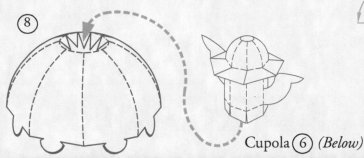

Cupola ⑥ *(Below)*

(1 PIECE—*Approximately 40 minutes***)**

1) Assemble dome. *(See large dome instructions above. Repeat steps 1–4 as before.)*

2) Glue tabs to eave heptagon.
 Be sure to match tabs tightly.

3) Flip over and glue tabs to underside of eave.

4) Glue together both sides of cupola base.

5) Glue dome to cupola base.

6) Glue finished cupola to the large dome.
 (See diagram above.) Make sure to glue the corner edges.

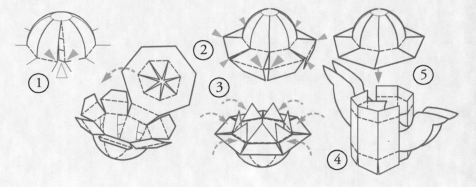

Chests ❁ Grade 5—Adeptus Minor ✠

Symbols on the Chests & Walls

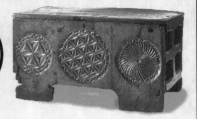

(6 PIECES—*Approximately 7 minutes each, 45 minutes total*)
1) Glue the three tabs to the chest front, then flatten against your table top.
2) Fold the back up, then swing sides around to glue to bottom tabs.
3) Glue, then fold over, the side's insides in. Press in place.
4) Glue, then fold the back and bottom into the chest. Glue, then fold side tabs and the lid to each other. Square and secure.

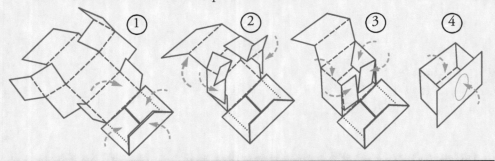

The symbols on the chests and door were taken from ancient figures of the "Flower of Life"— geometric patterns reflecting the creation of the universe. These figures are found in Egyptian tombs and can be seen in the middle of this typical medieval chest.

Chest Contents ❁ Grade 6—Adeptus Major ✠

(6 PIECES—*Approximately 7 minutes each, 45 minutes total*)
1) Glue the 3 tabs to the chest lid and flatten against your table top. On the book assemblies, glue cover to the adjacent page.
2) Fold the end up, then swing the sides around, to glue to the side tabs.
3) Fold this assembly up, then glue to the next tabs. Continue to glue the last section, then glue the box assembly to the lid. Be sure to glue the edges on these last steps, then press firmly but gently. Square and secure while the glue sets.
4) *Shows final assembly of book (top) and instrument (bottom) contents.*

The other symbols on the model walls were taken from Rosicrucian figures, such as this typical emblem, from *Secret Symbols of the Rosicricians*, by H. Spencer Lewis. The figures nicely express a realtionship between personal meaning and cosmic unity.

Altar ❁ Grade 7—Adeptus Exemptus ✠

(5 PIECES—*Approximately 30 minutes*)
1) Glue the sides up. Work counterclockwise as you:
 a) Attach the rims flat to the altar floor.
 b) Glue uprights and tabs to each other.
 c) Flip the last flaps over and glue to insides.
2) Glue the above, while pressing flat to your table top. Keep seams tight together, and the floor flat and square.
3) Glue inside heptagon last. Make sure assembly is flat and square against your table top. You can test the geometry of the bottom rim shape by pre-fitting into the crypt opening, then pulling it out and adjusting.
4) Gently pre-curve rim with thumbnail (like dome sides).
5) Glue altar top to the rim.
6) Glue altar base together, then attach its top.
7) Glue altar to the altar floor.

Father C.R.C. in His Coffer ✿ Grade 8—Magister Templi ✠

(1 PIECE—*Approximately 15 minutes*)
Score fold lines, cut out shape, then crease the fold lines.
1) Curve the figure and pillow into half rounds.
2) Glue the figure's back side to the inside bottom.
3) Glue and fold end flaps inside box.
4) Glue casket sides to outside bottom to make a box.
5) Glue and press figure into the casket interior.
6) Glue final right side to casket and square the assembly.

Minutum Mundum ✿ Grade 9—Magus ✠

(1 PIECE—*Approximately 10 minutes*)
Score fold lines, cut out shape, then crease the fold lines.
1) Bend the sides around and glue tab to other end.
2) Glue top and bottom on.
Be sure to glue the perimeter edges, especially when attaching the last end, where you'll only be able to press the edge to get a bond.
3) Burnish edges with thumbnail.

Final Assembly ✿ Grade 10—Ipsissimus ✠

(19 PIECES—*Almost home. Total time: approximately 8 hours*)
1) Glue hinge tabs from front walls into the back wall slots and the floor. Be sure to glue both sides of the tabs to the floor and wall. Secure.
2) Place *Minutum Mundum* inside the altar, the coffer in the crypt, and the altar in the floor. Put chests together and place in walls. The dome can just be inserted in slots and not glued.
3) Close front wall and praise yourself for a job well done.

Congratulations! You've just created something that has never existed in the world before. You've taken a vague one-dimensional idea, envisioned the two-dimensional plans, then manifested them in the 3rd dimension. You've allowed magic to happen. Now imagine and use this same process as a way to realize anything you can dream of.

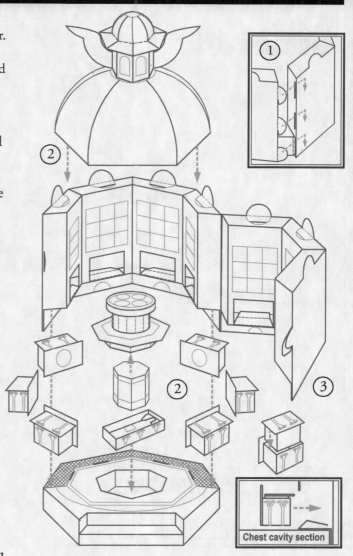

Chest cavity section

SUGGESTED READING

Case, Paul Foster. ***The True and Invisible Rosicrucian Order***. York Beach, ME: Samuel Weiser, Inc., 1985

Hall, Manly P. ***The Secret Teachings of All Ages***. Los Angeles: The Philosophical Research Society, 1988

Lewis, H. Spencer. ***Secret Symbols of the Rosicrucians of the 16th and 17th Centuries***. San Jose, CA: AMORC, 1935

Waite, Arthur Edward. ***The Real History of the Rosicrucians***. London: George Redway, 1887

Yates, Frances. ***The Rosicrucian Enlightenment***. London: Routledge & Kegan Paul Ltd., 1972

The complete text of the ***Fama Fraternitatis***, ***Confessio Fraternitatis***, and ***The Chymical Wedding*** can be found at *alchemywebsite.com*.

The tomb as described in the original *Fama Fraternitatis*

The description in the *Fama* is incredible in some details, but others are left to history's imagination. This model is faithfully true to the original description and uses conventions by historians taken from comparable Rosicrucian literature. Further architectural details were taken from norms of the time period with adjustments made for the tomb's manifestation as a paper model.

EXTERIOR There is no mention of an exterior, as it was a vault, possibly found beneath the *Spritus Sancti*. For modeling purposes we've used the 1604 etching of the "Invisible College," a symbolic representation of the Rosicrucian order.

VAULT GEOMETRY

"In the morning following we opened the door, and there appeared to our sight, a vault of seven sides and corners, every side five foot broad, and the height of eight foot... This vault was parted in three parts, the upper part or ceiling, the walls or sides, the ground or floor."

WALLS

"...every side or wall is parted into ten squares, every one with their several figures and sentences."

CHESTS

"...every side or wall had a door for a chest, wherein there lay diverse things, especially all our books, ...besides the Vocabulario of Theophrastus Paracelsus... Herein also we found his Itinerarium, and Vitam... In another chest were looking-glasses of divers virtues, as also in other places were little bells, burning lamps, & chiefly wonderful artificial Songs."

FLOOR

"The bottom again is parted into triangles, therein is described the power and rule of the inferior Governors." Historians claim this description alludes to John Dee's "Sigillum Dei Æmæth" heptagonal diagram, with names of the angelic hosts.

CEILING

"Of the upper part... was divided according to the seven sides with a triangle, which was bright in the center. Although the Sun never shined in this vault, nevertheless it was enlightened with another sun, which had learned this from the Sun, and was situated in the upper part, in the center of the ceiling."

ENTRANCE

"...the door, upon which that was written in great letters, POST 120 ANNOS PATEBO, with the year of the Lord under it."

CRYPT

"Now as yet we had not seen the dead body of our careful and wise father, we therefore removed the altar aside, there we lifted up a strong plate of brass, and found a fair and worthy body, whole and unconsumed, as the same is here lively counterfeited, with all the ornaments and attires; in his hand he held a parchment book, called T, the which next to the Bible, is our greatest treasure, which ought to be delivered to the censure of the world."

ALTAR

"In the midst, instead of a tombstone, was a round altar covered over with a plate of brass, and thereon this engraven: 'A.C. R.C. Hoc universi compendium unius mihi sepulchrum feci. 'Round about the first circle or brim stood, 'Jesus mihi omnia.' In the middle were four figures, inclosed in circles, whose circumscription was, '1. Nequaquam vacuum. 2. Legis Jugum. 3. Libertas Evangelij. 4. Dei gloria intacta.'"

MINUTUM MUNDUM

"Concerning Minitum Mundum, we found it kept in another little altar, truly more finer than can be imagined by any understanding man, but we will leave him undescribed."

Curiously left to our imaginations, scholars say this "miniature world" was a geometric mirror of the tomb, containing the essence of its symbolic secrets, and all the magic of its crystalline form.

 DEPARTING THE TOMB "...and so we have covered it again with the plates, and set the altar thereon, shut the door, and made it sure, with all our seals ... Finally we departed the one from the other, and left the natural heirs in possession of our Jewels. And so we do expect the answer and judgment of the learned, or unlearned."

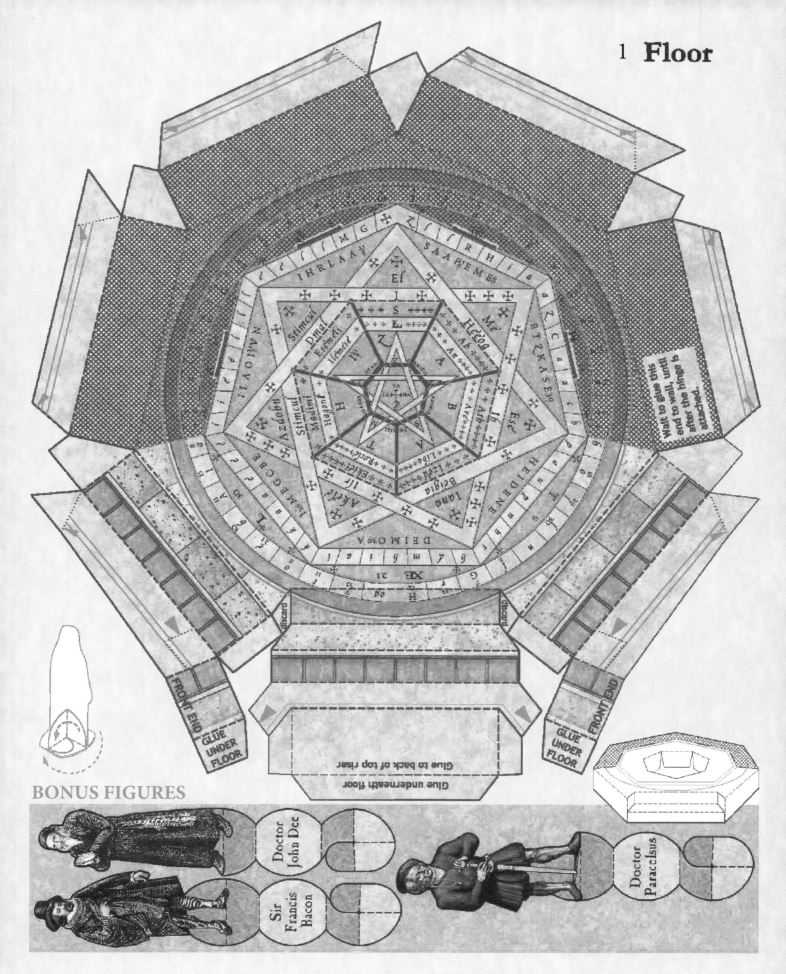

1 **Floor**

BONUS FIGURES

NOTE: If you don't want to rip up the book and would like to build the model on heavier coverstock, type 'Museum of Lost Wonder Tomb of Illumination Folio' in your browser's search bar.

2 **Exterior Back Wall**

FOLD AND CREASE THIS END, BEFORE SLITTING SLOT.
PULL INTERIOR WALL LATCH THROUGH SLOT.

3 Exterior Front Wall

GLUE THIS END OUTSIDE.

Glue over interior tab.

GLUE FLAT TO BACK SIDE

Glue over interior tab.

JUST FOLD BACK THESE TABS.

DISCARD

NO NEED TO GLUE.

Glue this tab under here. Align this edge with dotted line.

Glue this tab under here. Align this edge with dotted line.

hinge

Glue inside floor

Glue inside interior end.

Glue inside interior wall.

Glue under eave

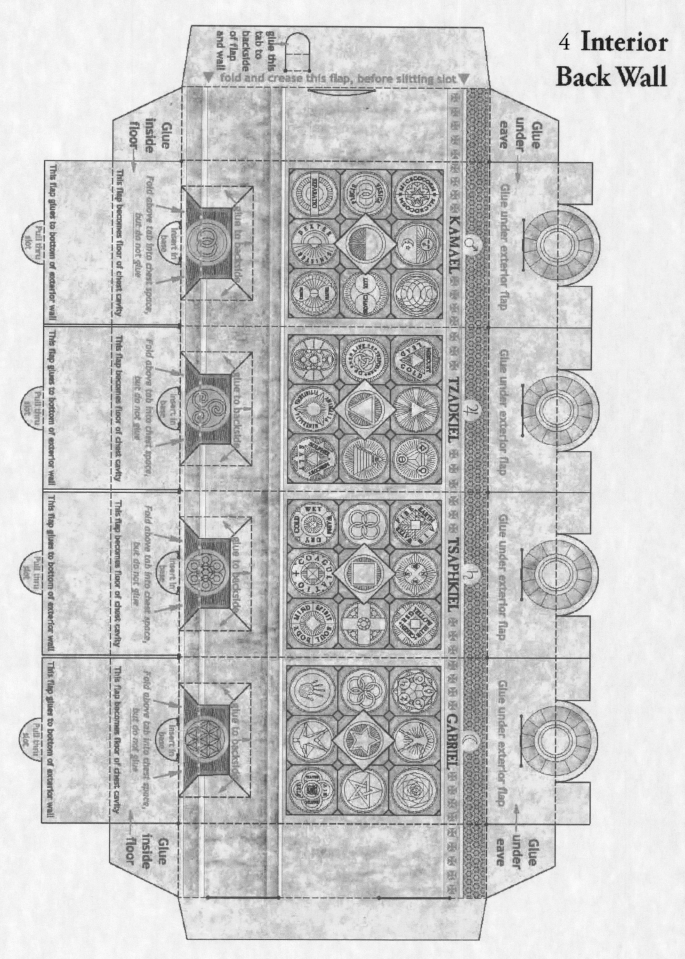

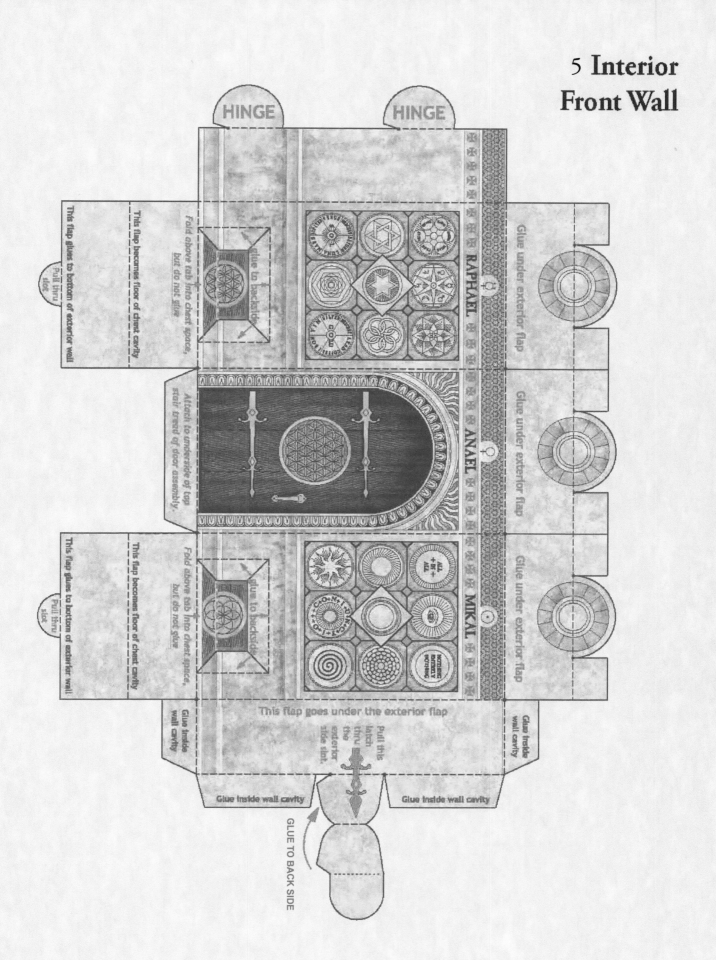

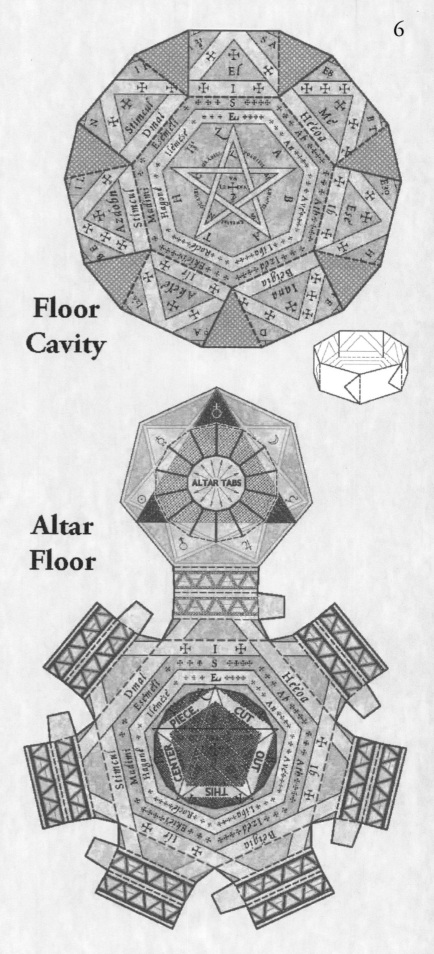

Floor Cavity

Altar Floor

ALTAR TABS

PIECE. CUT CENTER THIS. CUT OUT

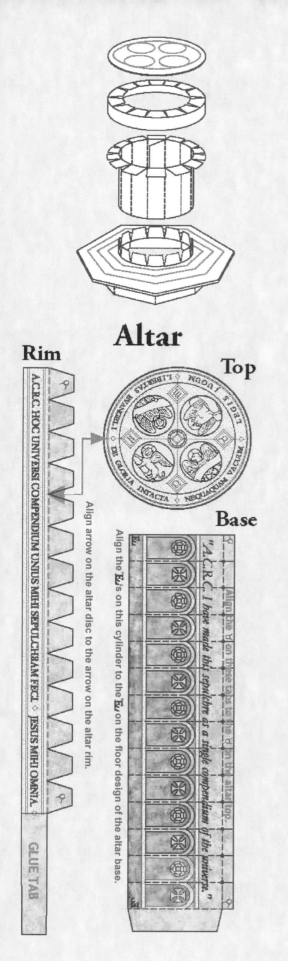

Altar

Rim

A.C.R.C. HOC UNIVERSI COMPENDIUM UNIUS MIHI SEPULCHRAM FECI ◊ JESUS MIHI OMNIA.

GLUE TAB

Align arrow on the altar disc to the arrow on the altar rim.

Top

LEGIS JUGUM LIBERTAS EVANGELII DEI GLORIA INTACTA ◊ NEQUAQUAM VACUUM

Base

"A.C.R.C. I have made this sepulchre as a single compendium of the universe."

Align the E's on this cylinder to the E on the floor design of the altar base.

Align the E on these tabs to the E on the altar top.

Father C.R.C.

curve figure

curve pillow

glue to bottom

Doorway

POST CXX
ANOS
PATEBO

·MCDLXXXIV·

After 120 years
I will open
1484

GLUE UNDER STEP

GLUE UNDER STEP

GLUE UNDER STEP

GLUE UNDER STEP

Minutum Mundum

Dome 8

BONUS FIGURES

Elias Ashmole

High Preist

Reverend Johann Andreae

Rene Descartes

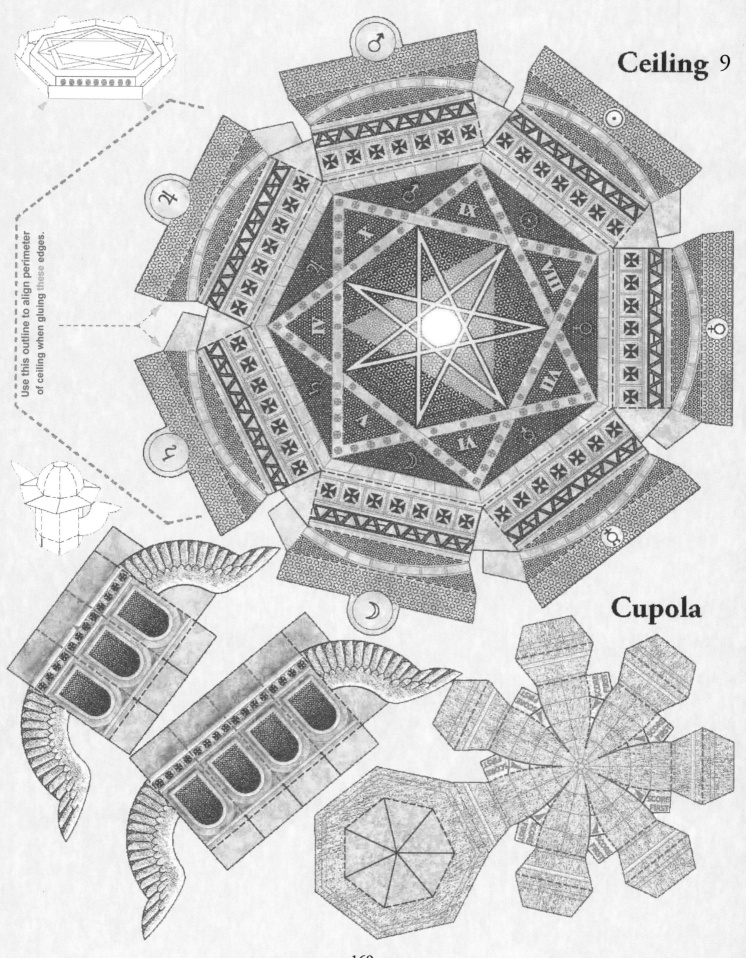

Ceiling 9

Use this outline to align perimeter of ceiling when gluing these edges.

Cupola

SCORE FIRST

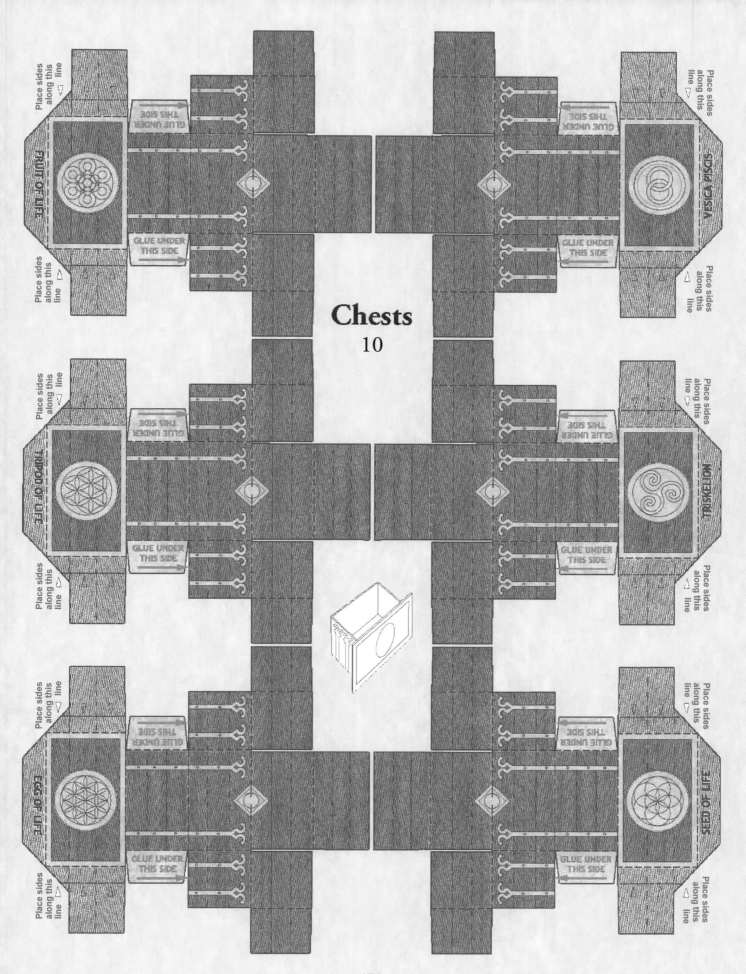

Chests
10

PARACELSUS' BOOKS

FATHER CRC'S BOOKS

ARTIFICIAL SONGS

LAMPS

BELLS

LENSES

Chest 11
Contents

Epilogue

"His way had therefore come full circle, or rather had taken the form of an ellipse or a spiral, following as ever no straight unbroken line, for the rectilinear belongs only to Geometry and not to Nature and Life."
—*Hermann Hesse*

Welcome home to our final Dream Palace—the Museum of Lost Wonder. It's an ephemeral structure—a memory palace dedicated to understanding the dark depths of the creative process and bringing them to the light.

Inside the Museum of Lost Wonder

Our Museum owes its form to many of the Dream Palaces in this book. Like the Tomb of Illumination, it incorporates a set of symbols and objects that encapsulate a distinctive hermetic philosophy. Like St Teresa's Interior Castle and Solomon's Temple, it delineates a progressive path from the mundane to the sacred. Like Tibetan mandalas, its building plan is meant to be constructed in the mind to enter a another realm—a portal to the inner self and beyond. And finally, like Gulliver's Laputa, it's a playful ludibrium that pokes fun at both science and myth, while embracing both. As a museum, like many Memory Palaces, it is made to preserve a forgotten way of seeing the world and a sense of wonder that is all but lost in today's world.

The Museum of Lost Wonder is a museum made up of museums. Each exhibit hall is its own type of museum that explores different ways of seeing and experiencing the world. Each hall offers a unique perspective on ourselves and our relationship to creation. Taken in order, they constitute a unique journey. The exhibits' progressive relationship to each other follows a formula common to many mythic adventures—and touring the Museum is a metaphor for the process of enlightenment. In its efforts to mix science and myth to find meaning, the Museum's exhibit halls are named after the stages in the process of Alchemy. Alchemy was a mix of both early chemistry and hermetic mythology. It sought to connect one's personal psychology with the transformation of physical matter, in an attempt to refine both. And wouldn't you expect a little refinement when you go to a museum?

Come with us and let's explore how the sequence of exhibit halls resonate with the science and psychology of alchemy, which mirrors the creative process, and how this combination of elements becomes a monomythic Hero's Journey. Each stage reveals a progressive method of personal transformation leading to self-discovery.

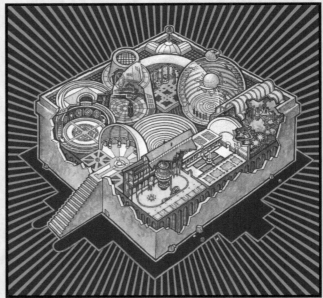

Museum Interior — Cutaway View

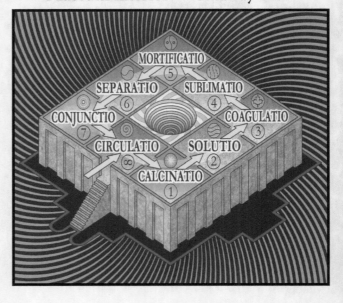

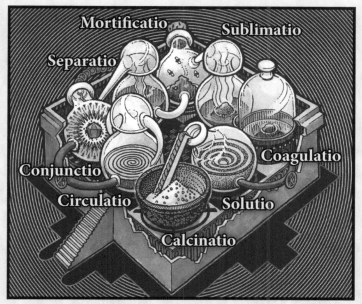

Alchemical Stages

Alchemy brought science and myth together, not only to transform physical elements, but psychic ones as well, in order to reach a spiritual state of refinement. As early chemistry, it was practiced by Egyptian priests in their temples. The method was refined in the Middle Ages, where the stages of the process were identified in Latin. These terms seem strange today, but can begin to be understood simply by putting an 'n' at the end of the words. Calcinatio becomes Calcination—to refine elements by heat. Solutio becomes Solution—a perfect homonym for a physical state as well as the answer to a mental query. Carl Jung identified these alchemical stages as meaningful in the realm of depth psychology. To him they outlined a path to 'actualization'—the integration and transformation of consciousness into a more enlightened state of wholeness.

Creative Process

Key to our Museum's mission is exploring the act of creation. Its alchemical terms can be used as prompts to facilitate the creation of something new and unique that aids in personal transformation. The creative process is slightly re-ordered for clarity, but the intent of the process remains the same. The creative act is not always a linear and rarely follows a prescribed path. Nor should it, as the process should be unique to each work and guided by one's personal idiosyncrasies and response to the elements in front of the creator. Here you can see it laid out symbolically, with hands highlighting the importance of manipulating physical matter to alter one's perceptions as a work progresses.

Hero's Journey

The alchemical method, creative process, and our museum tour follow a similar structure to many of the greatest mythic adventures. These epic quests share similar thematic elements referred to as a 'monomyth'. This adventurous process of character transformation was outlined and explained by the mythologist Joseph Campbell. The monomyth is an archetypical structure that one can see played out in the narratives of history's greatest mythic figures. From the stories of Prometheus to Hercules, Buddha to Jesus, one can see a similar theme. Basic elements in this Hero's Journey are: a Call to Adventure followed by a momentary Refusal to the Call. Then there is a journey. Along the way one finds mentors and is tested by elements and enemies. Friends and allies are encountered, while ordeals and even a symbolic death are experienced to transform the psyche. Join us as we take a detailed tour of the museum where we all become protagonists on our own Hero's Journey.

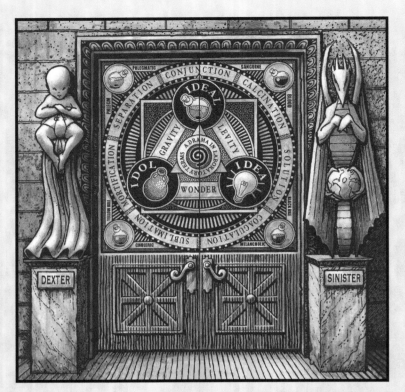

Entrance

The journey begins at our front door, where two guardians flank our portal to adventure. On the left is Dexter, the museum's right hand—representing the child in all of us that delights in wonder. On the right is Sinister, or left hand—symbolizing the inner demons that drive us forward. On the door itself is our Great Seal. The outer circle shows the circular path that makes up the museum. This is bordered by the four humors that affect our psychic state on the tour. Inside the circle is our trinity of creation—Ideals, Ideas and Idols, connected by our three principles—Gravity, Levity, and Wonder. In the center is the symbol for the spiral path—Circulatio—and around it is the description of our alchemical journey—'A Drama in Laboratory Terms'.

Hero's Journey STEP 1

THE ORDINARY WORLD— Here the hero takes stock of who they are, where they come from, and wonders about their reasons to go forward.

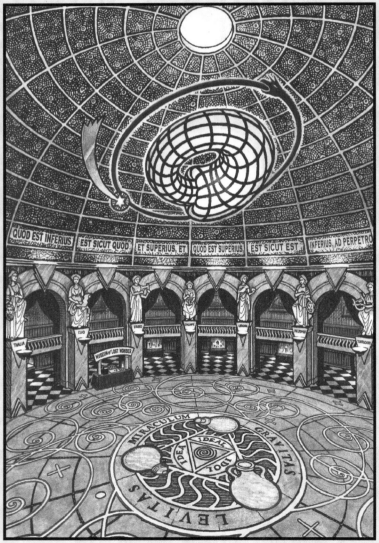

Circulatio =

Inside, we arrive at the entrance and exit hall. This is the creative core of the Museum and its circulation desk. We've left the ordinary world and entered a special realm—one full of wonder, but also tests and trials.

Alchemical Stage

CIRCULATION—Moving around in a closed loop. Alchemically, it's the process of repeated distillation that draws out purified essences.

Psychological State

Circulatio is the ongoing process of raising our normal awareness to a higher refined state, then bringing that knowledge back down to help guide our daily affairs.

Creative Process

Inspired by the Trinity of Creation symbol on the floor and the muses encircling the Great Hall, we embrace the creative urge. This signals a readiness for the Great Work ahead.

Hero's Journey = STEPS 2 & 3

CALL TO ADVENTURE & REFUSAL OF THE CALL
The muses inspire the hero to begin the journey. The hero hesitates at the entrance, wary of the dangers ahead, but is overtaken by curiosity and forges onward.

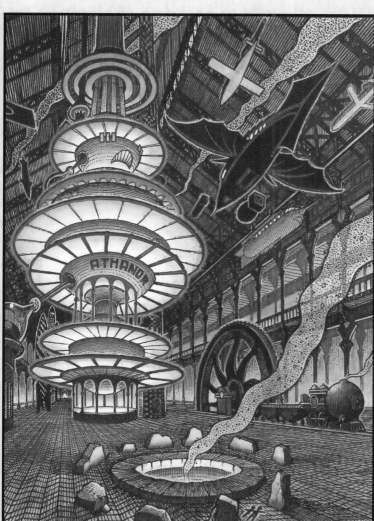

Calcinatio = ①

This is the Hall of Technology in the Museum of Lost Wonder. A home for all the hopes, fears, and preoccupations that civilization has brought us.

Alchemical Stage

CALCINATION—To apply heat to an unrefined substance in a crucible over an open flame until it is reduced to a fine white ash.

Psychological State

Psychologically, Calcinatio symbolizes the fire of introspection. Here we purify our petty preoccupations by reducing them to ash in the light of reason.

Creative Process

Here we ignite the ideas that fuel our passions. The inventions surrounding us inspire us to move forward and make our own contribution.

Hero's Journey = STEP 4

FINDING A MENTOR—Confronted by the fantasies of fellow inventors, our hero takes inspiration from their creativity and the industry that generates such awesome technological toys. This inspiration will fuel the journey ahead.

Solutio = ②

The Hall of Aquaria in the Museum of Lost Wonder. A hypnotic realm of water, where one's worries and cares are washed away in a world of living wonder.

Alchemical Stage

SOLUTION—A suspension of elements in fluid. The ashes of Calcination are dissolved in a liquid.

Psychological State

Solutio is the immersion of our normal awareness into a subconscious dream state.

Creative Process

Here we immerse ourselves in our passions, allowing them to settle in our subconscious and incubate, then bubble up from below.

Hero's Journey = STEP 5

THRESHOLD TO THE UNKNOWN— This under-the-surface realm of mysterious creatures mirrors the unknown entities deep inside the psyche.

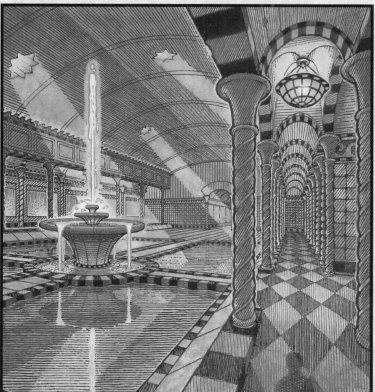

Coagulatio = ③

Our Zoological Garden of Eden in the Museum of Lost Wonder. An Earthly habitat where we acknowledge our relationship with all living things.

Alchemical Stage

COAGULATION—To gain solidity from an amorphous state. Alchemically, the liquefied ashes from Solutio congeal and harden.

Psychological State

Psychologically, Coagulatio is about grounding ourselves by experiencing the world, in all its immediacy, with our five physical senses.

Creative Process

This is about finally getting our hands dirty. We play with matter while matter plays with us, as matter has a mind of its own.

Hero's Journey = STEP 6
TESTS, ENEMIES & ALLIES—The power of nature and its dark denizens are intimidating, but there is also comfort and sustenance in this natural refuge.

Sublimatio = ④

The Kingdom of Astronomy and all things extraterrestrial in the Museum of Lost Wonder.

Alchemical Stage

SUBLIMATION—To purify by vaporizing into a gaseous state. The solidified mass from Coagulatio is distilled and further refined.

Psychological State

This is the process of raising our awareness above earthly concerns to gain a lofty perspective and become spectators of ourselves.

Creative Process

New inspiration springs from the matter we've just manipulated. These ideas float up into consciousness and offer a another point of view.

Hero's Journey STEP 7
APPROACH TO THE INNER SANCTUM—In the furthest recesses of the Museum, our hero enters an unfamiliar world, gaining perspective on the journey as they develop a new awareness.

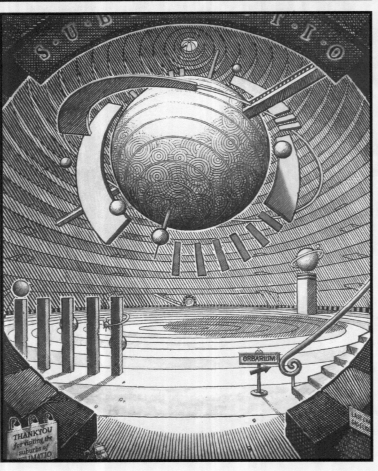

Mortificatio = ⑤

The Mausoleum to Memory that embraces the past, and puts old ideas to rest, in the Museum of Lost Wonder.

Alchemical Stage
MORTIFICATION—Fermentation. To decay. The matter left from the previous distillation is fermented to allow for new growth.

Psychological State
A sublime condition of humility brought by the contemplation of our own mortality. This helps us prioritize what's most important in our lives.

Creative Process
Contemplating the present state of the work, we sacrifice old ideas that are delaying progress so that novel new forms may emerge.

Hero's Journey = STEP 8
MORTAL ORDEAL— Facing a symbolic demise, a crisis point is reached where the hero must sacrifice the demons in order for the sense of self to be rejuvenated and reborn.

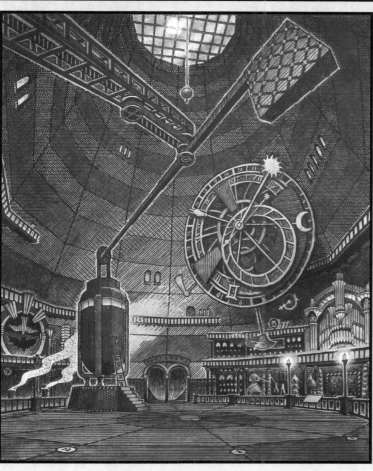

Separatio = ⑥

The Laboratory to Science and Faith in the Museum of Lost Wonder. On the right side is the Lab, where we labor. On the left is the Oratory—a place to meditate.

Alchemical Stage
SEPARATION—To refine and concentrate by distillation and condensation.

Psychological State
The ability to distinguish the motivations of our conscious and unconscious selves—separating the observer from the observed.

Creative Process
A very delicate and decisive stage, when final refinements are made with new perceptions, perseverance and more play.

Hero's Journey = STEP 9-10
REWARD AND RETURN— The insights achieved on the journey are measured and refined, rewarding the hero with new self-knowledge to bring back and apply to daily life.

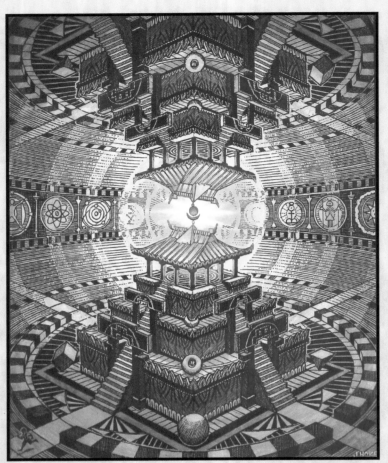

Conjunctio = ⑦

The Gallery of The Arts in the Museum of Lost Wonder. A refuge where our feelings, ideas, and their forms are married in a divine state of unification.

 ### Alchemical Stage
CONJUNCTION—To join previously separated materials to form a final perfected union.

 ### Psychological State
A state of rapture, where the conscious and unconscious minds are joined together to create a heightened state of awareness and unity.

 ### Creative Process
Finishing, then displaying our creation, is about connection and communication with others, and setting the work free to gain a life of its own.

 ### Hero's Journey = STEP 11
TRANSFORMATION— All the elements from the journey are brought together. Their unification brings about a psychic transformation, which culminates in a state of wholeness.

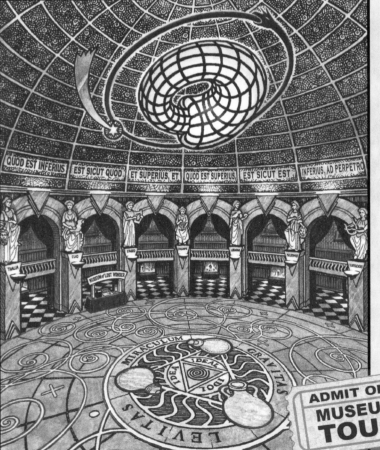

Circulatio = ∞

A final return to where we started. Hopefully rewarded and changed by the journey. One may decide to leave or take the tour again to continue the process of refinement.

 ### Alchemical Stage
RE-CIRCULATION and further distillation.

 ### Psychological State
Our normal awareness is raised. We bring back that knowledge to help guide our daily affairs.

 ### Creative Process
Getting feedback from showing our work brings on new inspiration. The muses are still there to

spur one on to start the next project. ### Hero's

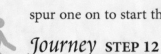 ### Journey STEP 12
Return with Elixir—Our hero is ready to re-enter the Ordinary World changed—with newly refined knowledge to share with others.

ADMIT ONE
MUSEUM
TOUR

If you'd like to take an interactive journey of the museum, go to **www.lostwonder.org** and click on the tour ticket on the homepage.

The Museum of Lost Wonder
A ray of hope in a dreary world

We hope you've enjoyed our little tour. It is the dream of the Museum to make itself viscerally present in the hearts and minds of those who enter. Every person that walks its virtual halls models a bit of it in their minds. Every time somebody does this, the museum becomes more real. A little more solid. Every time someone tours these pages, takes the website tour, and makes the models, it adds to the family of Museum thought-forms that emanate from the minds of every visitor. It is hoped that these rambling thought-forms will eventually coalesce, out there in the aether, to create a true Dream Museum, like the one St Thomas made King Gondophares so long ago.

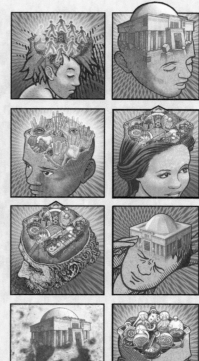

To facilitate the magical manifestation of the Museum in the world beyond, we invite you to make the following mini museum model. We believe that making it with your hands will strengthen the mental model in your mind, whose psychic emanations will model it life-size in the aether, for all to explore.

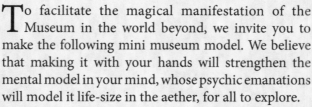

Take an interactive tour of the Museum of Lost Wonder at:

www.lostwonder.org

Micro Museum
model instructions

BUSY HANDS ARE HAPPY HANDS

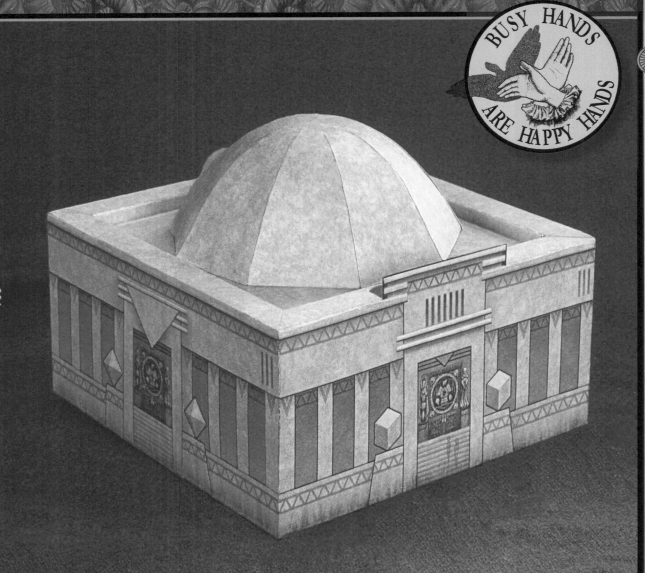

The secrets of the museum in the palm of your hand

Add your own secret exhibit to complete the Museum

Micro Museum model views

The Museum Exterior

The Museum Interior

The Museum Floorplan

The Secret Chamber

Museum of Lost Wonder Micro Museum Model

Assembly instructions

Tools & Techniques: SCORE - - - - - CUT ——— GLUE ▨▨▨▨▨ ALIGN · · · · · ·

Choose a glue suitable for paper—we find a simple glue stick works just fine, but wood glue helps in special cases. Find an implement to score with—such as a dull knife, a letter opener, or a dead ball-point pen. Anything comfortable to hold that can score the cardstock without cutting it will do. Use a straight edge to keep your scoring straight and centered on the dashed lines. Scoring all the fold lines before you cut out the shapes is very important for the success of your model. After folding the card, crease the folds with your thumbnail to make sure they're nice and sharp.

Exterior construction

A Score all the fold lines with a straight edge, then cut shapes out and crease folds with your thumbnail. Use a glue stick and/or white glue to adhere pieces. Make sure to glue both sides of all joints before you assemble them.

B Fold back the tabs along the bottom edge of the walls and glue to the reverse side of the walls. Apply glue to inner side tabs and assemble box exterior.

C Pre-fold inner side tabs and insert into the box. Fold the side opposite the front in first, then fold in the remaining side, slipping it into the slots on the previously folded side. Unfold, then apply glue to both sides of the end tabs where indicated. Make sure you align both inner sides along the bottom of the box before pressing them together. Leave top tabs up for now.

D Glue the ends of the top tabs to the reverse of the outer walls, then ease one tab at a time into place. Make sure the top tabs are positioned well below the fold line on the outer walls before gently pressing them into place. Allow to dry.

E Glue the tops of the outer walls and ease into place. Be sure to glue the round corner tabs, too. Align the top of the box and gently press together, making sure the corners are flat.

Interior construction

A Score all the fold lines with a straight edge before you cut out the shape. Then gently crease the folds with your thumbnail after cutting it out.

B Glue and assemble the bottom of the box. Make sure to glue both sides of the four side joints before assembling.

C Glue the tabs of the top lid and assemble. Glue the top tabs of the box and press them into the interior. Make sure NOT to glue the middle of the end tab with the slot in it.

D Get a toothpick or pencil and stretch out the center slot of the front inside tab.

E The top tab should easily go in and out of the slot, yet lock in place. This creates a secret chamber to hold a personal artifact of your choice.

Dome construction

A Carefully score all the fold lines, then carefully cut the shape out and bend the tabs in. The printed side will should be on the inside of the dome, so the lines don't show on the finished model. Pre-curve the sides with your thumbnail, while carefully holding the center of the dome so the sides don't tear off when curling.

B Take care to crease the tops of the skinny tabs at the center.

C Glue both edges of each segment. Align the bottoms first and press together. Then run your fingers over both sides of the edge and carefully position the curved edge while applying pressure. Adhere one joint at a time and let set before going on to the next one. To strengthen the center top, apply wood glue to the interior central joints. Let dry.

D When dry, glue the perimeter square tabs into the dome. You can then insert the bottom round tabs into the top of the museum interior box. Folding the side tabs to the inside of the dome will lock it in place.

Expert Finishing Tip After the pieces are put together, you can use an appropriately colored pencil to darken the lighter folded edges. Think of the paper as miniature wood that needs staining and waxing. The pencil's color will allow the paper's different shades to blend together. The wax in the pencil will fill gaps between the paper's exposed fibers and smooth the edges.

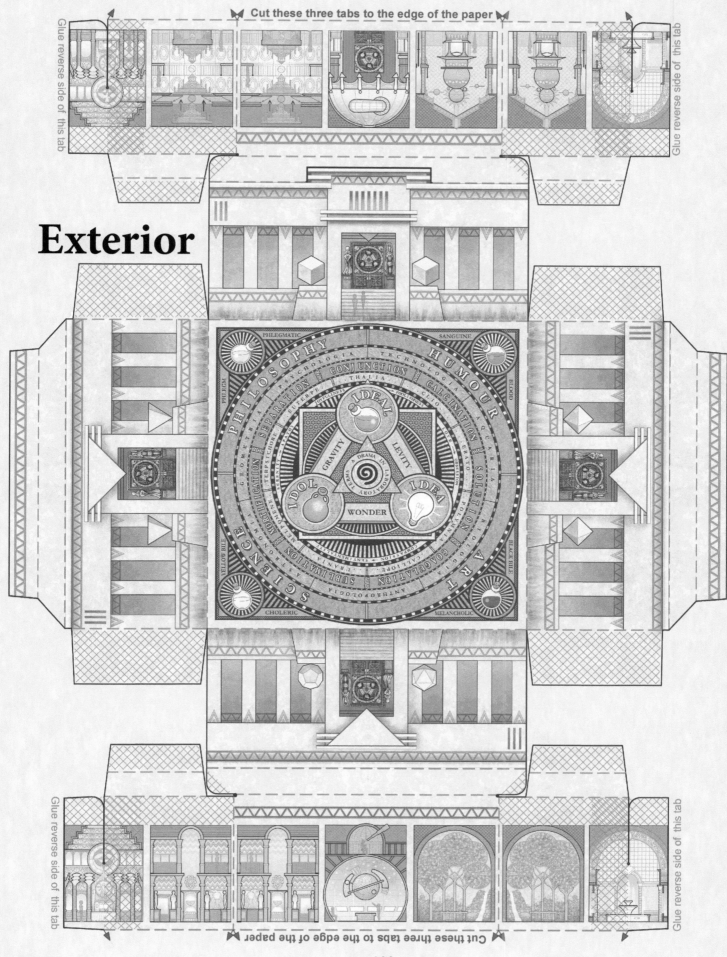

Exterior

NOTE: If you don't want to rip up the book and would like to build the model on heavier coverstock, type 'Museum of Lost Wonder Micro Model' in your browser's search bar.

Interior

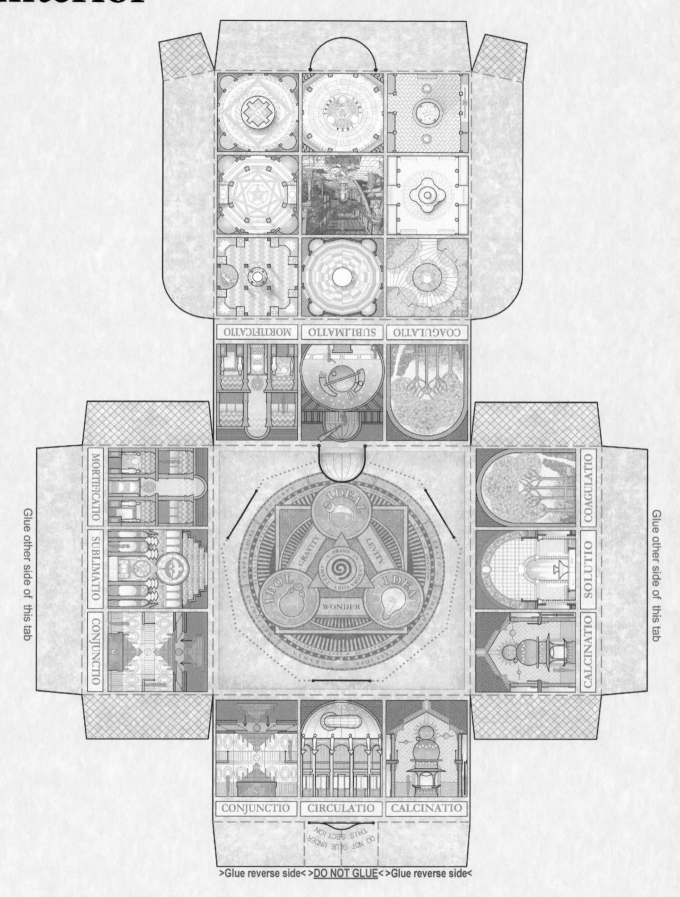

MORTIFICATIO

SUBLIMATIO

COAGULATIO

MORTIFICATIO

SUBLIMATIO

CONJUNCTIO

COAGULATIO

SOLUTIO

CALCINATIO

CONJUNCTIO

CIRCULATIO

CALCINATIO

IDEAL

GRAVITY

LEVITY

IDOL

A DRAMA IN A PARADOX FROM WONDER

IDEA

WONDER

191

The Dome

See instructions

GLUE INSIDE DOME

GLUE INSIDE DOME

GLUE INSIDE DOME

GLUE INSIDE DOME

GLUE INSIDE DOME

GLUE INSIDE DOME

Fold & glue tabs on this side of dome

Activating your model

A Insert the finished interior box into the exterior. If you've kept the two pieces square, the interior should easily slide in and out.

B To help you remove the interior, use the observatory dome tab to lift it out.

C Remove the interior and open the secret chamber. Find a special personal artifact of your own to be idolized inside the Micro Museum of Lost Wonder. Close the secret chamber.

D Reassemble the micro museum and display it proudly. Share it with others who'll wonder why you built it in the first place!

Bibliography

Ackerman, Diane. *An Alchemy of Mind.* New York, NY: Scribner, 2004.

Ball, Philip. *The Devil's Doctor: Paracelsus and the World of Renaissance Magic and Science.* New York, NY: FSG, 2006

Campbell, Joseph. *The Hero with a Thousand Faces.* New York, NY: Pantheon Books, 1949.

Carter, Rita. *Mapping the Mind.* Berkeley, CA: University of California Press, 1998.

Carruthers, Mary. *The Book of Memory.* Cambridge, UK: Cambridge University Press, 2001.

Case, Paul Foster. *The True and Invisible Rosicrucian Order.* York Beach, ME: Samuel Weiser, Inc., 1985.

Clark, Desmond M. *Descartes: A Biography.* Cork, Ireland: Cambridge University Press, 2006.

Crick, Francis H.C. *The Astonishing Hypothesis.* New York, NY: Charles Scribner's Sons, MacMillan, 1994.

David-Neel, Alexandra. *My Journey to Lhasa.* New York, NY: Harper/Perennial, 2005.

de Jong, H.M.E. *Atalanta Fugiens: Sources of an Alchemical Book of Emblems.* Boston, MA: Red Wheel Weiser, 2002.

Dennett, Daniel C. *Consciousness Explained.* Boston, MA: Little Brown and Company, 1991.

Edinger, Edward. *Anatomy of the Psyche: Alchemical Symbolism and Psychotherapy.* Chicago IL: Open Court, 1994

Elkins, James. *What Painting Is.* New York, NY: Routledge, 2000.

Evans, R.J.W. *Rudolph II and His World.* Oxford, UK: Oxford University Press, 1973.

Ghiselin, Brewster. *The Creative Process.* Berkeley CA: University of California Press, 1985.

Goddard, David. *The Tower of Alchemy: An Advanced Guide to the Great Work.* Boston, ME: Red Wheel/Weiser, 1999.

Hall, Manly P. *Lectures on Ancient Philosophy.* New York, NY: Tarcher/Penguin Books, 2005.

Hall, Manly P. *The Phoenix: An Illustrated Review of Occultism and Philosophy.* Los Angeles, CA: Hall Publishing, 1931.

Hall, Manly P. *The Secret Teachings of All Ages.* Los Angeles, CA: The Philosophical Research Society, 1988.

Hoke, Jeff. *The Museum of Lost Wonder.* Boston, MA: Red Wheel/Weiser, 2006.

Johnson, George. *In the Palaces of Memory.* New York, NY: Random House, 1991.

Kinney, Jay. The Inner West: *An Introduction to the Hidden Wisdom of the West.* New York, NY: Tarcher/Penguin, 2004.

Koestler, Arthur. *The Act of Creation.* New York, NY: Penguin Books, 1990.

Lewis, H. Spencer. *Secret Symbols of the Rosicrucians of the 16th and 17th Centuries.* San Jose, CA: AMORC, 1935.

Marshall, Peter. *The Magic Circle of Rudolph II.* New York, NY: Walker & Company, 2006.

Nelson, Victoria. *Writer's Block.* New York, NY: Houghton Mifflin Company, 1993.

McKim, Robert H. *Experiences in Visual Thinking.* Belmont, CA: PWS Publishers, 1980.

Revija, Jugoslovenska. *Tibet.* New York, NY: McGraw Hill, 1981.

Robertson, Ian. *Opening the Mind's Eye.* New York, NY: St. Martin's Press, 2002.

Rupp, Rebecca. *Committed to Memory: How We Remember and Why We Forget.* New York, NY: Crown Publishers, 1998.

Schama, Simon. *Landscape and Memory.* New York, NY: Alfred A. Knopf, 1995.

Sheldrake, Rupert. *The Sense of Being Stared At.* New York, NY: Crown Publishers, 2003.

Shepard, Roger N. *Mental Images and their Transformations.* Cambridge, Massachusetts: The MIT Press, 1986.

Slade, Neil. *Tickle your Amygdala.* Denver, CO: Brain Book Books & Music, 2012.

Wind, Yoram and Cook, Colin. *The Power of Impossible Thinking.* Upper Saddle River, NJ: Prentice Hall, 2006.

Paris, Anne, PhD. *Standing at the Water's Edge.* Novato CA: New World Library, 2008.

Sahakian, William S. *The History of Philosophy.* San Francisco, CA: Barnes and Noble Books, 1968.

Vogler, Christopher. *The Writer's Journey: Mythic Structure for Writers.* Studio City, CA: Michael Wiese, 1998.

Waite, Arthur Edward. *The Real History of the Rosicrucians.* London, UK: George Redway, 1887.

Wooley, Benjamin. *The Queen's Conjuror.* New York, NY: Owl Books, 2001.

Yates, Frances A. *The Art of Memory.* Chicago, IL: University of Chicago Press, 1966.

Yates, Frances A. *The Rosicrucian Enlightenment.* London, UK: Routledge & Kegan Paul Ltd., 1972.

With thanks to Wikipedia and other educational sites across the internet, too numerous and shifting to mention.

Notes

Visit the Museum of Lost Wonder

At www.lostwonder.org, you can take an interactive tour of the Museum, watch animated shorts, peruse the Curiosity Shop, buy books, models, prints, folios, and become a member. All in the comfort of your own home.

For a premium version of the models in this book, printed in full colour on heavy parchment vellum with an accompanying folio including background and full instructions, visit the Curiosity Shop. Type 'Museum of Lost Wonder Folios' in your browser. Most of the models have their own interactive animated movie to explore.

| Zoetrope from the Codex of Creativity | Mysterium Cosmographicum from Mental Modeling | Mind Mansion from Architecture of the Imagination | Interior Castle from Dream Palaces | Tomb model from Tomb of Illumination | Micro Museum Model from the Epilogue |

www.lostwonder.org